D1646338

United Nations
Educational, Scientific and
Cultural Organization

Human Remains
& Museum Practice

Jack Lohman and
Katherine Goodnow (Eds.)

2006

The designations employed and the presentation of material throughout this publication do not imply the expression of any opinion whatsoever on the part of UNESCO concerning the legal status of any country, territory, city or area or of its authorities, or the delimitation of its frontiers or boundaries.

The authors are responsible for the choice and the presentation of the facts contained in this book and for the opinions expressed therein, which are not necessarily those of UNESCO and do not commit the Organization.

Designed by Ole Kristian Øye
Printed by Sagraphic, Barcelona

ISBN-10: 92-3-104021-9
ISBN-13: 978-92-3-104021-4

Published in 2006 by the United Nations Educational, Scientific and Cultural Organization, 7. Place de Fontenoy, 75007 Paris, France and the Museum of London, 150 London Wall, London, ECY 5HN, United Kingdom.

Printed in Spain

Table of Contents

Foreword

O N THE BASIS of its unique mandate in the field of culture, for more than a decade UNESCO has highlighted the challenges facing cultural diversity and has promoted greater recognition of its importance through discussions at expert and governmental levels. UNESCO's efforts culminated at the international level in the adoption, at the 33rd session of its General Conference in October 2005, of the Convention on the Protection and Promotion of the Diversity of Cultural Expressions.

It is against this background that this publication should be understood. It seeks to stimulate intercultural dialogue on the theme of human remains in an innovative way amongst institutions which, by virtue of their mandate as guardians of collections, must approach scientific studies and interpretative presentations as a web of relations between scholars and specialists of different historical periods and regions; these relations occur at national, regional and international levels. This approach represents a pioneering initiative to explore cultural diversity from the multidisciplinary perspective of museums and to create the conditions for a better understanding of history and collections, especially by questioning assumptions and revisiting interpretations which might have become outdated.

How best can museums contribute to the construction and development of intercultural dialogue and disseminate UNESCO's values as expressed in its normative texts? In seeking to answer this question, this volume opens up new avenues for analysis and action to all of UNESCO's Member States and the communities served by museums around the world. In reporting on good practices in the treatment of human remains, this publication will be useful to institutions seeking to learn from others' experience and draw upon the latest developments in contemporary interpretative practice.

This volume reflects the findings of an international conference, hosted by the Museum of London, whose aim was "to consider how issues including rights and ownership, belief systems, historical considerations, competing cultural models and defining public benefits should be dealt with by museums and how they shape and influence their policy, practices and procedural frameworks". The dominant message of the conference was the need to draw up a variety of approaches that would influence both the policy framework and museum practices. This publication should become a useful tool for initiating a debate amongst museums with collections of human remains.

In conclusion, UNESCO considers that this publication, by presenting scholarly and innovative approaches towards delicate and often neglected topics, will be a stimulus for constructive intercultural dialogue both within museums and amongst museums. In addition, we hope that it will encourage countries sharing a common history to reinterpret their past links – through joint efforts of mutual enrichment – in order to achieve a clearer presentation and more accurate interpretation of their collections.

KOÏCHIRO MATSUURA
Director-General of UNESCO

Introduction

Jack Lohman

I N OCTOBER 2004 the Museum of London hosted an international conference that focused attention on the ethical, research, public policy and display considerations faced by museums in relation to the care, management and interpretation of human remains. Previous specialist conferences have addressed important issues relating to curatorial practices and scientific research findings – activities central to the role and responsibilities of museums – as well as politically sensitive issues such as the repatriation of human remains to the countries and communities of their origin. The Museum of London decided to create a forum in which these issues could be laid out in order to set an agenda for continuing discussions. The conference provided an opportunity for not only dialogue but also an understanding of various international perspectives, contexts and meanings associated with these issues, and a growing awareness that what may be appropriate for one museum is not necessarily appropriate elsewhere.[1]

Framing the discussion and emerging themes

The conference began from the position that human remains provide a rich source of information about humanity. The central task was to consider how issues including rights and ownership, belief systems, historical considerations, competing cultural models and defining public benefits should be dealt with by museums, and how they shape and influence their policy, practices and procedural frameworks. The conference was organised into four strands – the policy framework; the politics of human remains; display issues; and curatorial and research directions – as a means of examining and drawing out international perspectives on how museums treat and display the dead.

Displays of human remains and bodies hold a fascination for the public. Recently the Museum of Science and Industry in Tampa, Florida held an exhibition *Bodies: The Exhibition*, that drew long queues of visitors paying an entry fee of $US 19.95. This exhibition was held despite opposition from the Florida State medical board and attorney general. The interest can be partly attributed to a controversy over the origins of specimens. The cadavers on display were mostly middle-aged Chinese men and women, and there were 260 other body parts among the exhibits, all owned by the Dalien Medical University in China. The controversy revolved around consent practices and the lack of documentation proving that family members had identified the corpses and allowed their transfer to the university.[2] A similar exhibition, *Body Worlds*, created by Gunther von Hagens and featuring human corpses, organs, glands and arteries preserved by the injection of synthetic materials, has been travelling the world since 1996. It has attracted debate in relation to how the bodies are displayed and the generation of profit from displaying dead bodies.

Such displays do allow visitors to study how body parts function and how illnesses affect specific organs. The situation is analogous to one museums face, where human remains can be profitably studied medically and displayed for insight into present illnesses and patterns of disease. People will benefit, but at what cost to the sanctity of those remains?

Understanding, respect, sensitivity, and dialogue were words constantly used throughout the conference papers and proceedings. Increasingly they inform both the public policy framework and the museum practice that was the conference's focus.

Some nations, such as the United States, Canada, Australia, New Zealand, and more recently the United Kingdom, have established legislative frameworks in relation to the care and management of human remains. The first part of the conference explored recent public policy considerations in North America, Australia and the United Kingdom. Francis McManamon of the United States Park Service outlined the policies and procedures that have developed in the United States and Canada as well as the approaches followed by public agencies and museums. In Australia, where human remains are rarely displayed, there has been little attention given to protocols for their care, management and display. However, there is legislation in relation to Australian indigenous human remains that has been complemented for many years by good protocols relating to these 'categories' of remains. Michael Pickering of the National Museum of Australia describes the Australian context and highlights the consideration of indigenous cultural values as one of the key characteristics of these protocols. It is the experience in the care and management of human remains informed by the recognition of cultural values that informs the Australian experience, and in turn the perspectives that it brings to this debate.

In the British context the landscape for the acquisition, care, study and display of human remains is changing rapidly. This is owing to a number of separate but not unrelated initiatives. These include the publication in 2003 of the Department for Culture, Media and Sport (DCMS) *Palmer Report* into the use of human remains in museums, and the subsequent guidelines for museums; the enactment of the Human Tissue Act that regulates the rights of those dealing with human tissue that are reasonably believed to be under 1,000 years old; and the 2005 report by the Church of England and English Heritage into the excavation and study of human remains from Church of England sites, which together provide for the first time clear guidance and regulation for dealing with almost all aspects of human remains as they impact on museums. These initiatives cover England, Northern Ireland and Wales, but not Scotland, where the heritage agency Historic Scotland provides guidance for the excavation of human remains.

The key elements of the policy framework are:

- *The Report of the Working Group on Human Remains* (2003). This major report summarises background information on the ethical, legal and historical positions of the study of human remains in British museums. Although many of its recommendations have not been acted on, the report has had a considerable influence on the way human remains are considered, and led directly to the inclusion of section 47 in the Human Tissue Act, and the commissioning of the practice guidelines.

- *Guidance for the Care of Human Remains in Museums* (2005). Commissioned by DCMS with the support of the museum sector, the guidelines provide advice

[1] The preparation of this introduction has been informed by the following publications: Ames, M, (1992), *Cannibal Tours and Glass Boxes: The Anthropology of Museums*, University of British Columbia Press, Vancouver; Church of England and English Heritage, (2005), *Guidance for Best Practice for Treatment of Human Remains Excavated from Christian Burial Grounds in England*, Church of England and English Heritage, London; DCMS, (2003), *The Report of the Working Group on Human Remains*, DCMS, London; DCMS, (2004), *The Care of Historic Human Remains*, a consultation on the report of the Working Group on Human Remains, DCMS, London; DCMS, (2005), *Guidance for the Care of Human Remains in Museums*, DCMS, London; Fforde, C, (2004), *Collecting the Dead*, Duckworth, London; Hicks, M, (ed), (2000), *Exhibiting Human Remains: a Provocative Seminar*, Powerhouse Museum, Sydney; Historic Scotland, (1997), *The Treatment of Human Remains in Archaeology*, Historic Scotland Occasional Papers 5, Edinburgh; Institute of Ideas, (2003), *Human Remains: Objects to Study or Ancestors to Bury?*, Institute of Ideas, London; Jones, T, 'Burying the evidence', in *Spiked Culture*, 24 November 2003; Jones, T, 'Who owns human remains?', in *Open Democracy*, 4 December 2003; Museums Australia, (1993), *Previous Possessions, New Obligations, a Plain English Summary of Policies for Museums in Australia and Aboriginal and Torres Strait Islander People*, Museums Australia, Canberra; Museums Australia, (2003), *Continuous Cultures, Ongoing Responsibilities. A Comprehensive Policy Document and Guidelines for Australian Museums Working with Aboriginal and Torres Strait Islander Cultural Heritage*, Museums Australia, Canberra; Simpson, M G, (1996), *Making Representations: Museums in the Post-Colonial Era*, Routledge, London

[2] 'Storm over exhibit of corpses', in *International Herald Tribune*, 23 August 2005

to museums and other institutions with collections of ancient human remains on how to curate and use them correctly and, most importantly, on how to deal with repatriation claims.

- The Human Tissue Act (2005) requires all institutions holding human tissue under 1,000 years old to be licensed, and provides detailed protocols for dealing with human remains including the need to gain consent for holding and using such material. Most importantly for museums, section 47 allows nine named British national museums to de-accession human remains under 1,000 years old from their collections. This overrides the legislation of those museums that had prohibited de-accessioning. The practice guidelines assist these and other museums that are considering de-accessioning, circumstances which, it is assumed, will normally be prompted by claims for the return of remains to indigenous peoples.

- *Guidance for Best Practice for Treatment of Human Remains Excavated from Christian Burial Grounds in England* (2005). While this report emphasises the scientific value of excavating and studying human remains, it states that this must be undertaken in a context where remains are treated with dignity and respect, with the support of living descendents if they are known, and that burials should be disturbed only with very good reason.

The papers presented by Norman Palmer and Joseph Elders and the subsequent discussion highlighted that claims for the repatriation or return of remains, scientific research into remains as well as their use by museums, are all driven by agendas. While a major public benefit is the knowledge derived from the remains and in the case of repatriation the claimant communities, there is still a need to question what is meant by public benefits. While museums have strengths in remembering the past and what the past holds, a major theme emerged that demanded a dialogue between all parties, and an understanding of all perspectives.

The question posed by Neal Ascherson in relation to the politics of human remains was 'who owns the dead?'

There is a risk that museum practitioners see collections of human remains as a representation of the past. However, the remains are very much the present and the future. Museums have to make decisions on whether they retain these collections, as well as how to care for, manage, research, display, interpret and communicate knowledge about them. There are broader political issues such as the return of remains to their graves or to their countries and communities of origin. Both acknowledging and dealing with these complex issues are important steps and they need to be dealt with and discussed with considerable sensitivity. Museum practitioners must remember that they are dealing not simply with remains – they are dealing with human remains.

Several papers, especially those by Hedley Swain, Henry Jatti Bredekamp, Marilyn Martin and Wynne Cougill, explore this question from the perspective of the activities of their own institutions and in particular the way that they have used exhibitions to challenge and change previous practices. In 1998 the Museum of London staged an exhibition, *London Bodies*, that showed how the physical appearance of Londoners had changed over time. In addition to using innovative display techniques, the museum challenged more traditional ways of displaying human remains by being sensitive to how they were presented in their exhibits and how audiences behaved around them. Marilyn Martin uses the backdrop of the reconciliation process in post-apartheid South Africa to describe the creation of the exhibition *Miscast* at the South African National Gallery, where the issues of access to material in museums and to Khoisan voices were pertinent. Underlying the exhibition were fundamental questions regarding who is writing the history, who speaks for whom, and domestic and international responses to these questions. The following papers demonstrate that progress is being made in accommodating and negotiating cultural and historical diversity within museums, but suggest that profound changes in museum practice are also required.

Recent civil wars in Rwanda and Cambodia pose even more complex issues relating to human remains, especially where they are displayed as evidence of mass death as in the case of Cambodia, where the Khmer Rouge were responsible for the loss of approximately

one quarter or 1.7 million of the country's population in the 1970s through starvation, disease, forced labour and executions. Wynne Cougill's paper explores the debate concerning the preservation and treatment of the human remains in mass graves that might be used as forensic evidence in the prosecution of crimes committed during the regime. While the general population, the government and the religious community support the preservation of the remains, opposition has emanated from the King and the royalist party, who argue that the remains should be cremated so that the souls can find rest. The dilemma is to reconcile the views of the King and respect for Buddhist beliefs with the need for public education and forensic evidence of the genocide. It is unlikely that the issue will be resolved until the Khmer Rouge tribunal has completed its deliberations.

Museums and churches are not the only public agencies that have to deal with issues relating to human remains. Vince Holyoak's paper describes the work by the Ministry of Defence in relation to military air crash sites, especially those resulting from the events of World War II. 'Enthusiasts' whose motives are mixed – some wishing to perpetuate the memory and deeds of the war dead, others to sell recovered artifacts on the commercial market – have excavated many of these sites. The British government allows the sites to be excavated only under licence and, where human remains are known to exist, the sites are declared to be war graves. This applies even if relatives formally request an excavation, which has resulted in moral dilemmas and some public unrest when relatives seek to have remains re-buried with respect in a military war cemetery. Paradoxically there are no restrictions on the recovery of human remains of United States or other non-Royal Air Force or British Commonwealth military personnel in the United Kingdom.

A central part of the conference focused on the display of human remains. Museums have traditionally taken the position that it is appropriate to display 'old' human remains but not the 'recent' dead. Where is the line drawn between 'old' and 'recent'? Presumably a value judgement has been made not to display 'recent' remains; why doesn't the same judgement apply to 'old' remains, and vice versa? Museums are silent in response to these questions.

Both Katherine Goodnow and Verónica Córdova pose questions about the ownership and management of displays which, in some communities, are more important than the display itself. Córdova in particular explores how different cultures hold different belief systems relating to the human body and the relationship between life and death, and how those beliefs affect perceptions of the exhibition of human remains amongst the Aymara people from the Bolivian highlands whose ancestors, 'the powerful other', are displayed in the Tiwanaku Museum. Katherine Goodnow explores the considerations involved when museums are dealing with, on the one hand, requests for the return of remains and objections to the forms of display and, on the other, calls for an understanding of what makes human remains significant.

These papers open up a raft of questions about the nature of the exhibition as a medium. One of the more vibrant themes relates to the mixed emotions that the display of human remains can evoke – from repulsion to fascination. How do or indeed should museums build on these emotional responses though the use of lighting and other display techniques? Do visitors desensitise themselves from the 'other'? And do museums sometimes display remains as academic case studies with little or no acknowledgement of the dignity and respect that should be given to our predecessors? Power relationships also underpin the question of what is displayed and by whom. Should museum practices move away from an object-rich or object-driven display to exhibition techniques driven by an idea or argument and characterised by embedding objects and remains and other media in a narrative? Many of the papers represent important contributions to this discussion.

The final conference strand related to the role of research and curatorial practice in museums, coupled with some case studies of research practices and findings in Australia and London.

The Museum of London's research programme, as described in the papers by Bill White; Chris Thomas; Jelana Bekvalac, Lynne Cowal and Richard Mikulski; and Richard Steckel, Clark Spencer Larsen, Paul Sciulli and Phillip Walker, have provided important sources of direct evidence about the past, including:

- human evolution and adaptation, and genetic relationships
- population relationships through genetics and morphology
- past demography and health
- diet, growth and activity patterns
- disease and causes of death
- history of disease and of medicine
- burial practices, beliefs and attitudes
- the diversity of cultural practices in which the body and its parts are used.

The study of human remains also contributes to the treatment of disease, and to the development of forensic science, which assists in the identification of human remains and in crime detection. These benefits are likely to increase as research methods advance. While museums may have research frameworks in place that guide research programmes and outputs, rarely do they have codes of research ethics that assist with addressing any ethical considerations that might arise during the conduct of their research programmes. Similarly museums have not defined and published the statements of research values that are an integral part of their research framework. While this does not detract from the quality of the research undertaken by osteologists in the museum context, it is perhaps timely for museums to consider the adoption of codes of ethics and statements of research values that are placed in the public domain and assist with making museum procedures and processes more accountable and transparent.

Future directions for the Museum of London

The Museum of London holds one of the largest and most important collections of archaeologically recovered human remains in the world. This assemblage of approximately 17,000 individual skeletons has been recovered during the past 30 years from archaeological excavations in Greater London, especially central London. The particular strengths of these collections are that, because the dates and methods of burial are known, they offer a unique resource for the study of London's early history. Moreover, in view of their large number, they offer a

unique research resource for wider studies into human history, urban living and modern medicine.

As the first stage of realising the research potential of its human remains collections, the Museum established a Centre for Human Bio-archaeology that has been undertaking a major project funded by the Wellcome Trust to create an on-line database of information about the skeleton holdings. In addition, the centre has responsibility for the care and management of the human remains 'archive', provides a facility for the Museum of London Archaeology Service's human remains projects – most notably the Spitalfields project – and is also a research facility for the study of the Museum's human remains by internal and external individuals/groups.

The centre is also a focus for the Museum's thinking on the excavation, curation, display, study and reburial of human remains. The Museum has developed a policy for the reburial of those remains that are deemed no longer to have any scientific research value, and the implementation of this policy has already begun. Other assemblages of remains that still have scientific research value will be relocated from the Museum building to better storage facilities. However, the Museum recognises that it needs to establish both a code of ethics and a more comprehensive policy framework for all aspects of its responsibilities relating to human remains, as well as reviewing its existing guidelines for their display. The display of human remains should be guided by value statements, so also should research programmes.

The Museum of London can play a leading role in considering the most appropriate and ethically acceptable ways to care for and study human remains. The Museum has been involved with developing national frameworks for their storage, display and study and recognises that, although the majority of the public may support these activities, the Museum must be sensitive to changing opinion and respect the views of all.

Conclusion

The study of human remains illustrates their potential to unlock fascinating facts about the lives of people; contributes to research into the development of humanity particularly in urban environments; makes a material

contribution to modern medicine; offers a major teaching resource; and can engage the general public. Museums worldwide need to be more transparent about their processes and procedures for collecting, recording, storing, researching and interpreting human remains, and make more information available in the public domain about their policies, codes of ethics, practices and standards.

Context, meaning, the concept of the individual, reburial and repatriation are some of the many issues that emerged during the conference's proceedings. Inherent in the discussion were the questions of what we mean by the individual and body, and how our treatment of the remains should relate to the way they would be treated in the individual's original community. Implicit in these questions are issues about:

- the role of museums: are they simply custodians of collections?
- why museums collect and the meanings that are attached to collections
- the symbolic meanings attached to human remains which vary among nations and communities, and
- who decides on, and takes control of, displays, especially since not all people share the same beliefs and traditions.

Such diverse themes indicate the complexities faced by museums in addressing the politics of human remains and museum practice and the multiple perspectives from which topic can be viewed. The conference did not attempt to identify comprehensively all the social and cultural differences that are bought to bear on this subject. Rather, the purpose was to draw out different perspectives that influence both the policy framework and museum practices. Many of the papers presented at the conference worked in concert to develop a framework – an awareness of the issues, challenges and possibilities – through which the various agendas relating to ownership, research, care, management, interpretation and display of human remains in museums can be progressed.

Why and When Do Human Remains Matter: Museum Dilemmas

Katherine Goodnow

MUSEUMS HAVE A long history of collecting, storing, and displaying human remains. How they do so, however, is an issue now highlighted by two changes. One is the rise of challenges in the form of requests for return, questions about the legitimacy of retention, and objections to particular forms of display or archival treatment. The other is the recognition by museums that these challenges call for understanding the meanings that make human remains significant, especially to the people being 'represented' or 'viewed'.

Isolating those meanings, however, is not the easiest of tasks. They are likely to be implicit, rather than explicit and easily accessed, surfacing only when some violation of expected actions occurs. They are likely to involve different views from those held by museum staff. They are also likely to vary from one group or one time to another.

How then can we proceed? Proposed are several possible steps.

Step 1: Let's question any assumptions about the universality of meanings

More specifically, let's not assume that (a) human remains always matter, (b) that everyone wants them back, (c) that their significance is the same for all people, even within a single cultural group, (d) that all bodies are of equal significance (in fact some human remains matter more than others), or (e) that meanings are static.

I place the examination of those assumptions as a first step for two reasons. One is that they make it unlikely that any single set of interpretive or decision rules will apply. The other is that we are now beginning to accumulate examples of variations that move us beyond them and toward questions that might usefully be applied to all situations. Let me draw out some of those examples.

An example related to assumption (a) – human remains always matter – comes from Bolivia. It is tempting to think of human remains as always intended to stay buried. As Verónica Córdova points out in the paper written for this conference, *Chullpas* (Andean mummies) are not seen as significant in themselves by the current generation of Aymara. The current generation, however, are very interested in the achievement of independence. It is then ownership and management of displays that matter to them, rather than display itself.

The example chosen in relation to assumption (b) – everyone wants them back – is Australian. Both the South Australian Museum in Adelaide and the Australian Museum in Sydney have entered into discussions with Aboriginal traditional leaders with regard to the return of Aboriginal human remains and other sacred objects. In some cases, the decision was made that the remains and the sacred material attached to them should stay temporarily in the museum until thorough identification has been made and proper arrangements made for return.

In other cases, it was decided that the remains and sacred objects stay in the museum but are not used for display purposes. They also had strict viewing restrictions attached to them. Only some members of the group – the initiated – are allowed to view the material. The museum's role then becomes that of custodian with limited rights. The restriction on viewing, even among Aboriginals themselves, reflects a society structured around restricted access to seeing or knowing about many objects or events.[1]

The example chosen in relation to assumption (c) – that the significance of human remains is the same for everyone within a broad cultural group – comes from the United States. For many American Indians, Steve Russell comments, the return of the dead is significant because the spiritual welfare of the living group is regarded as dependant on the proper burial of the dead. On that basis, one might expect that all tribes would welcome the swift return of bodies.[2] That does not apply, however, to the Zuni. Their preference, Tamara Bray notes, is to move more slowly and first develop the purification rites needed to overcome the contamination that has occurred during the bodies' stay in museums.[3]

For an example related to assumption (d) – that all bodies are of equal significance – I return to Australia. The remains at issue are those of the Aboriginal woman Truganini, considered for many years as the last Aboriginal from Tasmania after the 'Black War' in which over 4,000 Aboriginals were either massacred, forcibly removed, or died of illness brought by the colonisers. Truganini died in 1847 and was first buried in the grounds of the female convict gaol in Hobart. Her body was later exhumed and her skeleton exhibited in the Tasmanian Museum until 1947. Only in 1976 were her remains cremated. In 2001, however, samples of her skin and hair were found in Britain's College of Surgeons. These were eventually returned to Australia together with several bones from unidentified Aboriginal people. A shell necklace belonging to Truganini was also found in a museum in southern England and has now been returned.

The way Truganini represented a perceived expression of power and lack of power (the original burial place was also against Truganini's expressed wish) made the return of those remains especially significant. For Aboriginal Australians Truganini was also a symbol of existence (the disappearance of someone often designated as 'the last Tasmanian Aboriginal' could be read as 'you've now wiped out all of us').

A similar example may be found amongst the Same people in Norway. A Same uprising in the 1800s led to the capture and beheading of two Same leaders. Their heads were sent to Oslo and were subsequently stored at the Medical College in Oslo together with other Same human remains. The heads of the two leaders were returned as part of a reconciliatory act upon demand by Same groups. Other remains kept in Oslo are subject to a commission hearing on their scientific importance. The commission will include Same representatives as well as university and college staff.[4]

Remains that have not been requested and are therefore kept in the College in Oslo, though not on display, are those of a Mexican woman. She was displayed in freak shows both during her life and afterwards (having been stuffed by her husband-manager together with their son, who died at an early age). She had a medical condition that led to her being called 'The Ape Woman'. Presumably the lack of request for her remains stems from the fact that she is not seen as politically important – unlike, for example, Sarah Baartman – since there are no real reconciliatory issues at stake between Norway and Mexico. The college has created a special space for the remains in their vaults but has chosen not to bury them.

The final example, for assumption (e) – all meanings are static – is European. The Natural History Museum

[1] See, for example, Anderson, C, (1990), 'Repatriation, custodianship and the policies of the South Australian museum', in *COMA Bulletin of the Conference of Museum Anthropologists*, 23, pp31–41; Kelly, L, Gordon, P, and Sullivan, T, (2000), *Evaluation of Previous Possessions, New Obligations: Policies for Museums and Aboriginal and Torres Strait Islander People*, Green Paper prepared for Museums Australia National Office; see also Michael Pickering in this volume

[2] Russell, S, (1997), Comments on the NAGPRA ACT at www.archaeology.miningco.com/library/weekly/aa83/197.htm

[3] Bray, T, (1995), Report issued by the Arctic Studies Center, published as of November 2003 at www.mnh.si.edu/arctic/html/repattb.html

[4] For a description of this incident see Schanche, A, (2002), 'Saami Skulls, Anthropological Race Research and the Repatriation Question in Norway', in Fforde, Hubert and Turnbull (eds), *The Dead and their Possessions: Repatriation in Principle, Policy and Practice*, Routledge, London and New York

in Vienna (Naturhistorisches Museum Wien) saw an increase in interest in physical anthropology in the 1920s and 30s. According to curator Karen Wiltschke-Schrotta's history of the museum, 'By 1930, physical anthropology became very important in the museum and space was provided for exhibitions. The goal of these displays was to educate the public and to provide a "scientific" basis for the eugenic thinking and the racial hierarchy of the then-current political regime.'[5] After the war, the museum retained physical anthropology halls, 'one of which focused on human evolution, and the other on racial differences.' Both halls were later closed 'as a result of political and cultural concerns'[6] with the memories evoked of the use of physical differences to justify assertions of superiority and acts of 'cleansing'.

Do these several examples do more than lead us to question assumptions? I stated earlier that they can also help us move toward questions that can be applied to many situations. Let me now list further questions:

Is the concern regarding 'ownership' or forms of display limited to concern about bodies, or is it part of a wider concern embracing claims to independence and self-management? Córdova's Bolivian example reminds us that these can be two different things.

Is the concern with bodies or their display part of a pervasive concern that also covers other aspects of what is regarded as sacred, secret or 'not to be seen'? If so, we must tread very carefully. Violating these concerns will be perceived as a threat to the very structure of society.

What are seen as the links between the living and the dead? The unpurified dead may be seen as a contaminating threat to the health of the living. The improperly buried dead may be seen as likely to haunt. The unburied dead (Córdova's example) may also be seen as acceptably so, happily displayed, and even appreciative of company.

Is it the perception of links between 'the living' and 'the dead' in general that matters? Which dead matter most? Asking that question can take us into meanings that go beyond beliefs about 'the dead' (unquiet or not) and into an understanding of where the greatest sense of insult or restoration may lie.

What are the current meanings of any remains? We can't rely on old accounts or old audience responses.

History changes things. The original collection may have been trophies of war, an exercise of power, a way of terrorising a group seen as in need of subjugation, covert pornography, or an expression of a science in need of 'data' based on physical measurements. The meanings of both collection and display, however, change and it is the current meanings that we now need to understand and work with.

Those questions mark the end of what I have called Step 1. I have given it the largest space, mainly because it cuts across many aspects of concern. The remaining steps I shall deal with more briefly. Each again, however, comes with a chosen example and with a prompted question.

Step 2: Are copies or casts the same as 'real' bodies?

The desire of many museums is to display 'the real thing'. In the words of one curator:

'We should never forget … that museums have the unique function of collecting, preserving and interpreting objects. Words and pictures can be found in books, but objects can be found only in museums. People visit museums to see original objects, not pictures or casts thereof.'[7]

When display of the original object is found to be objectionable or impossible, casts may be made and displayed in their place. This was the solution, for example, regarding burial materials in Curve Lake, Ontario. The original human remains and grave goods were returned to the relevant First Nations groups and buried. Casts, however, were allowed to be made for 'future interpretive use'.[8]

Casts, however, may be just as objectionable to some as the bodies or remains themselves. The South African Museum in Cape Town chose to make casts of the San people (known also as the 'Bushmen') for display within a diorama in a museum conventionally regarded as a 'natural history' museum. The diorama opened in 1960, and was originally popular and unquestioned:

'From the middle of the 1970s (the display) started to be quite controversial. The issues ranged from

the way of the casting of the actual people … they're very, very life-like casts, [to] … the appropriation of the bodies of people.'[9]

Step 3: Do some parts matter more than others?

This is the first part of a move toward breaking down what we call 'human remains'. In many situations, heads emerge as having particular significance, perhaps because they may be seen as expressions of power relations (tattooed Maori heads, shrunken heads, decorated skulls etc). Perhaps most upsetting are displays of what is considered 'private'. I return to the case of Sarah Baartman as an example. Napoleon Bonaparte's surgeon-general, Georges Cuvier, made a plaster cast of Baartman's body after her death in 1815 and put it, along with jars of her preserved body parts (including genitalia) on display at the National Musée de l'Homme in Paris. Nelson Mandela raised the issue with Mitterand in 1994, and South Africa's Foreign Minister, Alfred Nzo, followed up the initiative in 1996. It was, however, only in 2002 that a bill was passed in the French senate that ordered Baartman's remains to be returned to South Africa. The display of her genitalia came to be the source of particular objection, perhaps because it was both a major violation of 'the private' and one carried out in the guise of medical information.

Step 4: Making comparisons with other 'remains'

This is the second part of a move toward breaking down what 'human remains' covers. The comparisons that come most readily to mind are with 'remains' that are part of death and burial. These may be grave goods, burial grounds, sacrificial altars, or gravestones. Grave goods have emerged as significant for some Canadian First Nations. This was the case, for example, mentioned briefly above regarding the Curve Lake First Nation and the Peterborough Centennial Museum and Archives:

'In 1983, the curator responsible decided that it was no longer appropriate for the material to be displayed. The skeletal material was deteriorating and the display itself was no longer effective: younger children were so frightened by the replica burial that it even had to be covered up when primary school groups visited the museum. By 1988 staff of the museum had decided, with the agreement of the Board of Museum Management, that the remains should be de-accessioned and repatriated and so they approached the Ojiwaba Curve Lake First Nation …. Initially the museum had intended to de-accession and repatriate only the human remains, but they came to recognise that the grave goods were such an integral part of the burial that they had to be included in the agreement.'[10]

Similarly, the Aymara people in Potosi, Bolivia, were outraged when textiles woven specifically for individual dead were sold to a North American museum. Following their religious and spiritual beliefs, the textiles were seen as containing the souls of the dead. Only after lengthy court proceedings were these textiles returned and replaced in community chests.

Gravestones have emerged as significant in several countries. Witness, for example, the indignation expressed when a number of Norwegian gravestones (complete with names) were found piled on the side of the road.[11] Or the dismay of Polish Jews who, on returning to Poland, found gravestones missing or smashed and used for building material.[12]

To move again to a prompted question that can be applied to other situations: what other objects could carry the same set of meanings? How do human remains significantly differ from other remains that may also be symbols of power, disrespect or memory?

[5] Wiltschke-Schrotta, K, (2000), 'Human Remains on Display – Curatorial and Cultural Concerns', in reports to *Fellowships in Museum Practice*, http://museumstudies.si.edu/Fellowships/FMPFinalReportSchrotta.htm, p3

[6] *Ibid* p3

[7] Stewart, T D, (1969), cited by Wiltschke-Shrotta, (2002), p4

[8] Simpson, M, (1999), 'Memorandum submitted by Moira Simpson', to the Select Committee on Culture, Media and Sport, House of Commons, published 1999 at www.publications.parliament.uk/pa/cm1999++/cmcumeds/371/371ap48.htm

[9] Interview with Patricia Davison, 2002, cited in Goodnow, in press

[10] Simpson, (1999) *op cit* p10; see also Doherty, K, (1992), 'The Peterborough Precedent', a presentation at Queen's University Conservation Training Programme, 9 May

[11] Cited in the local Bergen, Norway paper *Bergens Tidende*, 2004

Step 5: What do people regard as the worst that could happen or the worst part of what has happened?

It may seem as if museums now face impossible tasks. Let me close then with what may provide a way in, one that may help avoid worst-case scenarios and bring implicit meanings to the surface.

From a museum's point of view one of the worst things that can happen is that a valued object becomes lost or destroyed. That could occur in the course of collection (as for example with the Soviet Ice-Maiden, the Austrian hunter, or desert mummies). It may also be seen as a 'worst' outcome when objects once 'owned' are returned. Australian objects, for example, may officially go back to traditional or created Aboriginal-run 'keeping places', but these are often perceived as insecure by museum staff, who feel the returned objects are likely to be stolen or lost. Similar concerns have been raised with regard to the return of Zuni Ahayu:da (wooden carvings). These are 'far more than mere inanimate wooden carvings; they are believed to be living beings and their creation is analogous to the physical development of a human.' Once returned, however, the carvings are 'placed in outdoor shrines where wind and rain will cause their eventual decomposition enabling them to complete the cycle and so fulfil their intended function.'[13] Nonetheless, all the carvings in American museums have supposedly been found and returned.

From the point of view of the people being 'represented' or 'viewed', the worst outcome may be the denial of one's status and dignity as a person or a group. That denial may come about in a variety of ways. It can be by the treatment of a human remain as a commodity (for example the offering in 1999 of some Australian Aboriginal skulls for sale on E-Bay[14]). It can also be by a form of display or storage that marks one as insignificant. To take Sarah Baartman's remains as an example, there were concerns about whether the museum involved could even find her remains and then positively identify them as hers. The treatment of Egyptian mummies placed on the floor in Madrid, discussed in Jack Lohman's paper in this volume, provides another possible 'worst case'. So also does the use of the San casts in an art exhibition *Miscast*, discussed by Marilyn Martin in this volume. It could also be by a form of collection or return that is itself insulting (such as the removal of parts without consent, or the misrepresentation of incomplete remains as intact).

The 'worst case' or 'worst feature' may clearly take several forms. The initial identification of the remains, however, may be a promising way to begin working toward the specification of meanings for particular places and people, and the shared understanding of meanings that we hope to see emerging between museums and their several audiences.

[12] Zubkowicz, R, (2003), 'On the Jewish Cemetery in Losice' in *Siedice Life*, October 2003, translated and posted by the Canadian Foundation of Polish-Jewish Heritage, Montreal

[13] Simpson, (1999) *op cit* p4

[14] *Sydney Morning Herald*, 19 June 2004

Parading the Dead, Policing the Living

Jack Lohman

If you walk into the giftshop in the Great Court of the British Museum, you can buy your child – or yourself, perhaps – a toy Egyptian mummy. You can buy several, in fact. But the Porsche of toy mummies is called enthusiastically 'Lift the Lid on Mummies'. It's quite the kit. It advertises 'amulets to bring good fortune', 'gauze to wrap your mummy in', and best of all, 'canopic jars to store the mummy's organs'!

It's a bit of fun, and we mustn't take it too seriously. But what are we saying to our children when we present them with such things? Are we offering them insight into the past? A sense that other cultures do things differently? Or are we – quite literally – toying with their perceptions, showing them that while we may honour our own dead, the dead of other nations are faintly absurd and a bit of a joke, that we can do what we like with them?

I have yet to find a toy entitled 'Lift the Lid on Church of England Burials'.

The dead are with us, sometimes more literally than we realise. Like us, they have their celebrities. Lenin's body still lies in Russia's Red Square, Mao Zedong can be visited in Tiananmen Square in China, Ho Chi Minh can be seen in Ba Dinh Square in Vietnam. The wax-headed embalmed corpse of Jeremy Bentham attends occasional meetings at University College, London – as a non-voting member, the university is keen to emphasise. Juan Peron wanted Eva Peron to be put on public display in Buenos Aires but, as we know, things didn't quite work out. First her embalmed corpse was shipped to Italy when Peron was ousted, then it was returned to Argentina when he regained power. 'It was good to see her again', Peron remarked. She was later buried alongside him.

Need for policy

This is not the place to attempt to outline the complex debate surrounding the treatment of human remains in general, and in relation to museum practice in particular. But there are important issues to bear in mind as we examine the implications of how we treat the dead and display them.

The long-awaited Human Tissue Bill faces up to some very difficult questions concerning organs for research, where the needs of the living who are ill are to be weighed against the needs of those whose relative has died. The situation is analogous to one museums face, where human remains can profitably be studied medically and displayed for insight into present illnesses and patterns of disease. People will benefit, but at what cost to the sanctity of those remains?

The Bill is, according to Lord Warner, compatible with the European Convention on Human Rights and is suitably wide-ranging. Section 52 touches on the power of museums to de-accession human remains. If the Bill is passed, nine national museums in the United Kingdom will be granted the right to 'transfer from

their collection any human remains if it appears to them to be appropriate to do so for any reason'.[1] This would include the power to transfer any mixed finds that could not readily – or perhaps appropriately – be separated from the human remains themselves.[2]

The Human Tissue Bill reflects a new sense of openness in discussing the dead. We have come so far from confronting death in real terms as a society – it is most often these days a question of technology and mediation – that the issues surrounding dead bodies have seemed unfaceable and undiscussable. But attitudes are changing, and with this change arises an opportunity for museums to look at death not as a social phenomenon, but as a cultural one. The bodies we keep in our collections had, and in some cases continue to have, significant lives in their communities. Can we address this? Can we balance our traditional institutional needs against the possible needs of those communities now? Are we toying with their past by not handing it back to them?

The Museum of London now posts its policy on human remains on its website. This is no embarrassment. It is an important acknowledgement both of what the dead contribute to our living museums (they are here, and people should know how we treat them) and of their autonomy. The dead are not all past, locked away and finished. They have a future: we must decide whether they stay in our collections, what to do with them, where to store them, when to display them, how to treat them. It may be an independent future – independent of us – if we decide for example they are best returned whence they came: to their graves, to their countries of origin, to those communities whose ancestors they are and for whom their importance may vastly outweigh any message they have for our own. The dead arrive in museums as to a home of sorts, but they may also depart. Especially if they are of little scientific interest or value.

Acknowledging this publicly is an important step. Dealing with the complexity of issues is another. There are times when it is appropriate to display remains – when it is sensitively done. There are times when it is worthwhile to study remains – when it is sensitively done. There are times when it is appropriate to acquire remains – when it is done with a thorough and deeply

considered understanding of the implications for both the dead and the living. The dead are not isolated. They belong to us not as curiosities – skeletons to be strung up and gawped at, bodies to be embalmed and spotlit – but as representations of what it means to be human.

And it is important to remember that having a policy on the treatment, display and return of human remains must not, however much we may wish to agree universal principles, become a different form of oppression. If the awareness of other cultures is what drives a new understanding of those to whom the dead may more properly belong, that awareness should furnish a suitably varied policy. To understand how Lithuanian Jews might wish to be depicted, or sub-Saharan Africans, or Spanish Muslims, is to find not one principle of respect or restitution, but many. We may learn more from acknowledging the variety of means of treating the dead than we do from the dead themselves. The lesson is one in living culture, and reminds us that, however remote the anthropological content of museums can seem, it does have a relationship with the many communities of our present world.

Bad practice and good practice

There is a fascination with dead bodies. The interest is evident in popular exhibitions such as the Hayward's *Spectacular Bodies*, the Museum of London's own highly successful *London Bodies*, and Gunther von Hagen's *Body Worlds* extravaganza. The British Museum's *Mummy: The Inside Story* is the latest in a long line of popular public attractions on the subject of ancient Egypt. And there is always, and perhaps forever (if they keep soaking him in embalming fluid every 18 months) Lenin, possibly the best-known living corpse in the world.

Special attractions are not quite the essence of museums, of course. They perhaps say less about our interest in knowledge and research, about the ongoing and often unseen study of the objects in our collections, than they say about the climate in which we work: who our public are, what they want, how we are serving them.

In the South Tyrol Museum of Archaeology in Bolzano, you can see a man in a big steel fridge. He is over 5,000 years old and was discovered sticking out of a glacier.

The presentation that accompanies his space-age entombment (perhaps acknowledging the suppressed comedy of his awful jutting limbs) treads an uneasy line between humour and seriousness. In Copenhagen and elsewhere the displays of 'bog people' cling to a theatre of morbidity, with little sense of dignity and a grotesquerie that far outweighs the academic justification for displaying them in the first place. In the National Museum of Copenhagen, the oak open coffins from Borum Esthøj present tiered bodies, each with a morbid expression of benevolent surprise.

The National Museum of Greenland in Nuuk presents its three mummified women and a child found near Uummaunnaq in North Greenland with scientific objectivity. At the Archaeological Museum in Madrid, the dead are simply laid out on the floor and captured by the glass box that sits on top of them. In Rotterdam an unnaturally elongated skeleton is presented to illustrate the story of the Dutch East India Company.

Good practice is possible. Careful selection and preparation for use seems critical.

London Bodies at the Museum of London showed a range of skeletons from prehistory to the present. It used innovative design to move away from the lurid and create something compelling and informative. It was praised in the press for the sensitivity of its display. Children had to be accompanied by an adult; visitors could assess the content through a window before entering; and a sign requested respect for the materials on display. The climate has shifted since then, but the exhibition at least tackled two of the worst aspects of the display of human remains: a lack of awareness of visitor sensibilities, and a lack of respect in terms of how remains were presented and how their audience behaved around them.

Different environments have called for different procedures. In the Swiss museum of Laténium in Neuchâtel, the past is approached with nuance: sensitive lighting, a different quality of space, a design for the display of human remains which creates respect, does not merely ask for it. What is particularly praiseworthy is the use of film to explain the context of archaeological discovery. The display of skulls and bodies at Gisozi in Rwanda – massed, painfully ordered – would be utterly inappropriate elsewhere. Where there is cul-

tural resonance, there is a strongly valid reason for such display. And even there, the same debate we are having here is taking place. Do not the dead deserve the honour of burial, or should they remain on display as a reminder of the Tutsi massacre? As Jean Ruremesha asked in a recent article on the subject, 'Should the bones be silenced?'[3] At the City Museum in Havana the human remains have been placed in a coffin and given a final resting place at the heart of the museum.

There is, as these examples show, no easy answer. What is appropriate for certain cultures to decide for themselves may not be appropriate elsewhere or for others to choose for them. Where those choices have been made – and our museums are full of such plunder – it may be that a gesture of goodwill carries a helpful contemporary message. We must be bold in trying to make such restitution and not cling nervously to all that we have. The return of bodies is a difficult subject, but it may make museums richer not for what they have acquired, but for their engagement with the world.

And though we fear public criticism, such acts may prove more popular than we know. It's worth remembering that in 2004, a poll in Moscow found that the majority of Russians under the age of 50 want Lenin to be removed and buried.[4]

Conclusion

In a recent review of Martha Nussbaum's *Hiding from Humanity: Disgust, Shame and the Law*, Stephen Mulhall wrote:

'A decent society must find ways to protect its members against shame and stigma: these will include laws protecting freedom of religion and conscience, providing a decent standard of living, punishing crimes based on hate and bias'[5]

[1] Human Tissue Bill, (2004), Section 52 (2), HL Bill 94
[2] Human Tissue Bill, (2004), Section 52 (3), HL Bill 94
[3] Jean Ruremesha, (2004), 'Should the Bones be Silenced?', Interpress Service News Agency, 5 August
[4] Mark MacDonald, (2004), 'Embalmers Keep Lenin's Body in Good Shape', *The Holland Sentinel*, 29 February
[5] Stephen Mulhall, (2004), 'Review of Martha Nussbaum, *Hiding from Humanity: Disgust, Shame and the Law* (Princeton, 2004)', *London Review of Books*, 22 July, p25

Shame and stigma. They are tough words, tougher than we sometimes credit. We must, above all, bear them in mind when we realise that it is not remains we are dealing with: it is human remains.

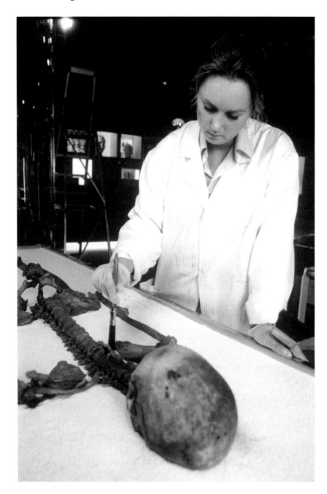

The Politics of Human Remains: The Case of Sarah Bartmann

Jatti Bredekamp

'[We] would like the world to know that we accept that the dignified return of her remains and the body cast for burial is a matter of national heritage interest.'
(Media statement of the National Khoisan Consultative Conference of South Africa, 18 February 2002)

'Difficult as it may be, we must celebrate … the gods would be angry with us if we did not, on the banks of the Gamtoos river, at the grave of Sarah Bartmann, of the Khoisan, of the millions of Africans who have known centuries of wretchedness.'
(Thabo Mbeki, 9 August 2002)

IT IS WITHIN the context of the above statements, echoing a collective voice of the Khoisan movement and of a Rainbow Nation in the making, that a multitude of South Africans from particularly the Eastern, Western and Northern Cape converged on the little town of Hankey on National Women's Day in 2002. They were there to pay their last respects to a national icon of post-apartheid South Africa who had died in desperate circumstances in France almost two centuries ago. Most of the audience that joined President Thabo Mbeki and other prominent leaders on the stage and in the crowd were of Khoisan and Xhosa descent. They had traveled to the former mission station of the London Missionary Society on the eastern bank of the Gamtoos river to celebrate a great moment in South Africa and participate in what President Mbeki called:

'the mission of restoring the human dignity of Sarah Bartmann, of transforming ours into a truly non-racial, non-sexist and prosperous country, providing a better life for all people.'[1]

This chapter begins with a biographical sketch of Sarah Bartmann. There follows a discussion of the cultural and political dynamics of the post-apartheid discourse that led to the repatriation and burial of her remains in 'the land she walked as a child and a young woman',[2] and the announcement by President Mbeki that 'a fitting monument will be built in Cape Town, from where Sarah Bartmann began her voyage of misery and death'.[3]

A journey of indignity, c 1789–1815

Sarah Bartmann was born in colonial Cape in the late 1700s. The Khoekhoe clans of the Eastern Cape frontier around the Gamtoos had already suffered heavy losses of cattle and land as a result of European settler intrusion. Ignoring the rights of the indigenous Damasqua, Inqua, Gamtoos and Gonaqua people, the Dutch East India Company (VOC) had promulgated colonial laws that declared grazing land on the colonial eastern frontier to be white man's territory, as did the British when they took over the Cape from the Dutch in 1795, and again in 1806 with their second occupation.

By the time of the second British invasion the young Sarah Bartmann had moved to rural Cape Town, though

it is not clear whether her two brothers and three sisters joined her on that journey. By 1810, after the Governor (the Earl of Caledon) had introduced his repressive Labour Codes to regulate indigenous Khoekhoe labour, Sarah Bartmann was indentured as a domestic worker of Peter Cezar. Peter's brother, Hendrik, brought an English ship's surgeon, Alexander Dunlop, to the farm in Cape Town that year, and they persuaded Sarah to accompany Hendrik and Dunlop to England. Sarah consented, believing their promise that she would make much money abroad. The Governor granted permission for her to be taken to England where she arrived via Liverpool 'at precisely the time when the issue of Khoekhoe slavery was becoming a highly politicised one, both in the metropole and the periphery'.[4]

On the northwest bank of the Thames at Piccadilly, the young Sarah was exhibited in a cage as a human freak from about September 1810. She was ordered to behave like a wild beast for the amusement of paying crowds. Her 'handler' ordered her to move backwards and forwards and to come and go into her cage 'more like a bear on a chain than a human being', and:

'when she refused for a moment to come out of her cage, the keeper let down the curtain, went behind, and was seen to hold up his hand to her in a menacing posture; she then came forward at his call, and was perfectly obedient.'[5]

This dehumanising treatment deeply offended the evangelical abolitionists in the humanitarian African Association in London, who took Dunlop to court. But the case was dropped following an intriguing court battle,[6] after which Bartmann 'disappeared from the public gaze in London'.[7] Professor Emeritus Phillip V Tobias, later commissioned to negotiate for the repatriation of the remains on behalf of the South African government, notes: 'whether or not she was exhibited in other English cities (as some aver) is not known'.[8] What we do know, however, is that she was baptised in an Anglican Church in Manchester as Sarah Bartmann on 7 December 1811. There is also some evidence that she married a West Indian by whom she had two children.[9]

In mid-1814, Sarah Bartmann appeared in the company of Hendrik Cezar in Paris, where she became known as the 'Hottentot Venus'. Near the banks of the Seine she was sold to an animal trainer who exhibited her in the Rue Neuve des Petits-Champs and hired her out for dinner parties. Her grotesque popularity, fed by 'rabid racism', served as inspiration for some equally grotesque French satirical cartoons and even for a musical melodrama.

She also drew the attention of several distinguished French scientists, including Lutheran naturalist, Baron Georges Leopold Cuvier. Cuvier examined her in the Jardin du Roi of Paris in chilly March 1815 where, it is said, 'she was obliging enough to undress and to allow herself to be painted in the nude'.[10] Cuvier noted:

'that she was gay, she had a good memory for faces, and she spoke Dutch, a little English, and a smattering of French. She danced, she liked music, pretty baubles, and brandy.'[11]

He also observed that 'the most disgusting part of this woman was her face, which displayed the characters of both the Negro and the Mongole countenance in its different features.'[12]

Sarah Bartmann died in wretched circumstances on the bank of the River Seine at about midnight on 31 December that same year.

From post-mortem of a dehumanised exile to repatriation of an African icon

Within a few hours of her death, Cuvier had obtained permission to study and dissect her body. He began by making a body cast in wax, and from the 'negative impression' he made a 'positive' cast which is still held in a vault of the Musée de l'Homme. He dissected the body, paying particular attention to the anatomy of Bartmann's buttocks, genitals and brains, searching for evidence as to whether the Khoekhoen were human or subhuman. His final report of his work on her body suggests a preoccupation with sexual characteristics.[13]

After her body had been dissected, her complete skeleton was mounted on a stand for exhibition with two other parts of the body: the brain and genitals. They were displayed to visitors at the National Museum in Paris for over a century and a half: first in the

Comparative Anatomy room in the Museum of Ethnography, Place du Trocadero, then as part of the collections of the Biological Anthropology Laboratory at the Muséum National d'Histoire Naturelle.[14] Not until 1974 were the remains removed to the museum storerooms. In March 1994, the cast was briefly exhibited for the last time at the Orsay Museum, near the South African Embassy in Paris, as an example of 19th century ethnographic sculpture.[15]

Before the dawn of the present political dispensation, South African Apartheid society was hardly aware of the Sarah Bartmann human rights issue. Over all the decades of her exile, the material conditions of most black South Africans would have permitted few to go to Paris to gaze at the remains, or to ponder upon the 'exhibition's' grotesque stereotyping of race and African sexuality. It was only after opinion-makers within the Kranshoek-based Griqua National Conference (GNC) of Paramount Chief AAS le Fleur II near Plettenberg Bay began raising the issue of repatriation with former President Mandela, that South Africa and the world became interested in the matter.

The Paramount Chief and his GNC delegation expressed their wish to President Mandela on three occasions. The President in turn raised the matter with President Mitterrand during his state visit to South Africa in 1995.

The Department of Art, Culture, Science and Technology (DACST) commissioned Professor Tobias to negotiate with the French authorities and in particular with Professor Henry de Lumley who, as former Director of the Musée de l'Homme and of the Muséum National d'Histoire Naturelle in Paris, was assumed to be custodian of Sarah Bartmann's extant remains. Discussions were held in Paris and Pretoria between November 1996 and January 1998,[16] reports of which suggest that De Lumley was vehemently opposed to the proposed repatriation. He pointed out that the Director of the Muséum National did not have legal powers to de-accession the remains of Sarah Bartmann and return them to South Africa: a new law would have to be passed by the French parliament to allow the repatriation.[17] Seemingly, after De Lumley's retirement in 1999, negotiations smoothed somewhat.

Among the many agencies that contributed to the repatriation on 3 May 2002 was the Council of the National Khoisan Consultative Conference (NKOK) that had to implement resolutions adopted at the NKOK Conference held in Oudtshoorn in March 2001. This conference decided under Resolution 5 in respect of repatriation of Khoisan human remains:

'that urgent negotiations with the RSA government be entered into on the repatriation of Sarah Baartman as well as other Khoisan human remains and for [the remains] to be returned in a culturally appropriate manner.'[18]

Following the resolution, the Minister of Arts, Culture, Science and Technology agreed to meet the Executive Committee of the NKOK Council, duly elected at the Oudtshoorn Conference. The meeting with Dr Ben Ngubane and the Deputy Director-General: Heritage, Themba Wakashe, took place in Cape Town in November 2001. Dr Ngubane suggested that the Deputy Director-General should strengthen Professor Tobias' position by

1 Thabo Mbeki, (2002), 'Address of the President of South Africa at the reburial of Sarah Bartmann, Hankey, Eastern Cape, 9 August 2002', http://www.info.gov.za/speeches/2002/02081209461001.htm, p4

2 *Ibid* p1

3 *Ibid* p4

4 Yvette Abrahams, (2000), *Colonialism, dysfunction and disjuncture: the historiography of Sarah Bartmann*, D Phil thesis, University of Cape Town, p148

5 P V Tobias, (2002), 'Saartje Baartman: her life, her remains, and the negotiations for her repatriation from France to South Africa', in *South African Journal of Science*, vol 98, March/April 2002, p107

6 Yvette Abrahams, (2000) *op cit* pp150–65

7 P V Tobias, (2002) *op cit* p107

8 *Ibid*

9 *Ibid*

10 *Ibid*

11 Carmel Schrire, (1995), *Digging through Darkness: Chronicles of an archaeologist*, University Press of Virginia, Charlotteville, p177

12 *Ibid*

13 P V Tobias, (2001), 'Memorandum on Miss Saartjie Baartman's remains and on the request by South Africa for the repatriation of the remains', 16 January, in Department of Art, Culture, Science and Technology, *Ms Saartjie Baartman: Briefing Documentation* p5

14 2nd Session of French National Assembly of 21 February 2002, Discussion of the Bill adopted by the Senate: Research Minister Roger-Gerard Schwartzenberg speech, Official translation, p3

15 *Ibid* p6

16 P V Tobias, (2001) *op cit* p1

17 *Ibid* p11

18 UWC Institute for Historical Research National Khoisan Consultative Conference, 29 March to 1 April 2001, Resolutions as agreed by official and associate delegates to the NKCC on Khoisan diversity in National unity, edited version

co-opting a national Working Group that would consist of the Deputy-Director General of DACST, a senior official of the Department of Foreign Affairs, the CEO of the South African Heritage Resources Agency (SAHRA) and the Patron of the NKOK. Meanwhile, the Provincial Legislatures of both the Western and Eastern Cape passed resolutions supporting the repatriation.[19]

In January 2002 developments in France took South Africans by surprise. Apparently, a former Western Cape MEC, Dr Audrey van Zyl, developed during her years abroad a close relationship with one of the most influential politicians in French-speaking Belgium, Dr Valckenier of the European Council. One of their acquaintances, Nicolas About, Senator for the Yvelines in France, had heard from them of the Muséum National d'Histoire Naturelle's refusal to accede to South Africa's request,[20] and started looking into the case. During his research he came across a powerful poem by Dianne Ferrus, written in Utrecht, Holland, in June 1998 while she was an exchange student of the University of the Western Cape. On 29 January 2002 the poem, I Have Come to Take you home, was read in translated form to the French Senate. Its reading helped About, who proposed the Bill, and others to argue that the French Civil Code based on Bio-ethics Law of 29 July 1994 should be applied to the Bartmann issue, namely that 'the human body, its elements and products cannot be subject to property rights'. In support of the Bill, the Research Minister, Roger-Gerard Schwartzenberg, stated that 'human remains are not subject to appropriation and therefore cannot be a State's or a public body's property. They cannot be elements of a national heritage.'[21]

However, in his introduction the minister pointed out that the Bill on the return of 'Saartjie Baartman's' remains to South Africa was case-specific, and could not set a precedent that would be applied generally and automatically. Parliament should support repatriation of the remains on the basis of 'total lack of scientific interest of the remains in question' and in order to

'do justice to Saartjie who was subject during her life and even after, as an African and as a woman, to offences resulting from long-prevailing ills, ie colonialism, sexism and racism.'[22]

Following the debate and unanimous adoption of the Bill, the one-article resolution was signed into law in Paris by President Chirac, Prime Minister Jospin and the five relevant ministers on 6 March 2002:

'From the date of enforcement of the present law, the remains of the person known as Saartjie Baartman will stop being part of the collections of the Muséum National d'Histoire Naturelle. The administrative authority has a period of two months, starting from the same Date, to return these remains to the Republic of South Africa. The present law shall be enforced as a State Law.'[23]

Seven weeks later Minister Ngubane invited Ms Ferrus, Mr Munchu on behalf of Professor Tobias, and me to accompany the South African delegation of his department (led by the then deputy minister, Bridgette Mabandla) to France to accept the remains on behalf of the South African government at a small ceremony scheduled for Monday, 29 April. The remains arrived in a crate draped in the South African flag at Cape Town International Airport on 3 May and were taken to the Wynberg Military State Mortuary after a short thanksgiving ceremony.

The cultural politics of Sarah Bartmann's interment and memorialisation

Managing the cultural-political process of Sarah Bartmann's interment and memorialisation in South Africa after her remains had been displayed in France for so long was no easy task. The most demanding challenge was to make provincial and ethnic-minded sectors understand that repatriation, interment and ownership of Sarah Bartmann's memory were in all respects of national relevance. The post-apartheid government's interest in the Sarah Bartmann issue stemmed primarily from its human rights significance for the new South African nation and international community at large.

Conflicting provincial cultural-political interests of the Western and Eastern Cape, and to a lesser degree the Northern Cape, had to be managed by the national host department of Arts, Culture, Science and Technology. The remains were flown back to Cape Town partly

because the Cape-based GNC were among the first to alert South Africans to the Sarah Bartmann issue, and also because of the leading role played by the Western Cape MEC, Mr Patrick McKenzie, in facilitating discussions about the repatriation.

As national government deliberated about the composition of a Reference Group to facilitate the interment process, MECs in the three provinces consulted their Khoisan forums about the place and date of burial. It was to take place as swiftly as possible either in Cape Town or near the banks of the Gamtoos river. Inspections of both sites were concluded in mid-July and a consultation meeting held in Johannesburg with the Executive Committee of the NKOK Council. Final recommendations were also informed by a University of the Western Cape-led consultative research process among target groups of Khoisan descent countrywide.

After the announcement of the bank of the Gamtoos river as the chosen site, the government embarked on a campaign to raise national awareness of the nation's struggle for the repatriation of the remains of the icon Sarah Bartmann. The nation was thus made aware that the repatriation and interment followed from a request of the Khoisan people to former President Nelson Mandela in 1995; that Sarah Bartmann had become a human symbol of the subjugation and humiliation of Khoisan women through the ages and an international icon of restitution for people affected by colonialism; and that her interment would be a symbolic celebration of the country's negotiation skills in the international arena, since former colonial governments had never before released remains that had been removed in a colonial context.

The burial was broadcast live on national television in South Africa on 9 August 2002, and thousands converged on the sports grounds of the former mission station of Hankey for the memorial service.

Iziko Museums, human remains and memorialisation of Sarah Bartmann after Hankey

On 29 March 2004, Iziko Museums became the custodian of the customised wooden casket in which Sarah Bartmann's remains had been airlifted to South Africa. The museum's professionals accessioned the temporary traveling casket into its Social History Collections, where it serves as a tangible reminder for future generations of the indignities suffered by Sarah Bartmann, and of the eventual restitution achieved by the return of her remains to South Africa for proper burial.

Restitution is a significant issue for Iziko Museums because its own collections of human remains and full-body casts of mostly Khoisan people have also aroused controversy. The longest and most public debate in the past decade has concentrated on the exhibition of the casts in a diorama for which the former South African Museum was known. For some critics the presence of the casts in a museum that also dealt with natural history was implicitly racist and promoted the racial ideas and physical stereotypes that underlay the production of the casts early in the last century.

In post-apartheid South Africa, Iziko is actively addressing the ethical issues pertaining to these collections. Criticism from the public and government culminated in 2001 in the closure to the public of the so-called 'Bushmen' Diorama, and in 2002 a moratorium was placed on research on the human remains collection. Towards the end of 2004 Iziko, together with community leaders and academics, formulated a policy on human remains that provides guidelines for consultation with external stakeholders. The policy is seen as interim, however, in the expectation that the South African Heritage Resources Agency will develop national policy with which Iziko will comply. The identification and documentation of human remains that were acquired unethically was completed in 2004. This research focused on acquisitions made to establish racial typologies and that often involved robbing the graves of recently dead people.[24]

[19] See *National Khoisan Consultative Conference of South Africa Newsletter*, January 2002

[20] *Le Figaro*, 21 January 2002

[21] French National Assembly discussion of Bill, p1

[22] *Ibid* p2

[23] Law No 2002–323 of 6 March 2002 on the return by France of Saartjie Baartman's remains to South Africa

[24] Martin Legassick & Ciraj Rassool, (2000), *Skeletons in the Cupboard: South African museums and the trade in human remains 1907–1917*, South African Museum & McGregor Museums, Cape Town & Kimberley

A consultative process between Iziko and communities living in the areas from which these remains were acquired is has reached a mutually agreeable decision regarding the re-interment of such remains. (Iziko is now the first heritage institution in South Africa with a human remains management policy.) A similar consultative process will be conducted in respect of the San diorama and the use generally of human casts in exhibitions.

President Mbeki's promise at the funeral of Sarah Bartmann of a Cape Town monument to commemorate her contribution to the human rights struggle has yet to be fulfilled. Such a monument in the Mother City could perhaps serve as a counterpoint to the statue of Jan van Riebeeck, 'first commander of the Cape', as a symbolic gesture of her significance to the City of Cape Town and the Rainbow Nation at large at the beginning of its second decade of democracy.

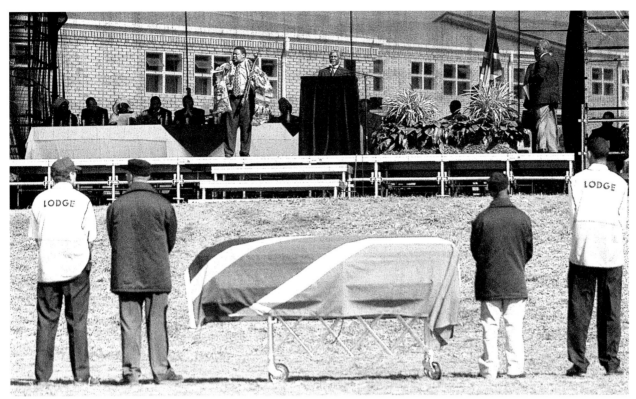

The reburial of Sarah Bartman

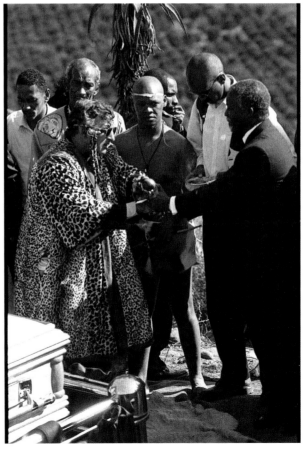

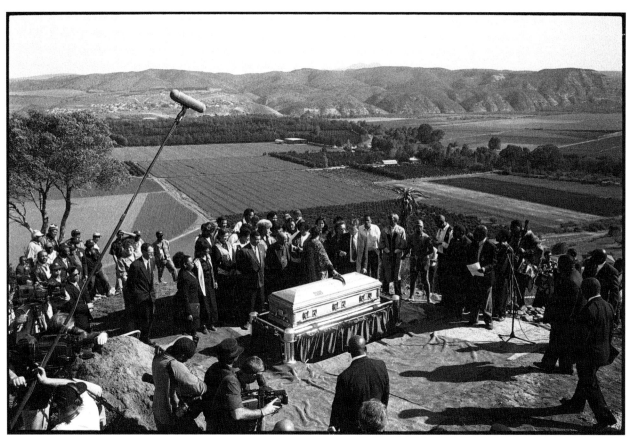

The reburial of Sarah Baartman

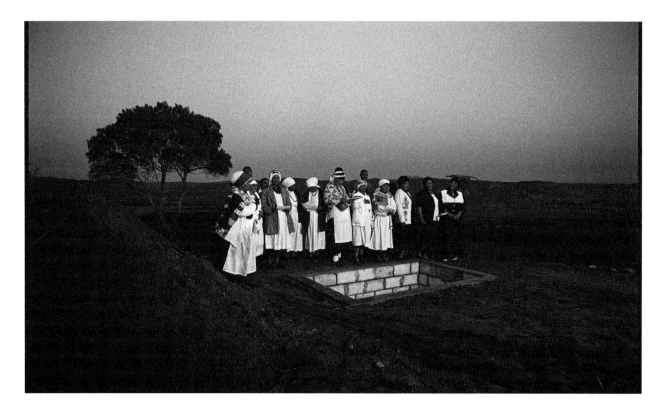

The Miscast Exhibition at the South African National Gallery

Marilyn Martin

T HE EXHIBITION *Miscast: Negotiating Khoisan History and Material Culture* has to be seen against the background of the transformation of the South African National Gallery (Sang). Since 1990, every function of the national art museum has been reassessed and tested against the needs and requirements of a changing South Africa. Our work was fired by a desire to interrogate and retell the past and its legacy. The implications and realisation of the shifts in approach and policy were daunting. It would have been far easier to sit back and give a list of reasons for not doing so: finances, priorities, expertise, tokenism and contradiction. We chose not to use these and other arguments against change, but to recognise the complexities and pitfalls while accepting the challenges.

The questions that are often asked of us are: Who is writing the history? Who is telling the tales? Who speaks for whom? Who has the right to represent whom? We understand that redress occurs only when individuals and groups are empowered to represent themselves but, ten years into democracy, South Africa still lacks the black researchers, art historians and curators to fulfil the task of reclaiming and representing history and art history. The changes in museums are painfully slow.

We have tried different approaches and some watershed exhibitions have resulted from the curatorial act being fulfilled by artists, whereby the past is brought into the present with installations that demand to be seen as works of art. *Miscast: Negotiating Khoisan History and Material Culture* was such an exhibition. It did

not include works by artist/academic/curator Pippa Skotnes. Informed by years of study and profound knowledge of the subject, Skotnes offered a revisionist account of a traumatic history, while curatorship itself became the creative act. The curator and designer Jos Thorne gave substance to the idea that '... meaning is present in the formal arrangement of things, and it is through that arrangement that knowledge, which cannot be realised by the written word, is to be found.'[1] Spaces and objects were pierced by the imagination to awaken the past, to examine the various relationships that were established when European strangers arrived in southern Africa, to recall the story of the genocide that ensued, and to reveal the extraordinary cultural and artistic achievement of the indigenous people of southern Africa.

The exhibition served as a reminder of the need to acknowledge and preserve San rock art as part of our heritage, while raising and stimulating awareness of the conditions, aspirations and interests of Khoisan descendants in southern Africa. It also allowed the tensions that exist in museums – between what is displayed, how it is displayed, what is in storage and what is available for study purposes – to come to the fore. Skotnes showed that museums exist in and for the present, not the past, and that history and material culture do not belong to one group or one experience but to all who formed and continue to form the complex relationships. *Miscast* was also intended as a visual confrontation of

the 'Bushman' diorama at the South African Museum, which was characterised by a conflation of nature and culture (little separated the San from the domain of animals in this context) and where they were presented as primitive hunter-gatherers, forever relegated to the past.[2]

Miscast was not about the Khoisan. It was

'... a critical and visual exploration of the term "Bushmen" and the various relationships that gave rise to it. These relationships were conducted on many levels, between strangers and indigenes, between colonists and resistance fighters, between researchers and their objects, and, more rarely, between individuals whose mutual respect for each other brought about mutual understanding.'[3]

The relationships were severely imbalanced in terms of power. Individuals were objectified by, for example, the anthropometric studies of the late 19th century. That these relationships resulted

'... in the tragic loss of thousands of lives and communities, in multiple language death and cultural genocide is evidenced by the images of trophy heads, hangings, prison victims and starvation. That these relationships also reflected the rare moments of mutual respect and a common humanity is witnessed in the life work of, for example, Wilhelm Bleek and Lucy Lloyd, which resulted in the photographs of /Xam and !Kung individuals, and an archive which is the closest thing we have to a "Bushman voice" from the nineteenth century.'[4]

In the book *Miscast Negotiating the Presence of the Bushmen*, Skotnes details the challenges she faced in mounting the exhibition and compiling the book. Pertinent to this paper is the question of access: access to material and access to Khoisan voices. All the institutions she approached for photographic material gave her unqualified access and permission to reproduce images. The Natural History Museum in London decided to withhold images of human remains in its collection, an attitude pertinent to some of the important issues Skotnes was trying to unravel and reveal.[5]

Skotnes saw the putative trophy heads in the Natural History Museum, but was not allowed to draw or photograph them and the museum refused to release photographs for purposes of the exhibition, as it wished '... to avoid the offence that may be caused'.[6] The scientific potential of the heads (to yield DNA) was acknowledged, but not their value as material evidence or symbols. Science has the right but '... the value of any other context in which the heads might provoke insight or stimulate understanding' was denied.[7] Skotnes was advised to obtain permission of the Khoisan, although the curator did not know who all the Khoisan were and the poor records made it impossible to trace descents. Skotnes did contact various groups and generally the response was favourable, but to no avail. The Natural History Museum never responded to my formal request for photographs of the heads. 'Colonial control, it seemed had once again been asserted over the gaze to which the bushman body should be subjected.'[8]

Most of the challenges facing Skotnes were related to accessing and presenting Khoisan voices. She made every effort to consult with groups on the nature of the displays during the preparation for the exhibition, but there are few voices around to articulate or even echo this particular past, and in the end consultation took place through the medium of legal advisers, anthropologists or organisations that represent San interests in South Africa, Namibia and Botswana. In an effort to bridge the gap between the curator and institution on the one hand, and the Khoisan descendants on the other, nine groups were brought to Cape Town for a preview and the opening of the exhibition by /'Angn!Ao/'Un from the Nyae Nyae Farmers' Cooperative on 13 April 1996. A public forum on the exhibition was organised, at which representatives from various Khoisan organisations had the opportunity to present issues and concerns for discussion, to speak for themselves.

What did they see? A quotation from Greg Dening's *Mr. Bligh's Bad Language: Passion, Power and Theatre on the Bounty* set the scene in the main room:

'There is now no Native past without the Stranger, no Stranger without the Native. No one can hope to be mediator or interlocutor in that opposition of Native and Stranger, because no one is gazing at it untouched

by the power that is in it. Nor can anyone speak just for the one, just for the other. There is no escape from the politics of our knowledge, but that politics is not in the past. That politics is in the present.'[9]

Along one wall were many archive photographs of the Khoisan in situations where they were exploited for reasons of spectacle or politics, with activities focusing on physical anthropology. In contrast, the work of Bleek and Lloyd was also shown. Thirteen cases contained some of Lloyd's personal effects, as well as objects that might have belonged to one of the San people whose language and stories she recorded, emphasising the contrast between colonial images of the Khoisan and those created by the San themselves.

In the centre of the Liberman Room was a grey brick structure, based on a centrally planned Renaissance church, but at the same time referring to a fort, a jail and a tomb. A central circle supported 12 rifles and a taller metal flag. A 'garden' comprised a half-buried box with a collection of cast human remains, cacti (not indigenous to South Africa) and five books, also half buried, with the spines collectively spelling the word 'truth'. This was contained within a semicircle of 13 pedestals, each displaying a resin cast of a body section made from the painted plaster casts at the South African Museum. They were translucent and lit from below. Accompanying texts described incidents of violence against the Khoisan.

In another part of the room were two piles of unlit body casts, metal shelves with cardboard boxes and two tall glass cabinets containing casts, documentation and anthropometric implements associated with 19th- and early 20th-century physical anthropology. The cardboard boxes were not labelled with the contents, but with dates of significant events in the recorded history of the Khoisan – date of event and date of recording. The double dating suggested that historians are characters in their own narratives, so '... history only begins to exist when its details are interpreted, and these interpretations are necessarily political'.[10] Viewers were implicated by the placement of mirrors, so that they could see their own reflections.

The room adjacent to the Liberman Room was highly contentious. Vinyl tiles screen-printed with largely derogatory images and reports taken from 19th- and early 20th-century sources covered the floor. On the walls were photographs taken by Paul Weinberg between 1984 and 1995 with the cooperation of Khoisan groups in southern Africa. They depicted scenes of daily life, thereby taking the Khoisan out of the timeless historical vacuum and placing them in contemporary society. The viewer, forced to walk on history, could not but register their continuing plight and deprivation. Cameras were placed on the floor, as if to record reactions.

The next room offered a comfortable, quiet space with a selection of the research materials that went into the making of the exhibition, as well as a visitors' book in which people could comment on their own experiences.[11] The walls displayed copies of Khoisan rock paintings produced by researches over time. We were keen to have original rock paintings in this space, but Skotnes resisted:

'This is the only place from the colonial period and before where Bushmen spoke entirely with their own voice. This voice belongs to the paintings and

[1] Skotnes, P, (ed), (1996), *Miscast Negotiating the Presence of the Bushmen*, University of Cape Town Press, Cape Town, p23

[2] See Skotnes's article 'Civilised Off the Face of the Earth: Museum Display and the Silencing of the /Xam' in *Poetics Today* 22:2, (Summer 2001), pp312–13, for a more detailed explanation of what motivated her to confront the diorama in *Miscast*. The rock paintings and other examples of San aesthetic production have historically been exhibited in natural history museums, rather than in social history or art museums. In some cases they still are.

[3] Skotnes, P, *op cit* p18. The jury is still out on terminology. For the purposes of this paper, I use the term San to refer to the artists of the rocks or Bushmen and, when speaking generally of the two major groups of indigenous southern African people, the San and Khoi, I use the term Khoisan. In 2003 I worked on a project with San descendent /Tuoi Stefaans Samcuia; I asked him whether he prefers the word San or Bushman. He replied that it was irrelevant, that he did not mind what he was called, as the San people do not refer to themselves in generic terms, but to the specific group to which they belong.

[4] *Ibid*

[5] Skotnes describes the small group of dried heads in the collection in *ibid* p19

[6] Letter from Dr R Cocks, Keeper of Palaeontology, 2 November 1995, *ibid* p20

[7] *Ibid*. The heads (dried and stuffed by a taxidermist) and skulls were described by George Williamson in 1857. They formerly formed part of the collection in the Museum of the Army Medical Department at Fort Pitt, Chatham, hence the assumption that they are trophy heads collected in military action or after executions. They were then moved to the Department of Anatomy at Oxford University before entering the collection of the Natural History Museum. See also 'Trophy Skulls, Museums and the San' by Alan G Morris in *Miscast*, pp67–79

[8] Skotnes, P, 'Civilised Off the Face of the Earth', *op cit* p316

[9] Skotnes, P, *Miscast, op cit* p15

[10] Skotnes, P, 'Civilised off the Face of the Earth', *op cit* p314

[11] This is a vast and invaluable resource of responses and reactions, some of which are highlighted in *ibid* pp317–18

the landscape where the paintings were made but the tragic truth is that there is no one left to interpret the paintings. No painter was ever interviewed, no unbroken painting tradition survives, and the multiple copies, drawn or photographed, with their accompanying interpretations, represent the impressions of others. At best, there is a kind of 'cooperation' between the painted images and their researchers, where the Bleek and Lloyd archive and the other ethnographies inform the interpretations. At worst, the paintings outside of their own environment are silent, bearing witness, in the museum or gallery, only to the act of tearing them out of the landscape and possessing them for museum collections.'[12]

How did the Khoisan groups react? Neither the curator nor staff at the Sang was prepared for the public interest, nationally and internationally. Intense reactions and controversy launched the event. On the one hand *Miscast* gave great impetus to the reputation of Sang as an institution of international influence and significance; on the other it offended and alienated many South Africans. Skotnes notes that responses '… were not divided along race or political lines, and people from all sides responded with shock, horror, sadness, anger, or wonder'.[13] The opening was attended by more than 1,000 people and the forum by 760. The Sang buildings reverberated with the indigenous languages that few South Africans know or have even heard (the American anthropologist, Meagan Biesele, acted as interpreter), and the beautiful singing of the Griqua people. Never had so many Khoisan descendants been brought together under one roof.

What went wrong? Not enough consideration was given to the lacunae that exist in the knowledge of the general viewing public – few people knew the histories that Skotnes was deconstructing within a complex conceptual framework. The Khoisan groups came, unprepared, into an unknown space and context with completely different cultural, experiential and viewing perspectives. Not only were they confronted with the cast body parts that for many equalled the remains of their ancestors, but they were also expected to walk on them. The displays were seen as voyeuristic and as reinforcing the violence, exploitation and prejudice of the past. As

Annie Coombes puts it in her book *History after Apartheid: Visual Culture and Public Memory in a Democratic South Africa*:

'Perhaps … it is a tall order to expect a Khoisan visitor to view with dispassion documents, photographs, and the instruments of colonial process that [have] systematically reduced the Khoisan to a set of dispersed, disenfranchised, and economically vulnerable communities throughout southern Africa.'[14]

The public forum had all the tension, emotion and excitement of a political meeting, but some of the perceptions and experiences of the exhibition were deeply painful and disturbing for us. It is one thing to take criticism from academics, art critics, artists and museologists; it is another to feel and absorb the hurt, anger and confusion of people who believe that they are being misrepresented by a public institution. Issues were raised around colonialism, dispossession, restitution of land and the politics of history and representation. Politically the exhibition became a rallying point and focus of both Khoisan unity and disunity, and the forum was exploited for political grandstanding by some factions and individuals. We learned a great deal about contemporary coloured politics, the claims and aspirations of indigenous movements and the fact that indigenous peoples' rights were not recognised by the democratically elected government.

The broader political context certainly played a role in the reception of and reactions to *Miscast* in a manner that we did not expect. We were two years into post-apartheid South Africa and the Truth and Reconciliation Commission had held its first hearings in April 1996, when *Miscast* opened. Many visitors saw the relationship. Although we repeatedly made clear that the exhibition was not representing the Khoisan, it came to bear the burden.[15]

Not all the reviews and responses were negative. Nadine Gordimer, South African winner of the Nobel Prize for Literature, wrote in the visitors' book: 'A bold and necessary contribution to the rewriting of what has too long passed for our SA history. Beautiful in its restoration of human dignity.' The importance of the exhibition and the forum was acknowledged and the Griquas

of Adam Kok V saw the exhibition as an opportunity for raising their most pressing concern – regaining their land for the reburial of ancestral Griqua remains. The Khoisan Representative Council requested that the 40 skeletons, whose return they had negotiated from the Anatomy Department at the University of the Witwatersrand in Johannesburg, be included in *Miscast* before reburial. Our council ruled against the display of human remains, fearing that the institution would become even further embroiled in post-apartheid contestations and politics. I regret that decision.

Taking responses, questions, issues and concerns raised during the five-month run of *Miscast* as point of departure, we organised another discussion forum, *Negotiating the Way Forward*, on 7 September 1996. We invited the public to engage with us and to assist us in mapping new routes, and it gave me the opportunity to apologise to those individuals and groups in the community who were hurt and angered by the exhibition.

One of the burning issues was that of the repatriation of the remains of Sarah Bartmann. This paper does not allow for an account of my own knowledge and involvement, save to say that I went to the Musée d'Orsay in Paris in May 1994 and, impressed by the architectural feat of converting the 19th-century railway station into a museum, I unsuspectingly walked through an entrance on the first floor. There, immediately on my right, was Sarah Bartmann's body cast in a vitrine. The shock that she was still being displayed, the naked horror of her plight and suffering, the sense of untold pain and shame, and the knowledge that this was part of my own history, were completely overwhelming. Her body cast formed part of an exhibition entitled *La sculpture ethnographique – de la Vénus hottentote à la Tehura de Gauguin*. In the eyes of the curator the cast was an ethnographic sculpture, an artefact. By 1996 Sarah Bartmann had become an icon – and a pawn – in fractious post-apartheid politics. Moreover, her odyssey of exploitation and public exhibition found a poignant echo in the lives of people who are displayed for tourists.

That the spaces at the Sang were indeed being opened, transformed and claimed by different constituencies – in a manner that was profound and far-reaching – was confirmed when the Griqua National Conference, in alliance with the East Griqualand Pioneers, the Nama

Representative Council and the Rehoboth Baster Community, approached us to use the Annexe building for a public forum on national Human Rights Day, 21 March 1997. Nearly 1,000 people arrived to discuss the return and burial of Sarah Bartmann.

Once again the annexe and gallery precinct reverberated with the sound of choirs, prayers and the indigenous languages of southern Africa. For us the forum was another milestone in forging a partnership with Khoisan groups, and we were enormously grateful for the positive cooperation and mutual trust that emerged and grew from the pain and misunderstanding that surrounded *Miscast*. Sadly these events, and the resolution passed by the South African Museums Association supporting the return of Sarah Bartmann's remains, were ignored when the long, often murky official process of negotiation finally manifested in her return, enrobement ceremony and burial in 2002.

After *Miscast* closed, the South African Museum invited Skotnes to create an exhibition that would contextualise the then rock art displays in the room adjacent to the diorama. The diorama has since been removed. The leader of a group of more than 20,000 /Xam descendants approached Skotnes in 2000 to write their history for review by the South African government commission looking into the status of the San and the reasons for their settlement patterns. Claims for compensation and restitution are taking place. People from the Kuru Project told Skotnes that they had never 'seen' their history until the exhibition, and they have started to record their oral history, drawing her into the publication of a brochure. Out of the trauma they were spurred on to do something themselves. Only three weeks ago I received an e-mail from Beaufort West seeking advice on the creation of a Khoisan museum in the town. So eight years later, *Miscast* is remembered and the Iziko South African National Gallery is remembered for an exhibition that astonished and prized open physical and metaphysical spaces of engagement.

[12] Coombes, A E, (2003), *History After Apartheid: Visual Culture and Public Memory in a Democratic South Africa* Wits University Press, Johannesburg, p236

[13] Skotnes, P, 'Civilised Off the Face of the Earth', *op cit* p314

[14] Coombes, A E, *op cit* p240

[15] *Ibid*, p237

Postscript

For an art museum, human remains do not necessarily mean trophy heads and skeletons in the cupboard. Recently we were approached by Beezy Bailey, a Cape Town artist, to create an installation that would focus on the severed leg of JP Andrews, a young surfer who lost his leg after a shark attack. He had his prosthesis fitted in the United States in August and is back in the water. His leg is currently frozen and the artist envisaged that it would be prepared with the assistance of a taxidermist and would be placed in formaldehyde in a cylindrical glass container. Beezy Bailey describes the installation as follows:

> 'Visitors would see a divided off area in the corner of one of the large rooms, (white board from floor to ceiling) with a white curtain at the door. A box would be placed at the entrance for R5 per person to enter, and that money would go towards JP's medical expenses (+/- R400 000,00). Inside the space is the leg in its container in the middle ground. A light will change from pink to green to blue to purple to yellow, illuminating the leg. On the far wall will be a video on a loop of Muizenberg beach with JP surfing (with his new leg) and soundtrack of the sea. If you stand on Boyes Drive you see rows of waves going back about a kilometre. These waves would be filmed from the air and the video on a loop would be exposed onto the ceiling of the space, upside down, above. JP is thinking of an appropriate name for the piece.'[16]

Bailey has the cooperation of the victim and his proposal was not anti-shark, but a reflection on turning a traumatic experience into something positive and visually compelling. It could have formed a powerful and unique counterpoint to *Sharkworld*, a comprehensive exhibition at Iziko South African Museum, but the curators at Iziko South African National Gallery were unanimous in their opposition to the proposal.

[16] Bailey, B, (2004), in an e-mail to the author, 23 June

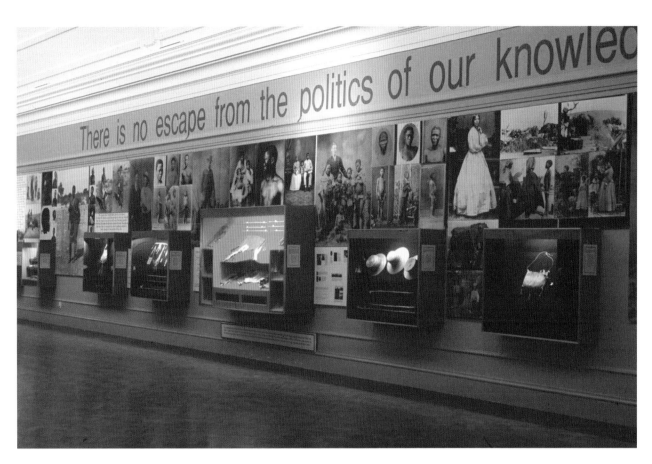

The main room, the Liberman Room, showing part of the quotation from Greg Dening's *Mr. Bligh's Bad Language: Passion, Power and Theatre on the Bounty*, archive photographs and cases containing some of Lucy Lloyd's personal effects and objects created by the San

Centre of the Liberman Room with the grey brick structure supporting twelve rifles and a metal flag

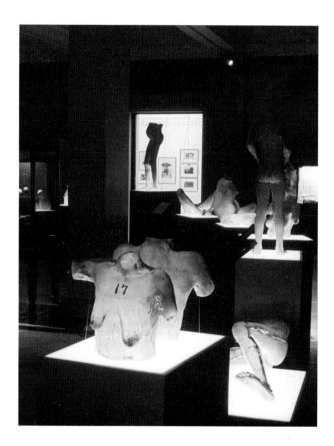

Pedestals displaying resin casts of body sections made from the painted plaster casts at the South African Museum

Tall glass cabinet containing various anthropometric implements and metal shelves with cardboard boxes

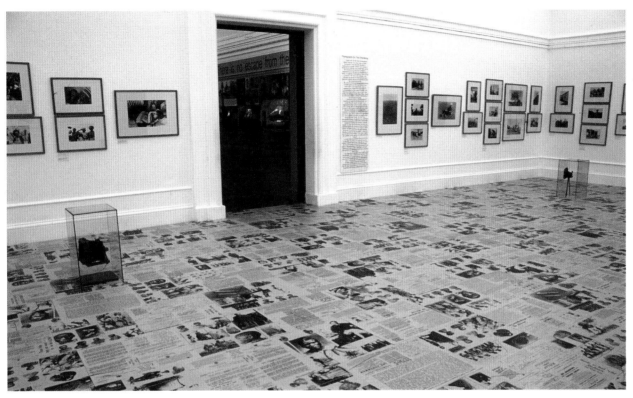

Room with vinyl tiles screen-printed with images and reports, photographs by Paul Weinberg and cameras on the floor

Room displaying research material, copies of rock paintings and visitors' book

Policy and Research Issues Affecting Human Remains in Australian Museum Collections

Michael Pickering

THE ISSUE OF policy and protocols to govern care, management, display and research of human remains, other than indigenous remains, has been poorly considered by Australian museums. This is not a strategic neglect but more the outcome of the low incidence of public displays of human remains by Australian museums over the past 25 years. The display of remains has simply not been recognised as a major issue facing Australian museums.

Similarly, there is very little pure 'anthropological' research on human remains being carried out in public Australian museums. This is because museums, if they hold remains at all, primarily hold those of indigenous people. Research on indigenous remains is tightly controlled by industry and institutional policies and protocols.[1]

It is certainly time for Australia to engage more closely with such issues. Not because there is likely to be a massive rise in the frequency of display or use of remains within Australian museums, but because the themes, philosophies, protocols and practices addressed in the debate also inform general museums policy and practice, particularly in sensitive areas. Indeed, the protocols that museums apply in representing the living can equally be applied in representing the dead.

Policy

Australian museums have and continue to display remains in a variety of contexts ranging from the ethnographic to the historic, to the biological. Although the total number of remains on display is low, their presence in a modern museum would still suggest that some consideration of the ethics and protocols for their display might have occurred. If it did, however, it has not percolated through to a written position statement by those institutions and, at time of writing, none had an operational policy regarding the care, management and display of generic human remains.

This is not to say that the issue of displaying human remains has not been discussed within the Australian museum industry. All Australian museums have policies regarding the display of Aboriginal and Torres Strait Islander remains.[2] Various researchers have independently joined the debate[3] and, in 2000, a Special Interest Group of Museums Australia called 'Health and Medicine Museums' produced a book of informative essays entitled *Exhibiting Human Remains*[4] containing contributions by authors from a variety of interests including museum professionals,[5] a forensic photographer,[6] a cleric,[7] an art critic,[8] and a forensic scientist.[9]

What are the reasons for this apparent neglect? First, most exhibitions in Australia where human remains are on display are of some age, typically at least 20 years. At the time of their development, the potential issues surrounding display, as might be discussed today, were simply not an issue to Australian curators. Second, Australian museums, like most public museums, have

focused on representation of the 'other', both ancient and contemporary. Remains of indigenous people were once displayed without regard for cultural protocols, and when disputes between the museum industry and indigenous communities did eventually occur, the response was the simple removal of the offending remains on the basis of immediate response rather than informed debate. Third, with the removal of indigenous remains from the floor, protocols for the care and management of non-indigenous remains were to be derived directly from prevailing state or territory legislation, in particular the Transplantation and Anatomy Acts.[10] Typically, the protocols of such legislation require: the informed consent of the donor, and/or the informed consent of the donor's family, and/or the consent of the coroner. Under this strategy there would appear to be little need for a museum to have its own policy.

Finally, the display of human remains has been accepted practice for so long it has become sanctified by what has become 'traditional museum practice'. It is only when the tradition has been challenged, as happened for example with indigenous remains, that the practice has been changed and the protocols documented. The display of non-indigenous remains has not yet been publicly challenged and, as a result, no need for any policy has emerged. The neglect is not a deliberate strategy; it is not the avoidance of a problematic issue. Rather it is an outcome of the fact that the care and management of non-indigenous human remains is still simply not an issue for most public museums in Australia.

Research

Most contemporary Australian public museums have emerged from colonial museums that focused on the science, technology, and natural history of the new country. Human remains collected by such institutions were, typically, those of the 'other', especially the indigenous populations. Indigenous people were seen as part of the country's natural history rather than cultural history and, as such, their remains ended up as specimens in Australian major natural history museums.

There are, of course, exceptions to this collection philosophy. The National Museum of Australia, for example, holds remains of non-indigenous Australians solely because it inherited these remains as a component of the collections of the Australian Institute of Anatomy when it closed in 1984. Most Australian museums also have examples of remains from antiquity, particularly mummies, as well as the odd medical specimen.

As a result, collections of indigenous human remains are the most common holdings of remains in Australian museums. Therefore, this discussion must concentrate on the use of indigenous remains – the bulk of these museums' collections – for its examples. Similar considerations apply to the issue of research on indigenous remains as apply to the consideration of research on non-indigenous remains.

Previous research

Previous research,[11] of course, starts with the first European colonisation of Australia. Almost as soon as the ships arrived, remains were being sent back to England, in particular to medical institutions. Until the 1960s, research with indigenous remains was largely the preserve of university medical departments, with the focus typically on unusual pathologies or attributes.

In the late 20th century, many of these university collections began to be transferred to public museums. For example, the George Murray-Black collections of several hundred remains were originally in the possession of the University of Melbourne and the Australian Institute of Anatomy in Canberra. The collections were, respectively, transferred to Museum Victoria in the 1970s and the National Museum of Australia in 1984. Only two years ago, another collection of indigenous remains was identified at Melbourne University and is in the process of being transferred to Museum Victoria prior to its repatriation to indigenous groups.

Museums certainly held human remains. However, these were usually few in number when compared with university collections, and had some particular anthropological characteristic that made them significant – such as decoration, mounting, deformity, and so on. They were used to communicate cultural phenomena. Such collections were limited and certainly not statistically viable. Their contribution was qualitative.

'Physical anthropological' research, as we know now

it, really took off only in the late 1960s. Improvements in dating techniques in archaeology that meant it was possible to better engage with the temporal, spatial and cultural attributes of indigenous human remains, not just the physical attributes.

So, for a brief period in the 1970s and 1980s, there was considerable investigation based on quantitative analysis of museum collections.[12] However, this corresponded with a rise in indigenous activism, with Aboriginal and Torres Strait Islander people protesting against the unauthorised use of ancestral remains. After some years of debate, most states and territories introduced heritage legislation that, amongst other things, placed certain controls on the use of indigenous remains. In the late 1980s, Australian museums were similarly imposing controls on access to indigenous remains in their collections.

Current research

The outcome is that today no Australian museum will allow access to its holdings of indigenous remains without the approval of the community socially associated with those remains. This is in accordance with Australian museum industry 'best practice'.[13] Not surprisingly, few communities are prepared to grant access at first request.

Some in-house research is carried out in order to facilitate provenancing, reunification, and repatriation of remains. However, such research is usually focused in its aims and restricted in its circulation. Again, access to such reports usually requires the approval of the community concerned.

Research using information acquired from previous studies of museum collections also continues. There are also occasional 'anecdotal' papers that emerge when a researcher develops a relationship with individual community members and approval becomes possible. Such papers are, however, rare and concerns have been raised about the appropriateness of relying on approval from an individual rather than a community.

In short, therefore, 'pure research' into collections of indigenous human remains, the bulk of museum holdings, has effectively ceased in Australian museums. The first response from many would be to decry this as a surrender to the political demands of a minority.

However, while indigenous activism has certainly accelerated the change in government and museum policy towards human remains, it has also encouraged professional ethical debate about the issue. The philosophies and considerations that informed the current policies and protocols of the Australian museum industry were the outcome of professional debates in which the ethics of museological theory and practice were paramount. Unfortunately, little of this debate has been formally captured in print. The exception being Museum Australia's *Previous Possessions, New Obligations* document and its successor *Continuing Cultures, Ongoing Responsibilities*.[14]

Further, researchers must accept some of the responsibility for closure of collections. The past relationship of 'pure' researchers towards indigenous communities has been characterised by antagonism – indigenous groups were lectured and criticised for their reticence in allowing research on remains that had dubious collection histories to start with. Not surprisingly, they got annoyed. Exchanges on both sides became dominated by rhetoric, leading to polarisation in both camps.

There has been, and continues to be, a consistent reticence among those with specialist interests in 'hands-on' research with indigenous remains to engage directly with affected indigenous groups. Indeed, in preparing this paper, other major state and territory museums were approached with the questions: how many people did they have doing pure research on any human remains (indigenous and non-indigenous) at the moment? How many in the past three years? How many in the past ten years? And how many approaches to do such research could they recall? The generic answer was that there had been little or no research in recent years, there was none at the moment and, while there had been some approaches, upon being told that community approval was required, no applicant researcher had taken the matter any further.

There is an expectation amongst many Australian researchers that access to remains should be allowed without community endorsement. This is despite Australian university, museum, and professional association ethics or protocols[15] and in some cases legislation that endorse such consultation. In all other areas of archaeological and anthropological practice, the researcher is required to engage with affected communities. Many

Australian 'physical anthropologists', however, still consider they have an exemption from this protocol. Researchers also frequently expect the museum to do community liaison on their behalf.

Consultation does break down barriers. For example, in 2004 the National Museum of Australia Repatriation Unit was engaged by a government department to initiate consultations with indigenous people over the preferred care and management of unprovenanced remains. Carried out by postal questionnaire, the questions included those on the theme of 'would the respondent allow research on remains if it allowed improved provenancing?' The responses were split. Typically, those individuals, communities, or representative bodies that had had experiences with the repatriation process generally endorsed qualified research, while those with little or no experience of the process generally opposed further research. It should also be stated that while Australian museums may not be carrying out in-house research, there have been occasions when they have facilitated contact between researcher and community in order to further the community's request for more information on remains, subsequent to their repatriation.

Future research directions

Anthropological research with human remains in Australian museums is thus in an arrested state. The future is uncertain. However, this pause may provide the time to investigate the important yet often neglected issue of the history of the collection of remains.

Until relatively recently, collection histories have been largely neglected. Yet, understanding the history of the collection of remains makes a significant contribution to knowledge, at least as important as any scientific contribution gained from studying the remains themselves. Indeed, it can be clearly demonstrated that some debates in Australian archaeology have been seriously compromised by a failure to acknowledge the parameters imposed by collection histories.

Take, for example the collections of George Murray-Black. Murray-Black, a pastoralist, collected indigenous remains from burial sites in the 1920s and 1930s. He sent these remains to the Australian Institute of Anat-

omy in Canberra and to the University of Melbourne. Subsequently transferred to the National Museum of Australia and Museum Victoria, these collections have

[1] Museums Australia, (1993), *Previous Possessions, New Obligations: a Plain English Summary of Policies for Museums in Australia and Aboriginal and Torres Strait Islander People*, http://www.museumsaustralia.org.au/structure/policies/ppno/ppnoshort.pdf; Museums Australia, (2003), *Continuous Cultures, Ongoing Responsibilities: A Comprehensive Policy Document and Guidelines for Australian Museums Working with Aboriginal and Torres Strait Islander Cultural Heritage*, http://136.154.202.120/dbdoc/ccor_final_feb_05.pdf

[2] For example, Museums Australia, (1991); Museums Australia, (2003) *op cit* reflects the content and philosophies of the policies and protocols of major Australian museums

[3] Leith, A, (2000), 'Exhibiting Human remains', in Hicks, M, (ed), (2000), *Exhibiting Human Remains: a Provocative Seminar*; collected papers from 'Exhibiting Human Remains', a seminar presented by Health and Medicine Museums (a Special Interest Group of Museums Australia Inc) held at the Powerhouse Museum, Sydney, 12 May 2000, http://amol.org.au/p47; Wholley, A, L, (2001), 'The Attraction of the Macabre: Issues Relating to Human Soft Tissue Collections in Museums', in Williams, E, (ed), (2001), *Human Remains Conservation, Retrieval and Analysis*, BAR International Series 934, Archaeopress, Oxford, pp275–81; Brothers, A, (2000), 'Exhibiting Ethically with Human Remains at the New Melbourne Museum', in Hicks, M, (ed), (2000) *op cit* pp33–39

[4] Hicks, M, (2000) *op cit*

[5] Brothers, A, (2000) *op cit*; Cornell, J, (2000), 'Welcome to Seminar', in Hicks, M, (ed), (2000) *op cit* p10; Fewster, K, (2000), 'Introductory Remarks to Seminar' in Hicks, M, (ed), (2000) *op cit* pp8–9; Horder, J, (2000), 'Titillating, Tempting and Tracking and Audience', in Hicks, M, (ed), (2000) *op cit* pp36–37; Stack, R, (2000), 'Aboriginal and Torres Strait Islander remains: Why should they have them back when we want to research and exhibit?', in Hicks, M, (ed), (2000) *op cit* pp21–24

[6] Gibson, R, (2000), 'Abstract. Fatality – Cruelty – Photography: The Work That Witnessing Does on Melancholy', in Hicks, M, (ed), (2000) *op cit* p4

[7] Lucas, B, (2000), 'Exhibiting Human Remains – What are the Ethical Issues?' in Hicks, M, (ed), (2000) *op cit* pp12–20

[8] James, B, (2000), 'If I only had a brain', in Hicks, M, (ed), (2000) *op cit* pp22–25

[9] Hilton, J, (2000), 'In Flanders Fields', in Hicks, M, (ed), (2000) *op cit* pp40–42

[10] For example, Australian Capital Territory Transplantation and Anatomy Act 1978, http://www.legislation.act.gov.au/a/1978-44/current/pdf/1978-44.pdf; South Australia Transplantation and Anatomy Act 1983, http://www.parliament.sa.gov.au/Catalog/legislation/Acts/T/1983.11.htm; New South Wales Human Tissue Act 1983, http://www.austlii.edu.au/cgi-bin/download.cgi/download/au/legis/nsw/consol_act/hta1983160.rtf

[11] See also Pardoe, C, (2005), 'Australian biological anthropology for archaeologists', in *ARX-World Journal of Prehistoric and Ancient Studies*, http://www.laiesken.net/arxjournal/

[12] For example, Pardoe, C, (1984), *Prehistoric Human Morphological Variation in Australia*, PhD thesis, Australian National University, Canberra; Bennett, C, (1995), *Morphology of the Major Limb Bones of South Australian Aborigines*, PhD thesis, La Trobe University, Melbourne; Brown, P, (1982), *Coobool Creek: A Prehistoric Australian Hominid Population*, PhD thesis, Australian National University, Canberra; Webb, S G, (1984), *Prehistoric Stress in Australian Aborigines: A Palaeopathological Survey of a Hunter-Gatherer Population*, PhD thesis, Australian National University, Canberra

[13] Museums Australia, (1993, 2003) *op cit*

[14] *Ibid*

[15] For example, *Australian Archaeological Association Code of Ethics*, http://www.australianarchaeologicalassociation.com.au/codeofethics.html; Australian Institute of Aboriginal and Torres Strait Islander Studies, (2000), *Guidelines for Ethical Research in Indigenous Studies*, http://www.aiatsis.gov.au/corp/docs/EthicsGuideA4.pdf; Museums Australia, (2003) *op cit*; Australian National University, (2004), *The Australian National University Human Research Ethics Committee Application Form*, http://www.anu.edu.au/ro/ethics/human_application.rtf; National Health and Medical Research Council, (2004), *National Statement on Ethical Conduct in Research Involving Humans*, http://www.health.gov.au/nhmrc/publications/pdf/e35.pdf

been the major source of information for bio-anthropological investigations into indigenous Australian history.[16]

One contribution made by this research was to the 'intensification' debate – the theory that the Australian Holocene saw a dramatic rise in local populations, reflecting environmental and social change. Evidence for this was seen as the increased rise in diet-linked disease upon Murray River populations – as reflected by the pathology of remains in the collections. However, recent research into Murray-Black's own field notes[17] shows that Murray-Black collected without regard for spatial or temporal control and, more significantly, selected only remains in good condition and with particularly interesting pathologies. He threw away remains he considered uninteresting. For example, he noted in a letter to the Head of the Australian Institute of Anatomy:

'I dumped all the incomplete skeletons except long bones into the creek – back bones, feet, hands, ribs, hips etc as you appear to only require complete skeletons.'[18]

The Australian Institute of Anatomy carried out further selection once the remains arrived in Canberra – discarding those that were of no interest.

As a result of a failure to consider collection history in any great depth, and to identify bias in the collectors and collection managers, any arguments about indigenous health in antiquity based on Australian museum collections are open to question. An important debate in Australian archaeology is potentially compromised.

'Science' is not the only means of contributing to knowledge. The humanities and social sciences have also been known to make a contribution occasionally. Research into the history of museum collections can address issues of law: was the collection legal at the time? What are the contemporary legal consequences of illegal collection in the past? It can address issues of ethics – for example, take the case of Tommy Walker, or Polt - pal - ingada, a Ngarrindjeri man who lived much of his adult life around Adelaide in the late 1800s and was a popular local identity.[19] In 1900, Walker took ill, and he died in hospital at midnight on 4 July 1901. His funeral was held the next day. The members

of the Adelaide stock exchange paid for his burial and his headstone. However, in 1903 the doctor present at the time of Walker's death, William Ramsay Smith, the State coroner, was suspended for a breach of the Anatomy Act. Ramsay Smith had secretly dissected Tommy Walker's body immediately after death. The coffin contained only Walker's dissected soft remains. The skeleton had been sent to Edinburgh University.

At the time this news was broken in 1903, it is fair to say that Adelaide was disgusted. An inquiry disclosed a secret industry in the removal of skeletons by senior medicos. Headlines at the time included: 'Tommy Walker – He Rests in Pieces – A Scientific Interment' and 'Human Skeletons at £10 Each. How They are Prepared. Australian Natives in Great Demand.' Ramsay Smith was, however, exonerated.

A common argument is that we cannot judge the acts of the past by modern ethical positions – we can, however, judge the acts of the past by the ethics that prevailed at the time. Ramsay Smith's behaviour was popularly considered wrong.

In Australia, considerable insights into the history of collections have been provided by investigations into the politics, theories, policies, protocols, and practices that underlay the collection of human remains by Australian and overseas museums, amongst other collectors. Turnbull, who dominates in this area of inquiry, has objectively documented and highlighted past practices, many of them illegal and unethical by the laws and values of the time. The result is well-documented histories of collection that are essential reading for anyone seeking to use a collection for research.[20]

Australian Anthropology has long included the study of indigenous mortuary beliefs and ceremonies in its investigations into Aboriginal and Torres Strait Islander culture. However, the characteristic of many studies, even today, is the search for the 'traditional'. Contemporary beliefs and practices are largely ignored. It must be acknowledged that contemporary beliefs are as important as historic beliefs – change is traditional and is to be understood, not criticised.

There is thus little to no pure research using museum collections of indigenous remains in Australia occurring today. The future of any such research depends upon improved relationships between researchers and

indigenous communities. However, despite this lack of 'physical anthropological' research, there are other avenues for research that should be encouraged.

Learning about cultures

The benefits of the Australian experience with indigenous remains are that, to a large extent, the same considerations are now generally applied to the care, management and representation of the dead that are applied to the museum representation of the living – that is consultation and involvement of the interested parties. In preparing any human remains management strategy, the voices of those claiming association are considered worthy of consideration, if not, ultimately, representation. In the research for these voices, insights are being gained into both the traditional and contemporary cultural perspectives of subject groups. This contributes greatly to the museums' understanding of alternative perspectives on an issue and, in turn, to a more accurate representation of those perspectives.

Major Australian museums have learnt to consult and to use the outcomes of consultation as a research experience. Such consultations will create difficulties for some in the short term. They do run the risk of empowering those whose views are not necessarily representative of the subject group. Nevertheless, addressing those difficulties, through consultation, will eventually prove a considerable asset to museums, contributing to museum research on, and representation of, contemporary cultures, sub-cultures, and social groups, through the medium of the museum.

Australian museums do have good protocols regarding the care, management, display of, and research on, Australian indigenous human remains. What characterises these protocols is their consideration of indigenous cultural values. It is the experience in care and management of human remains informed by this recognition of cultural values that the Australian experience can bring to this debate.

Conclusion

The debate about the display of, or research with, human remains, regardless of cultural affiliation, is not just the preserve of archaeologists or physical anthropologists. Within Australia at least, a much broader definition of 'research' needs to be encouraged, embracing disciplines from the sciences, social sciences, and the humanities. Further, armed with the findings of research by these disciplines, some retroactive documentation is required in which collection histories are better consolidated into the collection documentation. There is a role for museums to continue to impartially research and communicate the belief systems of other cultures and sub-cultures; this can only benefit from inviting more contributions from the disciplines of social and cultural anthropology, law, history, philosophy, and museum studies, amongst others. The outputs of such research will not only inform the public but also inform museum philosophy, policy, and practice in all areas.

[16] For example: Pardoe, (1984) *op cit*; Webb, (1984) *op cit*; Robertson, S, (2004), *A Critical Evaluation of the Application of Cribra Orbitalia in Australian Archaeology as a Correlate of Sedentism*, BA Hons thesis, Australian National University, Canberra

[17] Robertson, (2004) *op cit*

[18] Murray-Black, G, (1940), Letter to Dr Clements, Director of AIA, 10 October 1940, National Museum of Australia, File No 02/637

[19] Foster, R, (1998), 'Tommy Walker walk up here ...', in Simpson, J, and Hercus, L, (eds) (1998), *History in portraits: biographies of nineteenth century South Australian Aboriginal people*, Aboriginal History, Canberra, pp191–220

[20] Turnbull, P, (1991a), 'Science, National Identity and Aboriginal Body Snatching in Nineteenth century Australia', in *Working Papers in Australian Studies*, Working Paper No 65, Sir Robert Menzies Centre for Australian Studies, Institute of Commonwealth Studies, University of London, London; Turnbull, P, (1991b), 'Ramsay's Regime: The Australian Museum and the Procurement of Aboriginal Bodies, c1874–1900', in *Aboriginal History*, 15: 2, pp108–21; Turnbull, P, (1994), 'To What Strange Uses: The Procurement and Use of Aboriginal Peoples' Bodies in Early Colonial Australia', in *VOICES*, V4, No 3, Spring 1994, National Library of Australia, Canberra; Turnbull, P, (1997), 'Ancestors, Not Specimens: Reflections on the Controversy over the Remains of Aboriginal People in European Scientific Collections', in *Electronic Journal of Australian And New Zealand History*, http://www.jcu.edu.au/aff/history/articles/turnbull.htm; Turnbull, P, (1998), 'Outlawed Subjects: The Procurement and Scientific Uses of Australian Aboriginal Heads, c1803–1835', in *Studies in the Eighteenth Century*, 22, 1, pp156–71; Turnbull, P, (1999), 'Enlightenment Anthropology and the Ancestral Remains of Australian Aboriginal People', in Alex Calder *et al* (eds), *Voyages and Beaches: Pacific Encounters, 1769–1840*, University of Hawaii Press, , Honolulu, Hawaii; Turnbull, P, (2001), 'Rare Work for the Professors: The Entanglement of Aboriginal Remains in Phrenological Knowledge in Early Colonial Australia', in Jeanette Hoorn & Barbara Creed, (eds), *Captivity*, Pluto Press, Melbourne

CHAPTER 6

Policy and Practice in the Treatment of Archaeological Human Remains in North American Museum and Public Agency Collections

Francis P McManamon[1]

CLAIMS FOR CONTROL of archaeological resources have increased and now come from a wider range of groups. A century ago, it was common for eccentric antiquarians to be the ones who were most concerned about archaeological sites, with scientists just beginning to become interested in these ancient remains. At present, academic researchers, public agencies responsible for the stewardship of the archaeological record, and descendent communities all assert claims for access or control of the physical record of the ancient and historic past. This is to say nothing of others such as antiquities traffickers, treasure-hunters, and historic shipwreck salvors who also have laid claim to artifacts in archaeological sites. Of special concern for scholars, scientists, public stewards, and descendents are the human remains sometimes found in archaeological contexts. Basic questions regarding these remains include: what is the proper treatment for them, and who should be responsible for determining this?

We can consider the scale of this topic in the United States (national statistics are not available from Canada) by examining some of the quantities of human remains from archaeological contexts that are reported in collections curated by public agencies and museums. When considering only human remains reported as 'Native American', the total number is approximately 152,000 sets of individual remains. These remains are reported from over 1,000 museums that receive federal funding and public agency offices. Table 1 shows summaries of some of the general counts of human remains, as well as examples from several of the large institutions.

Table 1: Examples of quantities of human remains from archaeological contexts in United States public agency or museum collections

Number of US public museums reporting Native American (NAm) human remains[a]	689
Number of United States public agency offices reporting NAm human remains[a]	449
Number of sets (minimum number of individuals [MNI]) of 'culturally affiliated' NAm human remains reported by US museums and agencies[a]	29,284
Number of sets (MNI) of 'culturally unidentifiable' NAm human remains reported by US museums and agencies[a]	*108,247*

[c] National Park Service, (2003), Park NAGPRA Update, 30 June 2003, document on file, Park NAGPRA Program, Intermountain Regional Office, Denver, Colorado

[d] Archaeology Magazine, (2003), 'Return to the African Burial Ground: An Interview with Physical Anthropologist Michael L Blakey', Archaeology Online, www.archaeology.org/on-line/interviews/Blakey, accessed 28 February 2005; Harrington, Spencer P M, (1993), 'Bones and Bureaucrats: New York's Great Cemetery Imbroglio', Archaeology (March/April 1993), 28–38; Lathrop, Stacy, (2003), 'Following the Remains of Enslaved Africans', Anthropology News, November 2003, 15–16

Number of sets (MNI) of NAm human remains reported by the Repatriation Office, Department of Anthropology, National Museum of Natural History, Smithsonian Institution collections (3,224+ individual sets have been repatriated)[b]	15,963
Number of sets (MNI) of NAm human remains, National Park Service collections (3,606 of these sets have been determined as culturally affiliated and public notices have described their availability for repatriation to a culturally affiliated tribe)[c]	5,994
Number of sets (MNI) of 'culturally unidentifiable' NAm human remains reported by the Peabody Museum of Archaeology and Ethnology, Harvard University[a]	6,074
Number of sets (MNI) of 'culturally unidentifiable' NAm human remains reported by the Ohio Historical Society[a]	6,700
Number of sets (MNI) of 'culturally unidentifiable' NAm human remains reported by the Tennessee Valley Authority[a]	4,006
Number of sets (MNI) of human remains reported for the African Burial Ground site, New York City[d]	419

SOURCES:

[a] National Park Service, (2004a), National NAGPRA Program, Final Mid-Year Report, 31 March FY 2004, National Park Service, Department of the Interior, Washington DC, www.cr.nps.gov/nagpra/DOCUMENTS/NNReport0410.pdf, information provided by National NAGPRA program leader, 30 August 2005 accessed 24 October 2004

[b] Flynn, Gillian, (1998), Annual Report on Repatriation Activities at the National Museum of Natural History, June 1997 to June 1998, Repatriation Office, Department of Anthropology, National Museum of Natural History, Smithsonian Institution, Washington DC, www.nmnh.si.edu/anthro/repatriation, accessed 28 February 2005

In the United States, the largest number of human remains removed from archaeological sites and in agency and museum collections are Native American. Each set of remains counted is believed to represent a single individual. Many of these sets of remains, perhaps most of them, are fragments of individual skeletons. Relatively few of them are likely to be even nearly complete. The sets of remains are held by a large number of institutions, over 1,000 reportedly. However, relatively few public museums or agencies have over 500 sets of remains in their individual collections.[2]

Other ethnic groups also are represented in some of the collections. At the African Burial Ground site in the center of lower Manhattan, New York City, the remains of over 400 individuals were excavated in 1991–92 prior to the construction of a public office building. Before the reinterment of these remains in October 2004, they were extensively examined and scientifically analyzed.[3] A smaller 19th-century African American burial population (140 individuals) associated with the First African Baptist Church in Philadelphia was excavated in 1983–84 and analyzed before reinterment in 1987.[4]

So, in the United States there are substantial numbers of sets of human remains from archaeological contexts in the collections of a large number of public museums and agencies. Several national laws and regulations provide guidance on how these remains are to be treated by the organizations that hold them.

National laws and regulations affecting human remains from archaeological contexts

In recent years in the United States, public agencies and museums that are responsible for the care of archaeological human remains have developed general policies

and guidance for their treatment. Most specific examples, however, show that a case-by-case approach is usually followed.

The legal regulation of treatment of recently deceased human remains generally is not a matter of national law. Rather, such matters are handled by state or local laws and regulations. In 1997, the Natural Resources Conservation Service surveyed state laws and recorded 38 that specifically addressed '... reburial of human skeletal remains, repatriation of human skeletal remains and grave goods, and/or unmarked grave protection statutes'[5]

At national level, the United States has three laws that affect the treatment of human remains from archaeological contexts. In Canada, a national law providing uniform regulation of archaeological resources is being drafted, however, presently, except for archaeological resources within Parks Canada units, provincial laws regulate how such remains are treated. The Parks Canada policy provides its officials with directions for activities regarding human remains, cemeteries, and burial grounds.[6]

In the United States, since 1906, archaeological sites on public lands have been protected. Their investigation, the collection or excavation of artifacts or other remains, including human remains, and curation and public interpretation have been regulated by the Antiquities Act and subsequent laws (Table 2). Although this act and its regulations do not make any specific reference to human remains, such remains have clearly been considered as part of the archaeological record and appropriate for archaeological investigation under this statute.

Table 2: United States archaeological laws and human remains[7]

Antiquities Act of 1906, 16 USC 431–433: No explicit mention of human remains

Archaeological Resources Protection Act of 1979, as amended, 16 USC 470 aa-mm: 'Human skeletal remains' listed as one kind of material remains that are of archaeological interest and therefore covered by the law

Native American Graves Protection and Repatriation Act of 1990, 25 USC 3001–13: 'Native American' and 'Native Hawaiian' human remains are covered by the law

- 'Human remains': 'means the physical remains of the body of a person of Native American ancestry. The term does not include remains or portions of remains that may reasonably be determined to have been freely given or naturally shed by the individual from whose body they were obtained, such as hair made into ropes or nets.' (From the regulations for NAGPRA, 36 CFR 10.2[d][1])
- 'Native American': '... of, or relating to, a tribe, culture, or people that is indigenous to the United States.'
- 'Native Hawaiian': '... a descendent of the aboriginal people who, prior to 1778, occupied ... the area that is now the state of Hawaii.'

Human remains are specifically mentioned in the second major United States law covering archaeological resources, the Archaeological Resources Protection Act (ARPA), which explicitly includes 'human remains' recovered from archaeological contexts and susceptible to historic or scientific study as being covered by the law. The Native American Graves Protection and Repatriation Act (NAGPRA) contains the most detailed direction on how 'Native American' and 'Native Hawaiian' human remains are to be treated by public agencies and museums subject to the law.

There are several important limitations to the application of these national laws. In general they apply only on public lands, that is, land owned or controlled by the national government. This covers approximately one third of the landmass of the United States, so it is a substantial area. They do not, however, apply to private land or to the land held by states. An important distinction of NAGPRA, however, is that it does apply to collections held by museums that receive federal funding. The legal interpretation of receiving federal funding is so broad that in the United States this includes virtually every museum that is open to the public. The collections covered by the law are not limited to those that

contain objects or human remains from public lands. NAGPRA's collections-related requirements apply to federal agency collections and to collections held by museums that receive federal funding no matter where in the United States the objects and remains come from.

NAGPRA also contains important restrictions on the kinds of objects it covers. Only a limited range of objects from archaeological sites are covered. Specifically, in addition to human remains, these include: 'funerary objects,' 'sacred objects,' and 'objects of cultural patrimony.' Since this chapter focuses on human remains, the other object definitions are not described, but interested readers can check more specific sources[8] for detailed descriptions. Of course, NAGPRA also applies only to human remains that are 'Native American' or 'Native Hawaiian' (Table 2). Human remains of individuals from other ethnic groups need not be treated following the strictures of NAGPRA and its regulations.

Each of these statutes is supplemented by a set of regulations. Based on the language of the law and consistent with any congressional reports that accompany the law, regulations provide more detailed procedures of what must be done, and by whom, to implement a law.

The regulation most pertinent to the care and use of federal archaeological collections is found in Title 36 of the Code of Federal Regulations, Part 79.[9] Entitled *Curation of Federally-Owned and Administered Archaeological Collections*, it describes the activities necessary by federal agencies for the management and preservation, including appropriate use, of archaeological collections made as the result of their actions under the Antiquities Act, ARPA, and several other statutes. Section 79.10 of the regulation covers allowable uses of federal archaeological collections. Since human remains from archaeological sites may be 'archaeological resources', these guidelines apply to them as well as to artifacts and other items from archaeological contexts.[10]

Federal officials are required by the regulation to ensure that collections are available for 'scientific, educational, and religious uses, subject to such terms and conditions as are necessary to protect and preserve the condition, research potential, religious or sacred importance, and uniqueness of the collection.'[11] When a collection is from Indian land, the relevant Indian

tribe or landowner may place additional conditions on any request to study the collection.[12] If the collection is from a site that the responsible federal official has determined is of religious or cultural importance to an Indian tribe with historic ties to the site, the federal official may place additional conditions on any study of the collection.[13] The regulations encourage research on federal archaeological collections, including those that include human remains from archaeological sites. When the study of human remains is proposed, extra planning and review is normally required and certain conditions may be placed on studies in some circumstances.

Similarly, NAGPRA and its regulations do not place an outright prohibition on the study of Native American

[1] This article has been prepared as work of private scholarship. It is not an official statement of the National Park Service or the Department of the Interior

[2] National Park Service, (2004a), *National NAGPRA Program, Final Mid-Year Report, FY 31 March 2004*, National Park Service, Department of the Interior, Washington DC, www.cr.nps.gov/nagpra, accessed 24 October 2004;

[3] Harrington, Spencer P M, (1993), 'Bones and Bureaucrats: New York's Great Cemetery Imbroglio', in *Archaeology*, March/April 1993, pp28–38

[4] Crist, Thomas A J, (2002), 'The Relevance of Mortuary Archaeology', in *Public Benefits of Archaeology*, edited by Barbara J Little, University of Florida Press, Gainesville, Florida, pp101–17

[5] Natural Resources Conservation Service, (1997), *Compilation of State Repatriation, Reburial, and Grave Protection Laws* (2nd edition), Natural Resources Conservation Service, Department of Agriculture, Washington DC

[6] Parks Canada, (2000), *Management Directive 2.3.1, Human Remains, Cemeteries and Burial Grounds (File: C-8412)*, Archaeological Services Branch, National Historic Sites Directorate, Parks Canada, Ottawa

[7] Readers can access more information about United States laws related to archaeological resources, including summaries of the laws and the statute texts in 'Archeological Laws: A Guide for Professionals' at www.cr.nps.gov/archeology/tools/laws/index.html, accessed 22 February 2006

[8] For example: McManamon, Francis P, (1992), 'Managing Repatriation: Implementing the Native American Graves Protection and Repatriation Act', CRM 15(5), www.cr.nps.gov/archeology/sites/fpm_crm.htm; (2000), 'The Native American Graves Protection and Repatriation Act', in *Archaeological Method and Theory: An Encyclopedia*, edited by Linda Ellis, Garland Publishing Inc, New York and London, pp387–89, electronic copy available at www.cr.nps.gov/archeology/sites/NAGPRAsummary.html; (2003), 'An Introduction to the Native American Graves Protection and Repatriation Act', www.cr.nps.gov/archeology/sites/NAGPRAintro.html; all accessed 16 February 2006

[9] The shorthand for this regulation is 36 CFR 79; it can be accessed at www.cr.nps.gov/archeology/36cfr79.html

[10] A much fuller discussion of the care and curation of public archaeological collections, including more information about research on archaeological collections, can be found in Childs, S Terry, (2005), *Managing Archeological Collections: An Online Course*, Archeology Program, National Center for Cultural Resources, National Park Service, Washington DC, www.cr.nps.gov/archeology/collections/table(frame5).html, accessed 16 February 2006

[11] *Op cit* 36 CFR 79, 10(a)

[12] *Op cit* 36 CFR 79, 10(d)(3)

[13] *Op cit* 36 CFR 79, 10(d)(4)

human remains from archaeological sites. However, under most circumstances, Indian tribes that are 'culturally affiliated' with Native American human remains control access to these sets of remains and therefore may prohibit, or set conditions for, any studies of the remains. It is important to understand, therefore, what is meant by being 'culturally affiliated.' For the purposes of determining whether or not an Indian tribe can have a set of Native American remains repatriated to it under NAGPRA, cultural affiliation between the set of remains and the tribe must be determined.

' *Cultural affiliation* means that there is a relationship of shared group identity which can be reasonably traced historically or prehistorically between a present day Indian tribe or Native Hawaiian organization and an identifiable earlier group.'[14]

There are three components to determining that a relationship of cultural affiliation exists. First, there must be a modern tribe as the claimant. For purposes of NAGPRA, the tribe must be one that is recognized formally by the Bureau of Indian Affairs and the Department of the Interior. There must also be an earlier group that the individual set of human remains is associated with and the characteristics of the culture of that group should be fairly well known so that they can be compared with the culture of the modern tribe. The third critical component is that a 'relationship of shared group identity' must be 'reasonably traced' between the modern and the older group. This last component is usually the most difficult one to establish. For situations involving the relatively recent past, for example, showing a reasonably traced relation of shared group identity between a modern Puebloan or Apachean tribe and a set of human remains from a five- or six-hundred-year-old site near the current location of the modern tribe might be easily done. However, as time depth increases and geographic proximity is reduced, relationships of shared group identity become less generally agreed. In a recent prominent situation in Washington State, federal judges overturned a determination of cultural affiliation made by the Secretary of the Interior regarding an 8,000-year-old skeleton. The Secretary of the Interior had reached his determination based primarily on oral history evidence derived from traditional histories of the Indian tribes that had claimed the remains. Federal judges at both the district and circuit court of appeals levels, evaluating all the available evidence, pointed out that the oral history was contradicted by other evidence that Interior seemed to have ignored. They also pointed out that the oral history evidence could not be considered reliable and its historical roots were unlikely to extend to 8,000 years ago.[15]

While NAGPRA provides only a simple framework for how to make determinations of cultural affiliation, it does provide a list of the kinds of evidence that should be applied in attempting to reach determinations.

'Cultural affiliation is established when the preponderance of evidence – based upon geographical, kinship, biological, archaeological, anthropological, linguistic, folklore, oral tradition, historical, or other relevant information or expert opinion – reasonably leads to such a conclusion.'[16]

This section of the guidance also points out that a 'preponderance' of evidence, not overwhelming evidence or evidence beyond the shadow of a doubt, is the standard for making cultural affiliation decisions.

The Native American Graves Protection and Repatriation Act also takes account of a possibly more direct affinity between Native American human remains and individuals. This individual relationship is referred to as 'lineal descent.' A relationship of lineal descent is said to exist when a modern individual can be shown to trace

'... his or her ancestry directly and without interruption by means of the traditional kinship system of the appropriate Indian tribe or Native Hawaiian organization or by the common law system of descendance to a known Native American individual whose remains, funerary objects, or sacred objects are being claimed.'[17]

This kind of strong and especially well-documented relationship is relatively rare and not dealt with any further here.

The next two sections review a number of policies and guidelines developed by different public agencies and museums for research on and interpretive display

of human remains from archaeological sites in light of the legal framework sketched above.

Policies and guidance regarding research on human remains from archaeological contexts

In the United States, various public agencies and museums have written policies concerning research on human remains in their collections. The creation of these explicit policy statements has much to do with the requirements faced by federal agencies and public museums required to deal with Native American human remains under NAGPRA since 1990. Some of the policies have been written generally enough to take account of the human remains of other ethnic groups as well. While the information summarized here is not from a comprehensive survey of all the institutions that curate these kinds of archaeological remains, a general pattern can be discerned.

National Park Service (NPS) policies allow for study of human remains from archaeological sites with some conditions being placed on such studies. For NPS archaeological collections, managers

> … may allow access to, and study, publication [as in a report], and destructive analysis of, human remains, but must consult with traditionally associated peoples and consider their opinions and concerns …. Such use of human remains will occur only with an approved research proposal that describes why the information cannot be obtained through other sources or analysis, and why the research is important to the field of study and the general public.[18]

Consultation with 'traditionally associated peoples' is required before a study is approved. Traditionally associated peoples are communities or other recognized groups, including Indian tribes, that have multigenerational relationships with the park unit or archaeological site from which the collection to be studied derives.[19] The other main requirement is that the proposed research, whether conducted by NPS staff experts or researchers applying to undertake investigation of NPS collections, must be determined to be important based upon review of a detailed research proposal. Park super-

intendents are responsible for making decisions about whether or not to permit such research, but their decisions are to be informed by technical and policy advice from NPS archaeologists who also review the proposals.[20] Within these general guidelines, curatorial staff at individual parks may develop more detailed agreements for curation of collections that include human remains from archaeological sites, as has been developed between parks in the Flagstaff, Arizona area and the Museum of Northern Arizona.

The United States Army Corps of Engineers (COE) which constructs and manages substantial water control facilities and projects throughout the country, has a policy requiring that 'District Commanders ensure that archaeological collections are available for scientific and educational uses by qualified professionals … including access for study … exhibits, teaching, public interpretations, scientific analysis and scholarly research.'[21] When the human remains from collections are subject to NAGPRA, the COE procedures require compliance with these regulations as part of the conditions before conducting any research activities.

Parks Canada's *Management Directive 2.3.1*[22] applies to human remains from within Parks Canada units that are found *in situ* in archaeological sites, as well as human remains from archaeological contexts now in museum collections. The policy requires that when the remains are determined to be those of 'an Aboriginal person,' the '… nearest Aboriginal organization or other community of Aboriginal people that is will-

[14] 'Cultural affiliation' is defined in the statute, 25 USC 3001, Section 2(1). It is further described in the regulations 43 CFR 10.1(e). These regulations provide additional directions for implementation of the law

[15] Ninth Circuit United States Court of Appeals, (2004), *Bonnichsen v United States*, 367 F3d 864 (9th Cir 2004), www.friendsofpast.org/kennewick-man/court/opinions/040204opinion. html, accessed 28 February 2005

[16] Title 43 of the Code of Federal Regulations, Part 10, *op cit* 1(e)

[17] *Ibid* 2(b)(1)

[18] National Park Service, (2001), *Management Policies (2001)*, 'Stewardship of Human Remains and Burials – Research,' section 5.3.4, Department of the Interior, Washington DC, www.nps.gov/refdesk/policies.html, accessed 24 October 2004

[19] *Ibid* section 5.3.5.3, p57

[20] National Park Service, (2004b), *Director's Order #28A*, National Park Service, Department of the Interior, Washington DC, www.nps.gov/policy/DOrder.html, accessed 3 March 2005

[21] Corps of Engineers, (1996), 'Chapter 6 – Cultural Resources Stewardship', ER 1130-2-540, 15 November 1996, pp6-1 to 6-5, Corps of Engineers, Department of the Army, Washington DC

ing to act as the next-of-kin and whose members have a sense of relationship …' with the person represented by the remains will determine whether any study of the remains will be allowed. The management directive allows for 'minimal investigation and documentation … for identification purposes'.[23] However, any additional archaeological or scientific study must be '… deemed necessary or wanted by the culturally affiliated group or next-of-kin …' in order to be allowed.[24]

In the United States, public museums and university departments that curate human remains have developed specific procedures for dealing with requests for investigations of the remains. A number of examples are summarized in this section. The Department of Anthropology at the University of Illinois at Urbana-Champaign curates archaeological collections that include approximately 815 culturally unidentifiable Native American human remains from about 82 archaeological sites. The department's policy calls for these human remains to be made available to qualified researchers for scientific inquiry, including destructive analysis, if justified.[25] The department's policy requires that proposals be reviewed by the Osteology Committee of the department. The policy acknowledges that culturally affiliated remains subject to NAGPRA will be handled in accordance with NAGPRA requirements. Also, the policy prohibits adding to its collections any human remains that would be subject to NAGPRA for which lineal descendents or culturally affiliated tribes have been determined, without the permission of those entities.

The Florida Museum of Natural History, which reported curating 2,609 culturally unaffiliated Native American human remains from 157 archaeological sites, requires that proposals for testing, study, or loan be reviewed by the appropriate museum curator. The museum recognizes additional legal requirements by stating that further restrictions, which are not specified, may apply to collections from the United States that are subject to NAGPRA.[26]

The University of California at its various campuses that have human remains in their collections applies a consistent set of procedures. The main campuses, Berkeley, Davis, Los Angeles, Riverside, Santa Barbara, and Santa Cruz, report over 11,000 sets of culturally unidentifiable Native American remains from about 750

different sites in their collections. Human remains from archaeological sites normally are accessible for research by qualified investigators subject to approval by the appropriate curator. However, when NAGPRA applies, once a repatriation request has been granted, items covered by the request shall not be used for teaching or research without the consent of the tribal authority that has been determined to be culturally affiliated (that is, granted right of repatriation). Similar conditions apply when a tribe has been determined to be culturally affiliated and other aspects of the repatriation requirements have been met, but the tribe has not yet sought repatriation.[27]

The National Museum of Natural History, part of the Smithsonian Institution, curates nearly 16,000 sets of human remains from archaeological sites (see Table 1).[38] The museum allows nondestructive research on human remains. However, if the remains are Native American and have been determined to be culturally affiliated with a tribe, that tribe must either be consulted or give consent to the research proposed.[29]

The American Museum of Natural History in New York City reports curating 1,960 culturally unidentifiable Native American human remains from 395 different sites. The museum evaluates requests for study of these collections on a case-by-case basis.[30] The Field Museum of Natural History and Science in Chicago reports curating 1,256 sets of culturally unaffiliated Native American human remains from 122 sites. At the Field, the curator in charge of the collection reviews all study requests. Requests related to Native American human remains require consultation with culturally affiliated Indian tribes and the results of this consultation are taken into account by the curator while reviewing any study request.[31]

In summary, the main issue regarding research of human remains from archaeological sites in Canada and the United States involves whether or not the remains are Native American. For Native American remains, whether or not, and what kind of research will be permitted is controlled largely by culturally affiliated Indian tribes. For remains for which a cultural affiliation has not been determined, the curatorial facility or museum decides what research is allowed. Readers also should recognize that the term 'culturally

affiliated' differs between the Parks Canada definition from its management directive and the definition under NAGPRA in the United States.

Regarding the human remains of other ethnic groups, specific laws or procedures have not been established. However, the National Park Service policies and the Parks Canada directive are written generally enough to take account of all human remains, not only those related to modern Indian tribes. These policies, while in effect only within the boundaries of National Park Service and Parks Canada units, may serve as examples for situations outside of these specific jurisdictions.

Policies and guidance regarding museum display of human remains from archaeological contexts

In the United States and Canada, there are no national laws that deal with issues related to the museum display or exhibition of human remains. This topic has been addressed by some individual public agencies and museums in their own policies because of concerns expressed by representatives of descendent groups. These expressions have come mainly from Native Americans and certainly are consistent with the range of concerns that have received more attention due to the legal requirements established in the United States by NAGPRA. As with the research policies summarized in the last section, policies about display are often written generally enough to cover human remains of other ethnic groups in addition to Native Americans.

In the United States, the National Park Service has written policies on the display of human remains in exhibits at park units. The policy that covers both Native American and other human remains states that

'Native American human remains and photographs of such remains will not be exhibited. Drawings, renderings, or casts of such remains may be exhibited with the consent of culturally affiliated Indian tribes The exhibit of non-Native American human remains, or photographs, drawings, renderings, or cast of such remains, is allowed in consultation with traditionally associated peoples.'[32]

This policy was developed taking into account strong and consistent statements by representatives of Indian tribes and other Native Americans with whom NPS officials have consulted. The policy permits the use of illustrations of Native American human remains, such as drawings, casts, or other renderings in displays and exhibits with the consent of culturally affiliated Indian tribes or lineal descendents. The display of photos of non-Native American human remains showing skeletons, as well as other kinds of illustrations is allowed, however consultation with traditionally associated groups must occur before any decision is made on such display.

Among other public agencies in North America whose policies were reviewed for this article, the Parks Canada directive addresses the display of remains only generally because its focus is on the investigation and repatriation of human remains.[33] One of the general principles of the directive provides guidance on the matter of display, noting that

'Parks Canada will not display human remains to the

[22] Parks Canada, (2000), *Management Directive 2.3.1, Human Remains, Cemeteries and Burial Grounds (File: C-8412)*, Archaeological Services Branch, National Historic Sites Directorate, Parks Canada, Ottawa

[23] *Ibid* p 10

[24] *Ibid* p 14

[25] University of Illinois at Urbana-Champaign, (2001), *Policy for the Acquisition, Treatment, and Disposition of Human Remains and Funerary Objects of United States Origin by the Department of Anthropology*, University of Illinois at Urbana-Champaign, www.anthro.uiuc.edu/LOA/policynahr.html, accessed 25 October 2004

[26] Florida Museum of Natural History, (2004), *Policies for Use of FLMNH Human Osteological Collections*, Museum of Natural History, University of Florida, Gainesville, www.flmnh.ufl.edu/flmnh/osteology.html, accessed 25 October 2004

[27] University of California, (2001), 'Policy and Procedures of Curation and Repatriation of Human Remains and Cultural Items, Office of the President, University of California, Oakland, accessed 25 October 2004

[38] Flynn, Gillian, (1998), *Annual Report on Repatriation Activities at the National Museum of Natural History, June 1997 to June 1998*, Repatriation Office, Department of Anthropology, National Museum of Natural History, Smithsonian Institution, Washington DC, www.nmnh.si.edu/anthro/repatriation, accessed 28 February 2005

[29] *Ibid* Smithsonian Directive 600, (1999), *Collections Management*, Smithsonian Institution, Washington DC

[30] Personal communication, F P McManamon and David Hurst Thomas, Curator, American Museum of Natural History, 24 October 2004

[31] Personal communication, F P McManamon and Jonathan Haas, MacAuthur Curator of the Americas, Field Museum, 24 Oct 2004

[32] National Park Service (2001), *Management Policies 2001*, Section 5.3.4, 'Stewardship of Human Remains and Burials – Display', National Park Service, Washington, DC

[33] Park Canada, (2000), *Management Directive 2.3.1, Human Remains, Cemeteries, and Burial Grounds (File: C-8412)*, Archaeological Services Branch, National Historic Sites Directorate, Parks Canada, Ottawa *Supra* Note 10

public. However, reproductions or images may be displayed if consent is given by the culturally affiliated group or next of kin.'[34]

In the United States, in addition to the NPS policy summarized above, the Corps of Engineers'[35] policy for cultural resource stewardship prohibits the display of human remains: 'human skeletal remains shall not be placed on display or exhibited for public viewing in any fashion'. This prohibition is not qualified in any manner and covers human remains from any ethnic group. The policy does not address the use of photos or other kinds of illustrations.

The Department of Anthropology, University of Illinois at Urbana-Champaign has a policy that human remains in its collections may be used for educational and teaching purposes with the approval of the head of department. There is no reference to uses for public display or interpretive displays in the policy. Readers also should recall that the overall policy of the department states that North American human remains for which cultural affiliation or lineal descent has been determined may not be added to the collection without permission of the affiliated tribe or lineal descendants.[36] The Florida Museum of Natural History states in its policies that no specimens, casts, or images of osteological specimens shall be used for public display. In addition, that 'images of human skeletal material shall be for research purposes only and such images are not considered appropriate for public exhibition.'[37]

At several major public museums in the United States, the Natural History Museum at the Smithsonian, the American Museum of Natural History in New York, and the Field Museum in Chicago, no formal written policies exist regarding the display of human remains in museum exhibits. Decisions are typically addressed on a case-by-case basis. For example, in the *Vikings in America* exhibit which originated at the Natural History Museum, Smithsonian Institution in 2000 and traveled to the American Museum of Natural History and other museums nationally and internationally, human remains from Greenland were included in the displays of the opening section of the exhibition. In the international exhibition *Crossroads of the Continents*, also developed at the Smithsonian and followed by a multi-nation tour, photos of human burials were used along with artifacts recovered from the burial, but no actual bones.

There is a strong pattern in the existing policies, formal or informal, not to display Native American human remains. These policies result from the consistent and frequent statements by Native American representatives that such pubic display, no matter what positive educational results it might involve, is offensive and hurtful to Indian people. By and large, museum and public agency officials acknowledge these statements and have taken account of them in planning and developing new exhibitions and educational materials. Human remains of individuals from other ethnic groups sometimes are included in displays, but only after careful consideration, possibly including consultation with representatives of the ethnic group concerned, and the determination by curators and educators designing the exhibit that inclusion is required for the planned display to be effective. Overall, it seems that use of human remains in museum exhibits in North America is much less common that it may have been in the past.

Patterns of practice in the study or display of human remains from archaeological contexts

Whether evaluating requests by potential researchers to study museum human remains or considering the possible use of human remains in a new display, many public agency and museum policies in North America include consultation with closely related Indian tribes or other descendent groups. When the human remains involved have been determined to be 'culturally affiliated' with the tribe being consulted, the consent of the tribe often is required. Reliance on this concept of 'cultural affiliation' to determine who will have authority over how the human remains are treated means that the way in which the term is defined and the steps that are used in reaching such determinations are important. The concept has sometimes been extended to establish associations between skeletons of other ethnic groups and modern descendent communities or traditionally associated groups that claim them. The Parks Canada (2000) directive uses a different definition for the term from that used in United States law, basing the relationship

on either religious affiliation, if it can be determined, or geographical proximity in the case of aboriginal burials.

Table 3 is an attempt to outline who is recognized as the 'decision-maker' in current practice when living individuals or the remains of deceased humans from different contexts and chronological placement are involved. The list begins with modern individuals who have legal rights to decide whether or not to submit themselves to medical procedures or scientific investigations. The doctrine requiring that 'informed consent'

Table 3: Treatment decisions based upon degree of affinity and age of remains

Individual/remains of concern	Authority/decision-maker
1. Modern individual	Self, based on informed consent
2. Modern individual, incapacitated	Next-of-kin; designated individual, informed consent
3. Remains of a historically known individual from archaeological context	Lineal descendent: a modern individual tracing his or her ancestry directly and without interruption by means of a traditional kinship system or common-law system of descendance to the historically known individual
4. Remains of an individual from an ancient archaeological context for whom cultural affiliation can be determined	Culturally affiliated modern group
5. Remains of an iIndividual from an ancient archaeological context for whom cultural affiliation cannot be determined	Public agency or museum officials

be obtained from individuals serving as subjects in medical or scientific studies is well established. Similar requirements of informed consent are applied in other kinds of human subject scientific research.[38]

Unless individuals have left explicit written instructions about how they wish to be treated in case they are incapacitated or die unexpectedly, it is generally accepted that the next-of-kin will make decisions about providing or withholding treatment and whether post-mortem investigations are undertaken. For some individuals from historical archaeological contexts, the concept of 'lineal descendent', as defined in United States law by the NAGPRA regulations, might serve as a substitute for next-of-kin in deciding about post-excavation treatment. This hypothetical circumstance is illustrated as category 3 in Table 3.

For individual sets of human remains lacking the historical connections to establish next-of-kin or lineal descendent relationships, 'cultural affiliation,' based upon the concept used in NAGPRA, but more generalized, might be useful for determining who should make decisions regarding treatment.

Another frequently considered topic regarding research on human remains in the collections of pubic agencies or museums is whether or not proposed research involves any destructive techniques such as removing bone for radiocarbon dating, ancient DNA analysis, or other chemical studies, or thin-sectioning human bone. Such techniques require the consumption of a portion of the human remains being studied. Proposals to conduct research that includes destructive techniques typically require an additional level of review before they are approved. In the United States when the request involves Native American human remains for which a positive determination of cultural affiliation has been made, consent by the affiliated tribe

[34] *Ibid* p7

[35] *Op cit* Corps of Engineers, (1996)

[36] *Op cit* University of Illinois at Urbana-Champaign, (2001)

[37] *Op cit* Florida Museum of Natural History, (2004)`

[38] For example, the United States government requires certain procedures for human subject medical and scientific research, as described in 'Protection of Human Subjects', Title 45 of the Code of Federal Regulations, Part 46, Department of Health and Human Services, www.hhs.gov/ohrp/humansubjects/guidance/45cfr46.html, accessed 24 February 2006

would be required. In fact, some public agencies and museums would require tribal consent even for nondestructive research on culturally affiliated Native American human remains, as does the Parks Canada policy directive.

The simple outline illustrated by Table 3 may provide a series of useful categories into which human remains from archaeological contexts can be grouped and for which consistent and standard methods for deciding who should make decisions about their treatment and what kinds of treatments should be allowed can be developed. This simple organizational framework does not delve into questions of how concepts like 'cultural affiliation' will be determined in specific instances, what types of evidence are suitable for making such determinations, or how the evidence is evaluated in terms of reliability, independence, consistency, and credibility. Developing agreed concepts and method is essential. Yet there is much ground to be covered in this area. Readers will recall, for example, that even the term 'cultural affiliation' is used differently in the United States law and Parks Canada policy described in this article.

Agreed concepts and methods are essential for any generalized system and are among the most complex matters in need of resolution. The difficulty of determining group ownership and of evaluating assertions of group ownership of ancient and historical objects or human remains is recognized by experts who have reviewed this topic.

> 'Ethical issues are ... raised when ownership of historical objects is claimed by a group that defines itself by religious affiliation, tribe, or family line. Group consent is extremely complicated because of the elusive nature of cultural property and its ownership. Existing codes provide little guidance regarding the identification of a relevant group and the duties owed.'[39]

In situations for which no individual or affiliated group can claim legitimate authority to determine the treatment of human remains from archaeological contexts, the public authority responsible for the remains, whether a government agency, public museum, or educational organization, might be authorized to do so, as illustrated in category 5 of Table 3.

The laws, regulations, policies, guidelines and procedures developed in North America regarding research on and display of human remains from archaeological contexts provide frameworks for decision-making rather than simple formulas leading to a single 'correct' treatment for sets of remains.

The treatment of human remains often is an emotionally charged topic. Recognition that many of the different goals being put forward are worthwhile may help to reduce the antagonism that can arise in confrontations, and even in discussions. Some of the goals may even be compatible, or at least not conflicting.

One important and worthwhile goal, also part of national public policy in Canada and the United States, is respectful treatment for present-day cultural sensitivities and ancestral human remains. Certainly public concern about how human remains are treated has grown in the last generation. Personal contemporary concerns have been heightened with increased interest in family histories, personal privacy, individual genetic characteristics, and personal records of all sorts.

Another important and worthy public goal is advancing knowledge and providing fuller interpretations and better understanding of the ancient and historical past by analyzing skeletal remains. For over a century, national laws in the United States have been enacted in recognition of this value of archaeological remains. Established national policies and procedures support the scientific and historical study of archaeological sites and their contents, including human skeletal remains. It is important that such studies have as one of their outcomes the provision of broader public access and information about the results of the investigations. Public appreciation of a fuller and improved understanding of the past derived from these studies is necessary at some level for public support for such studies to continue.[40]

In North America, there is an additional challenge for public outreach on this topic. Many North Americans do not recognize the ancient American past and archaeological resources associated with it as a part of their own heritage. If someone does not hold a stake in something, he or she is less likely to be concerned with how it is treated and what happens to it. Yet, if all of us

are Americans now, the remains from America's ancient past are ours to care for and make decisions about.[41]

The web of concerns about how to treat human remains from archaeological contexts, whether one regards them as ancestors, informants, or scientific specimens, must be woven into a fabric that can reconcile all these perspectives. The diversity of culture, knowledge, and talent gives the nations in North America one of their great strengths. The ability to work together, appreciating national commonalities, is a skill that North Americans value and strive to achieve. Overcoming difficulties and reaching mutually satisfactory resolutions in the situations dealt with in this article try the strength and skills of those involved.

[39] Andrews, Lori B, *et al*, (2004), 'Constructing Ethical Guidelines for Biohistory', in *Science* 304:215–16

[40] McManamon, Francis P, (1999), 'The Native American Graves Protection and Repatriation Act and First Americans Research', in *Who Were the First Americans: Proceedings of the 58th Annual Biology colloquium, Oregon State University*, edited by Robson Bonnichsen, Center for the Study of the First Americans, Corvallis, Oregon, pp141–52

[41] McManamon, Francis P, (2003), 'Archaeology, Nationalism, and Ancient America', in *The Politics of Archaeology and Identity in a Global Context*, edited by Susan Kane, Archaeological Institute of America, Boston, Massachusetts, pp115–38

The Scientific Value of Human Remains in Studying the Global History of Health

Richard Steckel, Clark Spencer Larsen, Paul Sciulli & Phillip Walker

A T SOME LEVEL, virtually all researchers are aware of the significant processes of biocultural evolution that gave rise to modern societies over the past 10,000 years. We know that many modern problems have roots reaching deep into the human past, and that current conditions were often created by complex interdependent processes that unfolded over very long periods of time. As a result, the research of many social and medical scientists would benefit greatly from access to a very long-term historical perspective on fundamental issues relating to health and the human condition.[1] Working with numerous collaborators, we have designed a project to create that perspective for an important dimension of the quality of life, chronic morbidity as measured from skeletons. Project researchers will combine the skeletal data with contextual information about sites where people lived for use in reinterpreting the causes and consequences of changing health along the historical path leading to modern societies.

The diversity of human experience, and the corresponding variation in our health, have been enormous since the late Paleolithic era. These profound changes are highlighted by four pivotal transitions in the last ten millennia of human history: (1) the shift from foraging to farming, (2) the rise of cities and complex polities, (3) European expansion and colonization, and (4) industrialization. Each of these global transitions had an enormous impact on health and the human condition. With the rise of farming, the human population became larger and more sedentary, which resulted in crowding and the creation of conditions conducive to the spread and maintenance of infectious diseases.[2] During and following the transition to farming, pathogenic organisms causing highly contagious diseases evolved significantly. The diversity of foods eaten also diminished, eventually resulting in the modern worldwide dependence on a handful of super-crops (maize, wheat, rice) that lack specific nutrients essential for growth and development.[3] Many believe that with the rise of cities, health deteriorated further as a result of crowding, inadequate sanitation, growing inequality, and conflict.[4] Although colonization offered new opportunities for the rapidly growing European population, it also led to the devastating spread of new pathogens to formerly isolated populations in areas such as in North and South America.[5] The spread of measles, smallpox, and other acute infectious diseases resulted in huge population losses throughout the world, not just in the western hemisphere. Finally, the industrial age often brought new health costs, and many workers faced diets inadequate to sustain them in their hard work and heightened exposure to diseases spread at crowded places of work and living.[6]

Physical anthropologists and archaeologists are best equipped to provide the evidence necessary to measure very long-term health changes. Over the past several decades, they have excavated thousands of sites and studied hundreds of thousands of skeletons and their

contexts. Because of its biological basis in the physiological processes of growth, development, and acclimatization to environmental change, the information about interactions with past environments encoded in these human remains provides a valuable comparative basis for evaluating interpretations of the past based on artifacts, documents, and other sources.[7]

These basic sources of information on the lives and living conditions of our ancestors are often accessible, but for various historical, political, and logistic reasons have not been assembled into a truly comprehensive, detailed and coherent mosaic adequately depicting the evolution of health. Our effort will create such a resource for basic health indicators readily obtainable from human skeletal remains. While it builds upon a small project completed for the western hemisphere,[8] the immediate focus is Europe and the Mediterranean and the long-term goal is a global project.

Skeletal measures of health

Human skeletal and dental tissues are highly sensitive to the environment. They provide a storehouse of information on health from conception through adulthood that can be combined with estimates of age and sex to provide detailed individual health histories, and merged to form a valuable picture of community health.[9] For this investigation, we have developed and tested laptop-based software to collect the following commonly accepted general health indicators for each skeleton:

Adult height

Substantial evidence from the study of modern populations reveals that impoverished environments (ie, poor diets, heavy disease loads, and hard work) suppress growth in childhood and, if chronic and severe, substantially reduce final adult stature.[10] A large historical literature based on anthropometric records explores the relationship between height and economic wellbeing.[11] We will greatly expand this research by using established procedures to estimate stature from long bone lengths.[12]

Enamel hypoplasias

Hypoplasias are lines or pits of enamel deficiency commonly found in the teeth (especially incisors and canines) of people whose childhood was biologically stressful. They are caused by disruption to the cells (ameloblasts) that form the enamel. The disruption is usually environmental, due to poor nutrition, infectious disease, or a combination thereof. Although non-specific, hypoplasias

[1] Coatsworth, J H, (1996), 'Welfare', in *The American Historical Review 101*, pp1–12; Cordain, L, (1999), 'Cereal Grains: Humanity's double-edged sword', in *World Review of Nutrition and Dietetics 84*: pp19–73; Eaton, S B, and Eaton, III SB, (1997), 'Paleolithic nutrition revisited: A twelve-year retrospective on its nature and implications', in *European Journal of Clinical Nutrition 51*, 207–16; Eaton, S B, Konner, M, and Shostak, M, (1988), 'Stone agers in the fast lane: Chronic degenerative diseases in evolutionary perspective', in *The American Journal of Medicine 84*: 739–49; Popkin, B M, (1998), 'The nutrition transition and its health implications in lower-income countries', in *Public Health Nutrition 1*, pp5–21

[2] Cohen, M N, (1989), *Health and the Rise of Civilization*, Yale University Press, New Haven; Cohen, M N, and Armelagos, G J, (1984), *Paleopathology at the Origins of Agriculture*, Academic Press, New York; Larsen, C S, (1995), 'Biological changes in human populations with agriculture' *Annual Review of Anthropology 24*, pp185–213; Smith, B D, (1995), *The Emergence of Agriculture* Scientific American Library, New York

[3] Cordain, L, (1999) *op cit*

[4] Cartwright, F F, (1972), *Disease and History*, Crowell, New York; Cohen, M N, (1989) *op cit*

[5] Cook, N D, (1998), *Born to Die: Disease and new world conquest 1492–1650*, Cambridge University Press, New York; Crosby, A W, (1972), *The Columbian Exchange: Biological and cultural consequences of 1492*, Greenwood Publishing, Westport, Connecticut; Kiple, K F, and Beck, S V, (eds), (1997), *Biological Consequences of the European Expansion 1450–1800*, Ashgate, Aldershot, Hampshire, Great Britain/ Variorum, Brookfield, Vermont, USA; Larsen, C S, (1994), 'In the wake of Columbus: Native population biology in the post-contact Americas', in *Yearbook of Physical Anthropology 37* pp109–54; Merbs, C F, (1992), 'New world of infectious disease' in *Yearbook of Physical Anthropology 35* pp3–42; Verano, J W, and Ubelaker, Douglas H, (eds), (1992), *Disease and Demography in the Americas*, Smithsonian Institution Press, Washington

[6] Steckel, R H, and Floud, R, (eds), (1997), *Health and Welfare during Industrialization*, University of Chicago Press, Chicago, Illinois

[7] Walker, P L, (2000), 'Bioarchaeological ethics: a historical perspective on the value of human remains', in Katzenberg, M A, and Saunders, S R, (eds), *Biological Anthropology of the Human Skeleton*, Wiley, New York, pp 3–39

[8] Steckel, R H, and Rose, J C, (eds), (2002), *The Backbone of History: Health and nutrition in the western hemisphere*, Cambridge University Press, New York

[9] Larsen, C S, (1997), *Bioarchaeology: Interpreting behavior from the human skeleton*, Cambridge University Press, New York

[10] Eveleth, P B, and Tanner, J M, (1990), *Worldwide Variation in Human Growth*, Cambridge University Press, Cambridge

[11] Floud, R, Wachter, K, and Gregory, A, (1990), *Height, Health and History: Nutritional status in the United Kingdom 1750–1980*, Cambridge University Press, Cambridge; Komlos, J, (1989), *Nutrition and Economic Development in the Eighteenth-century Habsburg Monarchy: An anthropometric history*, Princeton University Press, Princeton; Steckel, R H, (1995), 'Stature and the standard of living', in *Journal of Economic Literature*, December 33, pp1903–40; Steckel, R H, and Floud, R, (1997) *op cit*

[12] Krogman, W M, and Iscan, M Y, (1986), *The Human Skeleton in Forensic Medicine*, C C Thomas, Springfield, Illinois; Sciulli, P W, Mahaney, M C, and Schneider, K N, (1990), 'Stature estimation in prehistoric Native Americans of Ohio', in *American Journal of Physical Anthropology 83*, pp275–80

have proven enormously informative about physiological stress in childhood in archaeological settings.[13]

Evidence of iron deficiency anaemia

Iron is essential for many body functions, such as oxygen transport to the body's tissues. In circumstances where iron is deficient – owing to nutritional deprivation, low bodyweight, chronic diarrhea, parasite infection, and other factors – the body attempts to compensate by increasing red blood cell production.[14] The skeletal manifestations of childhood anaemia appear in those areas where red blood cell production occurs, such as in the flat bones of the cranium. The associated pathological conditions are sieve-like lesions called porotic hyperostosis and cribra orbitalia for the cranial vault and eye orbits respectively. In infancy and childhood, iron deficiency anaemia is associated with impaired growth and delays in behavioural and cognitive development. In adulthood, the condition is associated with limited work capacity and physical activity.[15] We are aware that not all examples of porotic hyperostosis and cribra orbitalia are indicators of anaemia.[16]

Trauma

Fractures, weapon wounds and other skeletal injuries provide a record of accidents or violence. Accidents such as ankle fractures reflect difficulty of terrain and the hazards of specific occupations. Injuries caused by violence, such as weapon wounds or parry fractures of the forearm, provide a barometer of domestic strife, social unrest and warfare.[17]

Infectious disease

Skeletal lesions of infectious origin, which commonly appear on the major long bones, have been documented worldwide. Most of these lesions are found as plaque-like deposits from periosteal inflammation, swollen shafts, and irregular elevations on bone surfaces.[18] Most are nonspecific (the circumstances causing the infection cannot be determined) but they often originate with *Staphylococcus* or *Streptococcus* organisms. These lesions in archaeological skeletons have proven very informative about patterns and levels of community health.[19]

Dental health

Dental health is an important indicator both of oral and of general health. The most accessible dental health indices in archaeological skeletons are carious lesions and ante mortem tooth loss.[20] The former result from a disease process characterized by the focal demineralization of dental hard tissues by organic acids produced by bacterial fermentation of dietary carbohydrates, especially sugars. In the modern era, the introduction and general availability of refined sugar caused a huge increase in dental decay. In the more distant past, the adoption of agriculture led to a general decline in dental health, especially from the introduction of maize. The agricultural shift and the later use of increasingly refined foods have resulted in an increase in periodontal disease, caries, and tooth loss. The patterns of tooth decay and linkages with dietary and lifestyle changes have been studied in the western hemisphere but few have examined the timing and scope of regional differences elsewhere.

Degenerative joint disease

Degenerative joint disease (DJD) is frequently observed in archaeological skeletal remains. The condition commonly results from mechanical wear and tear on the joints of the skeleton due to physical activity.[21] Generally speaking, populations engaged in physically demanding activities have more skeletal manifestations of the disease (especially build-up of bone along joint margins and deterioration of bone on articular joint surfaces) than populations that are relatively sedentary. Studies of DJD have been valuable in documenting levels and patterns of activity in past populations.[22]

Robusticity

Skeletal robusticity refers to the general size and morphology of skeletal elements.[23] It is well known that bones are highly sensitive to mechanical stimuli, especially with regard to the ability of bones to adjust their size and shape in response to external forces. For example, foragers tend to be highly mobile, leading to

elongated or oval femoral midsections, whereas farmers are more sedentary and have circular midsections.[24] These and other morphological differences reveal much about habitual patterns of physical activity and behavioural change over time.[25]

Specific infections

Tuberculosis, leprosy, scurvy, rickets, and treponemal infections (for example syphilis) are examples of diseases that often leave significant evidence on the skeleton.[26] As these were major European diseases over past millennia, we will record their presence or absence.

Age and sex

The human skeleton exhibits many different age-related changes.[27] Juvenile age-at-death is best estimated from dental development. The extent of long bone epiphysis fusion is also a valuable age indicator for older juveniles. Adult age-at-death is typically determined based on assessments of data on a variety of age-related changes. Pubic symphyseal development is one of the more reliable age indicators for people between 18 and 50. Although they show considerable individual variation, cranial suture closure patterns can also prove useful for aging older adults. Tooth wear exhibits a regular increase with increasing age.

Data collection

In June of 2001, we organized a planning meeting at Ohio State University to inventory skeletal remains, discuss coding procedures, and consider administrative matters. The 16 physical anthropologists who attended from Europe reported personal access to over 130,000 skeletons at museums where they worked or conducted research. Their names and affiliations are given in Table 1.

This inventory is described in Table 2 and has since grown by involving additional collaborators who bring the total to more than one million skeletons located in 23 countries: Austria, Czech Republic, Denmark, France, Germany, Greece, Hungary, Italy, Iceland, Lithuania, Netherlands, Norway, Poland, Portugal, Republic of Ireland, Romania, Russia, Spain, Sweden, Switzerland,

Turkey, Ukraine, and the United Kingdom. Moreover, as publicity efforts have unfolded over the past year, we foresee expansion to additional collaborators and countries. The project has received seed funding and some financial support for data collection from the National Science Foundation (grants SES-0138129 and BCS-0527658), but we are seeking additional assistance.

The collections included in Table 2 are chronologically diverse and encompass a broad spectrum of ecological and socioeconomic conditions across more than 650 localities. While we have not gathered detailed information on all these collections, we can make some

[13] Goodman, A H, and Rose, J C, (1991), 'Dental enamel hypoplasias as indicators of nutritional status', in Kelley, M A, and Larsen, C S, (eds), *Advances in Dental Anthropology*, Wiley-Liss, New York, pp279–93; Hillson, S, (1996), *Dental Anthropology*, Cambridge University Press, Cambridge

[14] Walker, P L, (1986), 'Porotic hyperostosis in a marine-dependent California Indian population', in *American Journal of Physical Anthropology 69*, pp345–54

[15] Scrimshaw, N S, (1991), 'Iron deficiency', in *Scientific American 265*, pp46–52

[16] Schultz, M, (1982), 'Krankheit und Umwelt des vor-und frühgeschichtlichen Menschen', in Wendt, H, and Loacker, N, (eds), *Kindlers Enzyklopädie der Mensch*, Kindler Verlag, Zürich, pp259–312; Schultz, M, (1993), 'The initial stages of systematic bone disease', in Grupe, G, and Garland, A N, (eds), *Histology of Ancient Human Bone: Methods and diagnosis; proceedings of the palaeohistology workshop held from 3–5 October 1990 at Gottingen, Berlin*, Springer-Verlag, New York, pp185–203

[17] Martin, D L, and Frayer, D W, (eds), (1997), *Troubled Times: Violence and warfare in the past* Gordon and Breach, Australia; Walker, P L, (1989), 'Cranial injuries as evidence of violence in prehistoric southern California', in *American Journal of Physical Anthropology 80*, 313–23; Walker, P L, (2001), 'A bioarchaeological perspective on the history of violence', in *Annual Review of Anthropology 30*, pp573–96

[18] Ortner, D J, and Putschar, W G J, (1985), *Identification of Pathological Conditions in Human Skeletal Remains*, Smithsonian Institution Press, City of Washington

[19] Larsen, C S, (1997) *op cit*; Ortner, D J, and Putschar, W G J, (1985) *op cit*

[20] *Ibid*

[21] Hough, A J, and Sokoloff, L, (1989), 'Pathology of osteoarthritis', in McCarty, D J, and Koopman, W J, (eds), *Arthritis and Allied Conditions*, Lea & Febiger, Philadelphia, pp1571–94

[22] Larsen, C S, (1997) *op cit*

[23] Ruff, C B, (2000), 'Biomechanical analyses of archaeological human skeletons', in Katzenberg, M A, and Saunders, S R, (eds), *Biological Anthropology of the Human Skeleton*, Wiley, New York, pp71–102

[24] *Ibid*

[25] Bridges, P S, (1995), 'Skeletal biology and behavior in ancient humans' in *Evolutionary Anthropology 4* pp112–20; Larsen, C S, (1997) *op cit*; Ruff, C B, Walker, A, Larsen, C S, and Trinkaus, E, (1993), 'Postcranial robusticity in homo I: temporal trends and mechanical interpretation' in *American Journal of Physical Anthropology 91* pp21–53

[26] Larsen, C S, (1997) *op cit*; White, T D, (2000), *Human Osteology*, Academic Press, San Diego

[27] Bass, W M, (1995), *Human Osteology: A laboratory and field manual*, Missouri Archaeological Society, Columbia, Missouri; Konigsberg, L W, and Hens, S M, (1998), 'Use of ordinal categorical variables in skeletal assessment of sex from the cranium', in *American Journal of Physical Anthropology 107*, pp97–112; Stewart, T D, (1979), *Essentials of Forensic Anthropology, Especially as Developed in the United States*, Thomas, Springfield, Illinois; Ubelaker, D H, (1989), *Human Skeletal Remains: Excavation, analysis, interpretation*, Taraxacum, Washington; White, T D, (2000) *op cit*

Table 1: European participants at the first organizational conference

Name	Country	Department	Affiliation
Pia Bennike	Denmark	Biological Anthropology	Panum Institute
Joël Blondiaux	France		Centre d'Etudes Paleopathologiques du Nord
Miguel C Botella	Spain	Facultad de Medicina	University of Granada
Yuri K Chistov	Russia	Physical Anthropology	Museum of Anthropology & Ethnography
Alfredo Coppa	Italy	Antropologia	La Sapienza University of Rome
Eugénia Cunha	Portugal	Antropologia	Universidade de Coimbra
Ebba During	Sweden	Archaeology	Stockholm University
Per Holck	Norway	Anatomical Institute	University of Oslo
Rimas Jankauskas	Lithuania	Anatomy, Histology and Anthropology	Vilnius University
Antonia Marcsik	Hungary	Anthropology	University of Szeged
George Maat	Netherlands	Anatomy	University of Leiden
Anastasia Papathanasiou	Greece		Greek Ministry of Culture
Inna Potiekhina	Ukraine	Institute of Archaeology	National Academy of Sciences
Charlotte Roberts	United Kingdom	Archaeology	University of Durham
Michael Schultz	Germany	Zentrum Anatomie	University of Göttingen
Maria Teschler-Nicola	Austria	Archaeology, Biology and Anthropology	Natural History Museum, Vienna

Table 2: Distribution of skeletons by region and historical period

	Scandinavia	Western Europe	Southern Europe	Central Europe	Eastern Europe	Total	%
Post-medieval	1,476	7,829	360	0	4,729	14,394	10.9
Late medieval	14,025	24,344	2,240	229	2,354	43,192	32.8
Early medieval	4,201	20,174	1,740	2,623	9,330	38,068	28.9
Roman	0	8,657	2,125	591	1,399	12,772	9.7
Iron Age	12	514	5,111	500	2,462	8,599	6.5
Bronze Age	81	48	4,063	4,258	1,842	10,292	7.8
Neolithic	540	279	1,922	635	370	3,746	2.8
Mesolithic	90	0	121	0	288	499	0.4
Total	20,425	61,845	17,682	8,836	22,774	131,562	99.8
%	15.5	47.0	13.4	6.7	17.3	99.9	

general statements. Although their numbers are relatively small in comparison to later periods, the inventory includes many of the key collections that document the transition from hunting and gathering to agriculture in Europe. The rise of cities and complex polities and the effects of European expansion, colonization, and industrialization are especially well documented, with nearly 120,000 individuals available from sites used during the last two millennia. Materials from the medieval period onward are especially abundant, and when combined with the greater historical documentation of this era, these sources provide considerable potential for a refined analysis of the possible causes and consequences of health changes.

As learned from the western hemisphere project, diversity in the database is an important asset for study of determinants of health. We will achieve this through stratified sampling by categories that were found relevant in that project: time period, settlement size, geographic location, subsistence pathways, technology, elevation, vegetation and topography. Our project participants who know the collections within each country will prioritize recommendations, considering trade-offs relevant to cost-effectiveness of data collection efforts. Their suggestions will then enter our calculus for achieving diversity in environmental characteristics of the sample.

Graduate students will use laptops to collect the skeletal data under the supervision of senior researchers as part of their thesis or dissertation. They will keep a personal journal of cases that indicates the date, time and museum code number of each. In addition they may use, but the codebook does not require, photography to illustrate lesions for later analysis, which accommodates researchers who have interests not easily condensed into metric information or who utilize variables for which categorization is best done after examining a large number of cases. The personal journal helps researches to keep track of the disposition of cases and related information (such as photos), thereby preventing duplicates in the database.

Time since death

^{14}C, the heavy (radioactive) unstable isotope of carbon, is created in the atmosphere when cosmic radiation bombards ^{14}N atoms. The ^{14}C, along with ^{12}C, is ingested by plants as they metabolize CO_2 during photosynthesis. Animals (including humans) acquire the ^{14}C and ^{12}C in the same proportion as the plants they are eating. Once the organism dies, the ^{14}C atoms begin to decay. The ratio of the ^{14}C to ^{12}C identifies the age of the bone, or any other organic material. The dating method is used frequently in Europe for collections without historical documentation or chronologically diagnostic artifacts.

Dietary reconstruction

Much can be learned about diets by examining chemical isotopes extracted from small samples of bone for a few individuals who lived at each site. Isotopes of carbon and nitrogen can identify consumption of key domesticates, marine foods (fish and shellfish), and meat.[28]

Assessing environmental context

Economics, physical anthropology, archaeology, history, climate history, and geography are mature fields of study that are poorly integrated even though all involve or can involve study of the past. Among these, the closest links are traditionally found between physical anthropology and archaeology, which involve the study of artifacts such as pottery, tools, weapons, and coins, and their relationships to places of residence, work, travel, and so forth. Increasingly, archaeology is used to inform history, particularly in settings that lack written documentation. Climate history sometimes overlaps with research in traditional history, but most graduate history programs consider the field a minor specialty.[29] Geography in the form of geographic information system (GIS) databases and techniques is important in archaeology and its presence is increasingly felt in physical anthropology and history.[30] This project is unusual in the high degree to which

[28] Larsen, C S, (1997) *op cit*

[29] Lamb, H H, (1995), *Climate, History and the Modern World*, Routledge, New York; Rotberg, R I, and Rabb, T K, (1981), *Climate and History: Studies in interdisciplinary history*, Princeton University Press, Princeton; Wefer, G, (2002), *Climate Development and History of the North Atlantic Realm*, Springer, Berlin

knowledge from all of these fields is combined in the study of health.

Supplementing GIS is a considerable archaeological record for all eight of the major temporal periods covered in this project (Mesolithic, Neolithic, Bronze Age, Iron Age, Roman, Early medieval, Late medieval, Post-medieval). The historical record becomes substantially useful in the medieval period. Three key themes emerge from these records, namely (1) adoption and increased focus on farming as a means of acquiring food; (2) population expansion and movement; and (3) increase in social inequality. Especially critical for interpreting health is the impact of farming, which originally derived from the Middle East, and spread east to west.[31] A range of domesticated plants was cultivated, but wheat, barley, millet, and rye were key foods, fuelling local economies. Around five millennia ago, farming within Europe was acquired last in Scandinavia and Britain.[32] Agriculture laid the essential economic foundation for the appearance of villages, some of which eventually grew into cities. Analysis of burials from the Neolithic onward shows growing stratification and associated inequality.[33]

Climatologists have devised numerous ways to measure climate and its variability in the past from sources such as ice cores, tree rings, marine sediments, and pollen analysis.[34] Thompson et al discuss sudden adverse climate events such as occurred approximately 5,200 years ago, when Otzi the Ice Man froze in the Austrian Alps. Direct quantitative measures for some climate variables, such as temperature, are quite recent relative to the chronological span of this project, but models have been developed to estimate many of them. The issue is whether the output of these models is sufficiently accurate to warrant use as explanatory variables. Our climate advisor (Lonnie Thompson) indicates that, at a minimum, categorical variables can be estimated for temperature and precipitation. Tree rings and lake sediments, which extend back as much as 11,000 years for some parts of Europe, are proxies for annual variability in weather.

Coding data on the environmental context

It is a challenging but manageable task to construct consistent and useful measures of the environment in which people lived over the millennia. Our collaborators from Europe and the Mediterranean will be invaluable in providing expertise for this activity.

Settlement size: This aspect of life will be measured on a categorical scale in efforts directed by key personnel in archaeology (Phillip Walker) and history (John Brooke). Following procedures used in the western hemisphere project, and in consultation with the lead researcher for each site and other scholars consulted as needed, they will assign each site into mobile (hunter-gatherer), settled but dispersed, village, small town, or city.

Technology and material culture: Given the diverse evidence on technology, material culture and other aspects of life in the distant past that archaeologists have assembled, the field has developed a methodology for categorizing information[35] that indicates the material standard of living. The technology is an indirect measure of material living, which indicates types of products that could be produced and the scale on which they may have been distributed. We will utilize this methodology to classify technology and material culture into categories of tools, power sources, and housing. With regard to tools, five categories are readily known from archaeological and historical sources: stone, copper, bronze, iron, and steel. Over the past ten millennia (up to the late 19th century) societies have used five major sources of power: human, draft animal, water, wind, and steam. Archaeologists can readily classify housing into two types, temporary and permanent, and within the latter by type of construction: stone versus wood foundations and whether floors and walls were finished or unfinished.

Interregional trade: Archaeologists know that only very simple and inevitably rough classifications are available for this category. As with the material culture, we will use the transportation technology as an indirect measure that crudely indicates the cost of transporting products. Our categories are: backpack; wheeled carts; draft animals; lake or river boat; coastal vessel; ocean vessel (reliably able to travel beyond the sight of land). We can also obtain some notion of the types of products that were traded and the distances over which they were delivered in the prehistoric past. Unfortunately, archaeological evidence on products is heavily skewed

toward those of high value in relation to weight such as stone used for tools, shells, beads and so forth. However, some shipping containers survive which indicate the types of products, such as grain, wine or oil, that were exchanged in trade. The recoverable record is far more elaborate for the historical era with shipping manifests indicating the types and amounts of products that were transported. Trade may have acted as a double-edged sword for health by increasing the quantity and diversity of products for consumption while also exposing populations to new pathogens.

Literacy: Numerous modern studies point to the relevance of education for health, and for lack of information on years of schooling, historical studies often use literacy as a crude proxy. At first glance it may seem to be an almost impossible challenge to estimate literacy rates over the millennia. But for most of the time span in this study, we are confident of the result: zero. In fact among historical populations up to the era of relatively cheap printing that began in the late 1400s, literacy rates were undoubtedly low as evident from the few people who had access to writing instruments and materials or possessed private libraries. In ancient Greece and Rome – environments in which literacy rates were probably highest before the 15th century – there is little evidence for a publishing industry, and the share literate was low among women and among the unskilled,[36] implying quite low levels overall. Because professionals and some artisans possessed the skill in the ancient (and later) world, contextual information about the burial sites is important in making approximate assessments. The share literate rose with the Protestant reformation, which obliged the faithful to read the Bible. From the 16th century onwards we can estimate literacy rates from signatures on marriage registers, and by the late 1700s some governments in Europe published data on the subject. With contextual information we expect to classify literacy rates (r) into 6 groups: zero and quantiles that range from $0 < r \leq 20$ on up to $80 < r$.

Socio-economic inequality: We rely on several indicators of inequality, beginning with the presence or absence of monumental architecture, which would have required enormous physical effort of workers within a stratified society. Second, we will measure the frequency of housing styles, whether communal such as

long houses or private, that could have enclosed and protected private property. Third, we will assess the presence or absence of slave labour. Fourth, there is a well-developed methodology for using material artifacts to assess social status,[37] from which we will design a template or set of standards. Note that we will prepare a relative scale within the sample of 120 localities based on benchmarks created from several examples within each category, drawing from sites and localities that have exceptionally good contextual information. Ultimately, it is a judgment call to assign a particular site to a category, but it will be an informed judgment made before any data on health are examined for the locality. Moreover, all relevant information collected for each site, such as descriptions of artifacts and historical documents

30 Aldenderfer, M S, and Maschner, H D G, (1996), *Anthropology, Space, and Geographic Information Systems*, Oxford University Press, New York; Lock, G R, and Stancic, Z, (1995), *Archaeology and Geographical Information Systems: A European perspective*, Taylor & Francis, London

31 Milisauskas, S, (2002), 'Early Neolithic: The first farmers in Europe, 7000–5500/5000 BC' in Milisauskas, S, (ed), (2002), *European Prehistory: A survey*, Kluwer Academic/Plenum Publishers, New York, pp143–92; Sherratt, A, (1980), 'Early Agricultural Communities in Europe' in *Encyclopedia of Archaeology*, Cambridge University Press, Cambridge, pp144–51

32 Richards, M P, Price, T D, and Koch, E, (2003a), 'Mesolithic and Neolithic subsistence in Denmark: New stable isotope data', in *Current Anthropology, Special Issue: Divergences and commonalities within taxonomic and political orders 44*, pp288–95; Richards, M P, Schulting, R J, and Hedges, R E M, (2003b), 'Archaeology: Sharp shift in diet at onset of Neolithic' in *Nature 425*, p366

33 Milisauskas, S, and Kruk, J, (2002), 'Late Neolithic: Crises, collapse, new ideologies, and economies 3500/3000–2200/2000 BC' in Milisauskas, S, (ed) *op cit* pp247–69

34 Baillie, M G L, and Brown, D M, (2002), 'Oak dendrochronology: Some recent archaeological developments from an Irish perspective' in *Antiquity 76* pp497–505; Bradley, R S, (1999), *Paleoclimatology: Reconstructing climates of the quaternary*, Harpcourt Academic Press, San Diego, California; Frenzel, B, Pfister, C, and Gläser, B, (1992), *European Climate Reconstructed from Documentary Data: Methods and results*, G Fischer, Stuttgart; Magny, M, Guiot, J, and Schoellammer, P, (2001), 'Quantitative reconstruction of younger dryas to mid-Holocene paleoclimates at le Locle, Swiss Jura, using pollen and lake-level data' in *Quaternary Research 56*, pp170–80; Thompson, L G, Mosley-Thompson, E, Brecher, H, Davis, M, Leon, B, Les, D, Lin, P-N, Mashiotta, T, and Mountain, K, (2004), *Abrupt Holocene Climate Change in the Tropics*, Ohio State University, Columbus, Ohio

35 Abrams, E M, (1994), *How the Maya Built their World: Energetics and ancient architecture*, University of Texas Press, Austin; Chang, K C, (1968), *Settlement Archaeology*, National Press Books, Palo Alto; Fagan, B M, (2003), *Archaeology: A brief introduction*, Prentice Hall, Upper Saddle River, New Jersey; Feinman, G M, and Nicholas, L M, (2004), *Archaeological Perspectives on Political Economies*, University of Utah Press, Salt Lake City; Whallon, R, and Brown, J A, (1982), *Essays on Archaeological Typology*, Center for American Archeology, Press Evanston, Illinois

36 Beard, M, (1991), 'Literacy in the Roman world', in *Journal of Roman Archaeology*, Ann Arbor, Michigan; Harris, W V, (1989), *Ancient Literacy*, Harvard University Press, Cambridge, Massachusetts

37 Chapman, R, Kinnes, I, and Randsborg, K, (1981), (eds), *The Archaeology of Death*, Cambridge University Press, Cambridge; McGuire, R H, and Paynter, R, (1991), *The Archaeology of Inequality*, B Blackwell, Cambridge, Massachusetts

upon which judgments are based, will be available for inspection, comment or recalibration according to any scheme future researchers may wish to construct.

Climate: Under the guidance of the project climate specialist, a post-doctoral student in climate history will assemble evidence for each locality in the project. Climate will be constructed as a categorical variable for two components (temperature and precipitation) of five parts. Variability in climate will be represented by the annual variance in tree-ring width and from pollen in lake sediments at or near the locality. We will also construct a dummy variable for a sudden, catastrophic natural event (earthquake, volcano, rapid change in climate and so forth).

Analysis

For over a century scholars have debated the impact of the natural environment on social performance. They have observed that tropical countries languished in economic development and suffered high mortality rates relative to countries located in temperate zones. These casual observations became more clearly delineated with the arrival of national income accounts, vital registration systems and indirect demographic estimation techniques of the post-World War II era.

One line of explanation emphasizes the natural environment. A century ago scholars believed that the stultifying heat and humidity of the tropics sapped people's physical and creative energy while bathing them in parasites and pathogens. Among geographers, Ellsworth Huntington[38] vigorously pursued the connection between the natural environment and human activity. By the 1950s and 1960s, economists and other social scientists were abandoning geographic explanations in favour of human interventions such as technological change, human capital (both education and health) and institutions for understanding social performance. These ideas ascended when economic history emerged as a sub-discipline and its followers have largely viewed economic growth through these lenses.[39]

Recently, economists have renewed the debate over the natural environment's contribution to social performance. Several papers with collaborators demonstrate connections between GDP per capita and life expectancy with geographic or ecological variables such as climate, disease ecology and distance from the coast.[40] While acknowledging its relevance, other researchers[41] have claimed that geography operates predominantly through choice of institutions. In painting with a broad brush to interpret human performance around the globe and over the millennia, Jared Diamond[42] endorses climate and geography as important prime movers of economic and demographic success. Steckel and Rose[43] found that skeletal health was not systematically related to climate, conceding that it may have been poorly measured, but report that other aspects of the physical environment were important, including topography, elevation, vegetation, and subsistence pathways. It remains to be seen whether these variables, debated by scholars for relevance in both the modern and historical eras, were important for health in Europe and the Mediterranean over the past ten millennia.

Although study of the evidence will begin with exploratory data analysis, we will be testing specific hypotheses that arise from the literature about environmental effects on health. First we will summarize chronic morbidity at each site using a new methodological tool called the health index.[44] Then, we will test hypotheses by estimating the regression model:

$$HI = \beta_0 + \beta_1 P + \beta_2 C + \beta_3 S + \varepsilon$$

where HI denotes the health index for a particular site or locality, P is a vector of characteristics of the physical environment in which they lived, C is a vector of climate characteristics of the localities, S is a vector of measures of the social environment within the locality, and ε is an error term. P incorporates measures used by advocates in current debates, including (a) distance of the locality from the coast; (b) elevation; (c) vegetation; and (d) topography. C includes categorical variables for two attributes of climate (temperature and precipitation) and a measure of annual variability of climate within that zone. In testing the null hypotheses about the impact of the physical environment, it is important to control for social factors known to affect health. In our procedures, S is composed of categorical variables for settlement size, the material standard of living, technologies in use, inter-regional trade, literacy, the degree of socio-economic

inequality for the burials at the locality, and food-group components in the diet. We will estimate the model, and test corresponding hypotheses, for each of the eight components of the health index, discussed above in the section on skeletal measures of health.

The two major research elements of the larger project – description and exploratory data analysis, plus results from tests of specific hypotheses about environmental influences on health – will be combined in an edited volume. Among our collaborators, experts in each area will take the lead in preparing individual chapters, and the graduate students who collected the skeletal data and helped in preparing the environmental context are expected to become research partners and co-authors. In preliminary conversations, editors from Cambridge University Press have expressed an interest in publishing such a book, as they did for the western hemisphere project. Upon publication, all data collected in the project will be released to the general public.

The book will begin with an introduction that sets forth the issues at stake and then provide a brief summary of how the book will address them. The next two sections will review the literature on health-ecology relationships in the present and the past. We will prepare a large chapter on data and methods for a general audience such that any college graduate well trained in the social sciences could grasp the approach. We will keep technical terms to a minimum and explain concepts involved in skeletal lesions, biochemical analysis, GIS and so forth. To help readers understand the meaning of the health index in archaeological contexts, which were generally harsh by modern standards, we will use information in health interview surveys from developed and developing countries to estimate the health index. Comparisons will help the audience calibrate or scale morbidity in the distant past relative to modern times.

Broader impacts

Astronomy has been greatly invigorated by newly deployed telescopes, which allow observers to peer deep into space, gathering light emitted from vast distances and recording events early in the history of the universe. In a similar but smaller way, skeletons and related artifacts can be powerful for the medical and social sciences,

allowing observers to measure and analyze important aspects of health deep into human history, before the dawn of civilization. Neither astronomy nor bioarchaeology is an experimental science; both operate within the confines of observational evidence from which the intellectually curious can nevertheless learn much about astronomical or human origins and evolution.

This project offers a new and exciting way of collecting and analyzing large data sets in anthropology, climate history and GIS and using them for research in the social and medical sciences to build an understanding of the very-long-term history of human health. One long-term benefit will be a substantial heritage of human capital or expertise, which will lay the foundation for a new approach to studying health, in the form of training for physical anthropologists in broader questions and methods of the social sciences; education of many social and medical scientists in methods of physical anthropology and the uses of skeletal data; and ties among an international network of scholars committed to studying the global evolution of health.

The project will create numerous research opportunities beyond that of the immediate effort on ecology and health, which we will pursue first among the

[38] Huntington, E, (1945), *Mainsprings of Civilization*, J Wiley, New York

[39] See, for example, Landes, D S, (1969), *The Unbound Prometheus: Technological change and industrial development in western Europe from 1750 to the present*, Cambridge University Press, Cambridge; Mokyr, J, (1990), *The Lever of Riches: Technological creativity and economic progress*, Oxford University Press, New York

[40] Gallup, J L, and Sachs, J D, (2001), 'The economic burden of malaria', in *The American Journal of Tropical Medicine and Hygiene 64*, pp85–96; Mellinger, A D, Sachs, J D, and Gallup, J L, (2000), 'Climate, coastal proximity, and development' in Clark, G L, Feldman, M P, and Gertler, M S, (eds), *The Oxford Handbook of Economic Geography*, Oxford University Press, New York, p169; Sachs, J D, (2001), *Tropical Underdevelopment*, National Bureau of Economic Research working paper No 8119, Cambridge, Massachusetts

[41] Acemoglu, D, Johnson, S, and Robinson, J A, (2001), 'The colonial origins of comparative development: an empirical investigation', in *American Economic Review 91*, pp1369–1401; Easterly, W R, and Levine, R, (2002), *Tropics, Germs, and Crops: How endowments influence economic development*, National Bureau of Economic Research working paper No 9106, Cambridge, Massachusetts; Rodrik, D, Subramanian, A, and Trebbi, F, (2002), *Institutions Rule: The primacy of institutions over geography and integration in economic development*, National Bureau of Economic Research working paper No 9305, Cambridge, Massachusetts

[42] Diamond, J M, (1997), *Guns, Germs, and Steel: The fates of human societies*, W W Norton, New York

[43] Steckel, R H, and Rose, J C, (2002b), 'Patterns of health in the western hemisphere', in Steckel, R H, and Rose, J C, (eds), *The Backbone of History: health and nutrition in the western hemisphere*, Cambridge University Press, New York pp563–79

[44] Steckel, R H, Sciulli, P W, and Rose, J C, (2002), 'A health index from skeletal remains', in Steckel, R H, and Rose, J C, (eds), *ibid*, pp61–93

possibilities because we feel the results will be funda-mental to progress on the other topics. We plan to pur-sue these extensions as this particular project winds down, including: (1) long-term trends in patterns of trauma and violence; (2) social inequality and health; (3) early childhood biological stress and adult health; (4) the health of women and children; (5) health during the rise and fall of civilizations; (6) degenerative joint disease and work; (7) analysis of population genetics and migration patterns using ancient DNA, and (8) use of DNA from specific pathogens to study the co-evolu-tion of humans and pathogenic organisms.

Chullpas: Aymara Indians and their Relationship to Ancestors on Display

Verónica Córdova S

DIFFERENT CULTURES HOLD different belief systems concerning the human body and the relationship between life and death. In this paper I will explore how those beliefs affect perceptions of the exhibition of human remains amongst indigenous people whose ancestors are displayed.

Let me start by arguing that what makes exhibitions of human remains in museums possible is the distance (in time and in culture) between the subject looking and the object being looked at. After all, most human remains exhibited belong to people who have been dead for centuries: recently deceased unburied bodies belong to the police and not to museums. Few people would agree to have their father or grandfather on display in a museum, as demonstrated by the public reactions to recent art exhibitions using human bodies such as Gunther von Hagens's *Body Worlds*.

The very words used to name those objects in the museum context – human remains – suggest a vague belonging to human nature while not suggesting a direct relationship with ourselves as onlookers. The objects on display could have been one of us long ago, but in a sense they aren't anymore. They have lost connection with a specific family, clan, or society. Even the indigenous peoples who claim the return and proper burial of bodies they recognise as their ancestors can seldom name the dead they reclaim. They belong to a generic category: they are 'nobody's dead'.

This idea of being 'nobody's dead' is particularly important for the Aymara people from the Bolivian highlands, whose dead should be buried near their places of work and living, for upon death they turn into protector spirits and look over the activities of their family and community members.

Ancient forms of burial thus included inside the grave the tools and food the dead needed for their journey from humanity to divinity. Aymara communities in the Titikaka lake region continue to prepare their dead for the journey by including inside their coffins miniature tools, food and even letters for earlier dead. Pre-Hispanic tradition required the dead to be mummified in a foetal position, the religious underpinning of death being a return to mother earth's womb. Some groups then placed the dead inside a ceramic vase large enough to hold the sitting body. Others crafted a sort of straw basket surrounding the body, leaving only the face uncovered.

There were no cemeteries as such, but each clan would have a hill dedicated to build the *chullpas*, as they called the burial towers where mummies were placed. *Chullpas* were built in clusters and had a small door facing the sunrise. Through this door mummies received offerings and were visited regularly by community members related to the dead by kinship. If the mummy belonged to a leader or priest, visits would be made for consultation before important decisions for the community were made.

Old people took pride in remembering the names

of the long-dead members of the clan who dwelled in the *chullpas*. They recited their names in prayers, and passed the names on the youngsters. Once those prayers were over, they would recite an even longer prayer for those whose names had been forgotten, so as to prevent them from becoming 'nobody's dead'.

During the colonial period the *chullpa* clusters suffered destruction at the hands of Catholic priests who forbad praying before *chullpas*, considering it idolatry. Spanish soldiers then took advantage of the *chullpas's* destruction to loot the contents, taking with them all but the corpses. Later came the archeologists, who removed the human remains for research and displayed them in museums. The *chullpa* clusters were left standing alone, as empty coffins. The link between the community and their dead was broken. No one knows anymore to whom the displayed human remains belong. They are 'nobody's dead'.

In the year 2000, Aymara communities from the highlands of La Paz took over the Tiwanaku archeological site and the two adjoining museums, claiming the right to administer the complex themselves. They based this claim on their being the inheritors of the pre-Hispanic culture that built the site and crafted the goods displayed in the museums. Agreements with the authorities from the National Institute of Archeology resulted in a system through which the Aymara communities surrounding the complex take turns in administrating it and share the income from the tourists' visits. Following this important step towards indigenous self-representation in museums, the Aymara people did not however change the nature of the exhibitions, nor remove their ancestors' remains from the displays.

I found this fact quite interesting, and so I conducted a series of interviews among Aymara people regarding the pertinence of exhibiting their dead ancestors in the Museum of Tiwanaku. Not one of the interviewees raised ethical or cultural concerns on this matter. Most of them justified the exhibitions as being a way of showing how ancient people used to take care of their dead. As Aymara leader, Marcelino Carwani told me: '[The exhibition] shows us, teaches us how our ancestors, our grandparents went about, how they had their own thoughts, their own ideas.'[1]

Even though they considered the *chullpas* on display were their ancestors, the Aymara people I interviewed still did not question their exhibition. One of the reasons for this attitude, I would argue, is related to the estrangement between object looked at and subject looking, as previously mentioned. This distance is indispensable for any visitor to relate to human remains on display.

An Aymara rural teacher interviewed used the word 'domesticated' to refer to the *chullpa* in the museum. He recounted the respect felt towards the *chullpa* clusters in the Aymara communities, but when asked if the same respect should be shown to the *chullpa* at the museum, he answered that it was not necessary because: 'this one is domesticated, everyone has seen it, we all see it, it is now out in the clear, before the lights. Inside the *chullpa* grave it would have been different.'[2]

In general terms I could deduce from the interviews that most Aymara people in Tiwanaku do not identify themselves with the *chullpas* on display, seeing no relationship between themselves and the exhibited 'other'.

I will borrow from film studies some concepts to help me interpret this lacuna between Aymara Indians and their displayed ancestors. I base my analogy between museum visits and film spectatorship by arguing that both experiences have in common a gaze on 'stories represented by present images of absent objects and people'.[3]

In cinema, just like in a museum visit, 'images and their spectators do not share the same time and space, as they do in theater, for example; there is a pervasive sense of absence at the heart of the representation.'[4] Furthermore, in film as in museums, there is an important 'segregation of spaces' which depends on the distance between spectacle and spectator. In the cinema, the film unfolds before the spectator in the inaccessible elsewhere delimited by the screen. Similarly, for the museum visitor the story or history represented is inaccessible by means of the glass in front of the displays or the social norms that forbid touching or using objects in an exhibition.

Let me draw this analogy between film and museum spectatorship even further, introducing some concepts from film theory that could be useful when thinking about the subject/object relationship in the museum visit. According to feminist film theory, conventional

cinematic codes impose a masculine point of view, defined as the perspective of the enunciator whose gaze or look dominates the narrative. The woman's image, existing to be looked at and to be desired, is offered to a masculinised spectator-consumer. Thus, while women are turned into objects of the gaze, female spectators are forced to identify with an alien masculine gaze in order to extract pleasure from the viewing experience.[5]

I would argue that a similar process takes place when Aymara Indians visit the Tiwanaku museum and look at themselves and their ancestors 'otherised' in the displays. The predominant reaction is to assume an alienated distance necessary for identification with the westernised gaze. Thus, rather than identifying with the object displayed, they identify with the subject of the gaze: the museum's underlying enunciators, the white, urban archeologists who put together the collections and organise the displays.

Besides this identification with the owner of the gaze, with 'the powerful other', the fact is that the Aymara people have lost symbolic kinship with *chullpas* which, removed from their ritual and community context, have been turned into 'nobody's dead'. Just as they don't belong to the family pantheon of the archeologists that exhibit them, they ceased to belong to the indigenous traditions from the moment they were placed in a foreign space (as the museum is perceived).

A second reason for the ease with which Aymara people take the exhibition of their ancestors' human remains can be found in their conception of death as a form of continuity with life. While for some indigenous people the display of human remains is a form of contamination or desecration of their dead, for Andean cultures it was a common practice during certain festivities to take the dead out of their burial compounds and parade them through town so that all relatives and friends could see them and feel visited by them. As Spanish chronicler Pedro Pizarro described it in 1571:

'It was customary for the dead to visit one another, and they held great dances and debaucheries, and sometimes the dead went to the house of the living, and sometimes the living came to the house of the dead.'[6]

This tradition continues today. In La Paz as well as in some Andean rural towns, skulls have been turned into cult objects. According to sociologist Silvia Rivera, the contemporary cult of skulls revolves around the personal history of how the skull is inherited, found or rescued from cremation, starting a relationship of 'adoption' through which this 'nobody's dead' receives a name and a symbolic kinship.[7] People who have adopted the skulls keep them in domestic altars praying for them, offering them cigarettes, coca leaves and alcohol, and during the Day of the Dead festival in November take them for a ride so they can 'meet' and 'chat' with other skulls at the local cemetery.[8]

This fluid relationship between living and dead that is part of the Aymara culture is, I will argue, a second reason why the Aymara people from Tiwanaku happily guide tourists to see their *chullpas* on display, while at the same time they demand from the Bolivian State self-government and representation in almost all other aspects of politics and culture.

One of the forms these demands took was the taking over of the Tiwanaku archeological site and museums, as well as other much more radical measures that range from the expelling of judges and policemen to establish Aymara traditional justice, to organising themselves in indigenous political parties to take over power in their communities and beyond.

At the Tiwanaku museum, now administered by the Aymara people, mummies and skulls are shown as mere objects, and invested solely with a proof value:

[1] Interview conducted on 24 September 2004

[2] Interview conducted on 24 September 2004

[3] Stam, R, Burgoyne, R, and Flitterman-Lewis, S, (1998), *New Vocabularies in Film Semiotics. Structuralism, Post-Structuralism and Beyond*, Sightlines, New York, p139

[4] *Ibid* p140

[5] For more on this theory see Mulvey, Laura, (2000), 'Visual Pleasure and Narrative Cinema', in Stam, Robert and Miller, Toby, (eds), (2000), *Film and Theory. An Anthology*, Blackwell, Oxford

[6] Quoted in: Bauer, Brian S, (2004), *Ancient Cuzco. Heartland of the Inca*, University of Texas Press, Austin, p159

[7] Interview with Silvia Rivera, La Paz, 30 September 2004

[8] This tradition is reported annually in Bolivian newspapers, and in the last few years has become less clandestine. See for instance the following online articles (in Spanish only): http://www.laprensa.com.bo/20031109/politica/politica03.htm; http://ea.gmcsa.net/2001/11-Noviembre/20011109/Ciudad/noviembre/ciu011109a.html; http://ea.gmcsa.net/2002/11-Noviembre/20021109/Sociedad/Noviembre/soc021109b.html; http://www.laprensa.com.bo/20041109/ciudad/ciudad02.htm

they are there to demonstrate the great capacities of the long-gone indigenous ancestors, while those capacities are effaced in their current descendants. Thus, a large assortment of human skulls is exhibited to show how Tiwanaku people were able to perform brain operations. Museums do not show what the descendants of those great doctors are capable of doing today.

Furthermore, in Bolivian museums the indigenous is seen as the antecedent of a history that reached its adulthood with the European invasion and the establishment of western political forms through the republic. The Indian ancestors that are displayed as a source of pride and mysticism have no stronger link to Aymara people than to any other Bolivian citizen, for the Aymara people had to relinquish their indigenous identity in order to become Bolivians. As Aymara historian Carlos Mamani argues:

'Not long ago, just before the agrarian reform in 1952, we Indians were not considered persons; we lacked the most elementary citizen rights. Starting with the so-called national revolution in 1952 they tried to neutralise our rebellion by granting us some of those rights; thus we were 'integrated', but only under the condition of stripping us of our cultural heritage, which was passed on to museums, alienated and turned into a simple reminiscence of a dead past.'[9]

The Aymara people base their cosmology in the *Pacha* unity, which combines the dimensions of time and space, thus *Pacha* can be translated as totality. According to Mamani, colonisation of the indigenous world provoked a rupture between the two components of totality: time and space. In spite of the fragmentation of their territories, Aymara people have only partially lost control over the dimension of space. They have, however, lost complete control over the dimension of time, that is, over history. As Mamani also argues:

'Our struggle against the colonial rupture means for us a recovery of history, to be able to reunite time and space in the Pacha unity.'[10]

In the case of Tiwanaku, the Aymara people physically took over the archeological site and museums, con-

quering a space from which they had been excluded, the moment it became national patrimony, when a fence was built around the site and the Aymara people were required to pay a fee to enter, just like any other tourist. I would argue, however, that the physical take-over of the space dimension in this case was not accompanied by a take-over of the time dimension, that is a take-over of history. This can be evidenced in the fact that the Aymara people who are now in control of the representation made of them in the museums do not question it, leaving it to the archeologists and technicians. They have not conquered their history and their link to their past, they have not questioned the break in history to which they are submitted in the museums' narrative. That is yet to be done.

Drawing made by Indian Chronicler Guamán Poma de Ayala in 1615, showing the offerings made to mummified ancestors before an open burial chamber

[9] Mamani Condori, Carlos, (1992), 'Historia y Prehistoria'. Dónde nos encontramos los indios? in *Los Aymaras frente a la historia: Dos ensayos metodológicos*, Aruwiyiri, (ed), La Paz p1
[10] *Ibid* p9

CHAPTER 9

Buddhist Cremation Traditions for the Dead and the Need to Preserve Forensic Evidence in Cambodia

Wynne Cougill

WHEN VIETNAMESE-LED forces invaded Cambodia in late December 1978 and toppled the Khmer Rouge, they discovered ample evidence of the mass death brought about by Pol Pot's Democratic Kampuchea regime. The death-toll during the nearly four years that the Khmer Rouge held power was relatively small compared to those of many modern genocides (an estimated 1.7 million people perished from execution or as the result of starvation, disease, or forced labour) but the scale of no other genocide has approached Cambodia's as a percentage of the population. The Khmer Rouge were responsible for the loss of about a quarter of the country's people.

In the wake of the devastation the Khmer Rouge visited on Cambodia, there was little public outcry over the disposition of the bones found in the mass graves that dotted the country, most of which were left untouched and exposed to the elements. Nearly all Cambodia's infrastructure had been destroyed during the regime (schools, banks, post offices and telecommunications were shut down, and religious structures were converted into prisons) and most of its educated people had died, leaving survivors more concerned with the struggle to live than attending to the dead.

After seven years of negotiations, in October 2004, the Royal Cambodian Government and the United Nations ratified an agreement on the prosecution of those involved in crimes committed during Democratic Kampuchea, and amendments to the law that estab-

lished Extraordinary Chambers for a tribunal of the regime's senior leaders. In addition to their historical importance, the bones in Cambodia's mass graves will provide physical evidence of mass murders at the trials. But more recently, a debate has surfaced over their treatment and preservation.

Early efforts to preserve the bones

The Vietnamese-installed government of Cambodia (the People's Republic of Kampuchea, PRK) sought to preserve the skeletal remains in Cambodia, at first to prove that their ideological and political enemy China had been behind the mass murders in Cambodia. Later, they viewed the bones as evidence of genocide and thus a justification for the PRK's control of the country. (At this time, the United Nations and several western governments still recognised the Khmer Rouge as the country's legitimate government.) Two important sites in the Phnom Penh area were the focus of their attention, and have become symbolic of the horrors of Democratic Kampuchea today.

The first is Tuol Sleng, a former Phnom Penh high school that served as a secret State-level prison during Democratic Kampuchea (it was known to the Khmer Rouge by its code name S-21). According to documents found in and around the prison, at least 14,000 enemies of the State were detained here, and when the Vietnamese entered Phnom Penh on 7 January 1979, they found

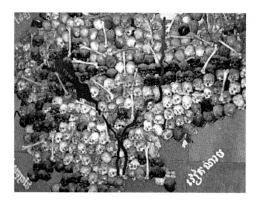

The skull map at Tuol Sleng Genocide Museum

less than a dozen survivors.

At Tuol Sleng (which was made into a national museum in 1980 using the copious documentation that survived at the site) the PRK created a 12m² map containing 300 exhumed skulls, with Cambodia's many rivers painted in blood red. The map remained on public display until 2002, when it was dismantled. Today, the skulls from the map are housed in a wooden case enclosed by glass.

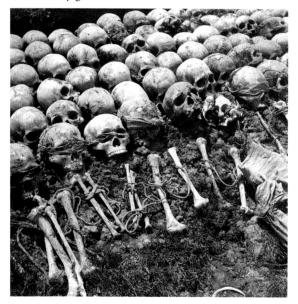

Skull arrangement at Choeung Ek

The second is the 'killing field' of Choeung Ek, which was discovered about a year after the invasion. Most of Tuol Sleng's inmates, in addition to many other Cambodians – at least 20,000 people – were executed at this site, which is about 15km from the prison.

Victims were usually forced to kneel at the edge of the mass graves while guards clubbed them on the back of the neck or head with a hoe or spade.

Large-scale excavations took place at Choeung Ek in 1980: about 89 mass graves were disinterred out of the approximately 130 in the vicinity. Nearly 9,000 individual skeletons were removed from the site with the assistance of Vietnamese forensic specialists. The remains were treated with chemical preservatives and placed in a wooden memorial pavilion with open walls. To the dismay of many, PRK officials also 'arranged' bones in a decorative manner for photographs.

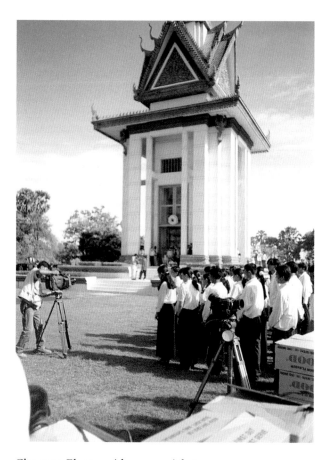

Choeung Ek genocide memorial stupa

In the decade immediately following the toppling of the Khmer Rouge, many national and local-level memorials were constructed throughout Cambodia. A new memorial was built at Choeung Ek in June 1988. Its 62m-tall concrete stupa contains a sealed glass display housing about 8,000 skulls. Vietnamese General Mai Lam, the

archivist of Tuol Sleng Museum and designer of the skull map, characterised the preservation of human remains as 'very important for the Cambodian people – it's the proof.'[1]

Buddhism and the preservation of remains

About 95% of Cambodians practise Hinhayana Buddhism, which does not prescribe cremation. Nevertheless, cremating the dead has been a tradition in Cambodia and other Buddhist societies in Asia for centuries. Many Cambodians believe that cremation and other rituals for the dead help ease the deceased's transition to rebirth. After cremation, Cambodians store their family members' ashes in a stupa so their souls can be liberated for reincarnation.

Overlaying this tradition is the syncretistic practice of Buddhism in Cambodia, which combines elements of Hinduism and animism. Among the many spirits present in the animistic world are those of the dead. The spirits of people who died unnatural deaths are considered the most malevolent of these: because their spirits cannot rest, they haunt the living and cause them misfortune.

In the case of especially inauspicious deaths, such as by violence or accident, it is widely believed that the dead person's spirit or ghost remains in the place where he or she died, and does not move on to rebirth. One researcher has noted that 'many Cambodians consider Choeung Ek a highly dangerous place and refuse to visit the memorial. In addition, to have uncremated remains on display is considered by some to be a great offence, and tantamount to a second violence being done to the victims.'[2]

The controversy over the remains

Most Cambodians – the general population, the religious community, and the government – seem to support the preservation of skulls and other human remains of Democratic Kampuchea. (This support is reinforced by an underlying belief in Buddhist tradition that people can cremate the remains only of their family members. Because virtually no individuals in the country's killing fields have been identified from their remains, cremation

could pose some obstacles in Cambodia.)

The Cambodian government has long supported the preservation of the bones as evidence. Prime Minister Hun Sen, for example, issued instructions for the remains in late 2001:

'In order to preserve the remains as evidence of these historic crimes and as the basis for remembrance and education by the Cambodian people as a whole, especially future generations, of the painful and terrible history brought about by the Democratic Kampuchea regime … the government issues the following directives:

1. All local authorities at the province and municipal level shall cooperate with relevant expert institutions in their areas to examine, restore and maintain all existing memorials, and to examine and research other remaining grave sites, so that all such places may be transformed into memorials.'[3]

Neither has there been an outcry from the Buddhist clergy. In fact, many monks seem to welcome the preservation of remains *in situ*. A local patriarch monk, who had initiated the construction of a memorial for the remains from Sa-ang prison in Cambodia's Kandal province in late 1999, told staff from the Documentation Center of Cambodia:

'One reason I got the idea to construct this memorial is that one member of my family was killed at Sang Prison. Another reason is that I observed the remains in a sad state, just sitting there exposed to the sun,

[1] Hughes, R, (2004), 'Memory and Sovereignty in post-1979 Cambodia: Choeung Ek and Local Genocide Memorials', in Cook, S, (ed), *New Perspectives on Genocide: Cambodia and Rwanda*, Yale Center for International and Area Studies, New Haven, p271

[2] *Ibid*, p76. A few caveats are in order regarding these observations. First, Cambodian Buddhists do not bury their dead and thus do not visit grave sites as such (those of Chinese descent do bury their dead and honor them by grave visits, however). Thus, most Cambodians view Choeung Ek as a stupa, not as a memorial. Second, the offence taken is a natural human reaction: the bones may be those of one's relatives, which makes many people reluctant to visit the memorial. Last, some Cambodians do view Choeung Ek as a dangerous place because of the ghosts present, not because they fear physical violence by robbers, etc. Those who have visited this site do so to share their sorrow; thus, Choeung Ek can be viewed as a place of healing for survivors.

[3] Royal Government of Cambodia, (2001), Circular on preservation of remains of the genocide (1975–1978), and preparation of Anlong Veng to become a region for historical tourism, Phnom Penh, 14 December, copy held at the Documentation Center of Cambodia, p1

wind, and rain. The remains have decayed and have even been eaten by cows. That inspired me to think that if the remains continued to lie in the state they were in they would certainly vanish and no evidence would be left for younger generations to see. In addition, if Buddhist followers wanted to come to light incense and pay homage to commemorate the souls of the dead, there was not a place for them to do so. So this idea of building a memorial for the remains came to my mind.

But the loss of the remains is what I have worried about the most. Because if people say "many died there", but there are no remains there, how can we believe? So preserving the remains is the most important reason. I am not conceited. Many people have contributed their money. I did not build this on my own. I do not want to lose the evidence, so that people from various places can come to pray and pay homage to the dead. And I will request the district governor that this memorial for the remains should exist forever. And I am thinking of having monks stay there and for people to come and pay homage because some souls of the dead have made their parents or children dream of them, and told them that they are wandering around and have not reincarnated in another world. I want to have monks meditating there so that the souls of the dead will rest in peace. In Buddhism, when someone dies and their mind is still with this world, then their souls wander around. The remains are a legacy for the younger generation so that they may know how vicious the Khmer Rouge regime was, because the young did not experience the regime. I experienced this regime. Some lived through this regime as children but they still do not believe; how can those who did not live through believe? What can they base belief on?

[Speaking of the possibility that authorities would require that the bones be moved] I would not dare to oppose them at all. I could only request that they do not burn them, but give them to me. Please do not touch the remains because I have a stupa for them already. If they do not want that, I can bring them to my pagoda here. But if they still insist that the remains be burnt, I dare not oppose them. In my opinion, if they do not want us to keep the remains

there, I would like to keep them in my pagoda so that people can come and hold religious ceremonies for their dead relatives.'[4]

Instead, opposition has come mainly from former King Norodom Sihanouk and some members of Cambodia's royalist party, FUNCINPEC. On 23 February 2001, Sihanouk wrote to Hun Sen asking that the skulls be removed from the map at Tuol Sleng and 'cremated in the Buddhist way' so their souls could find rest.[5] Hun Sen later indicated his willingness to hold a national referendum on the issue after any trials of former Khmer Rouge.

Sihanouk also posted a letter on his website in February 2004, decrying the way the bones of Khmer Rouge victims had been left out and exposed around the country. He wrote that those killed by the Khmer Rouge will 'never have peace and serenity' and that their remains should be cremated in nationwide religious ceremonies.[6] On 17 April 2004, Sihanouk marked the 29th anniversary of Phnom Penh's fall to the Khmer Rouge by calling for the cremation of victims of the killing fields.

'We are Buddhists whose belief and customs since ancient times have always been to cremate the corpses and then bring the remains to be placed in the stupa at the pagoda,' he wrote.[7]

An effort to resolve the controversy

The Documentation Center of Cambodia (DC-Cam) has made a number of efforts to reconcile the views of the King and respect for Buddhist beliefs with the needs for public education and forensic evidence from the genocide. For example, in 2002, it replaced the skull map with a satellite map of Cambodia identifying the locations of prisons and mass graves from Democratic Kampuchea. The King subsequently wrote to DC-Cam,

'I would like to express my profound gratitude and warm appreciation of your unique state-of-the-art initiative in plotting the map of Cambodia with genocide sites to replace the existing skull map being displayed at the Tuol Sleng Genocide Museum.'[8]

In 2003, the center provided a large number of skulls

from Choeung Ek and other parts of Cambodia to a team of North American forensics specialists.[9] The experts chose ten skulls for analysis. In February 2004, DC-Cam mounted an exhibition of the skulls at Tuol Sleng Genocide Museum. Entitled *The Bones Cannot Find Peace until the Truth they Hold in Themselves has been Revealed*, the exhibit sought to demonstrate the value of forensics in documenting the Khmer Rouge's crimes against humanity and to educate the public about the types of information that can be scientifically gathered from victims' remains.

Originally, DC-Cam wished to display the skulls for public viewing. However, out of respect for King Sihanouk and other Cambodians who are uncomfortable with the idea of boxing human remains, the center looked for another solution. It thus housed the skulls in a separate room at Tuol Sleng, which is open only to officials (for example, prosecutors at the Khmer Rouge tribunal). Their final disposition will be determined once the tribunal is over.

The skulls rest on identical pedestals built from slightly overlapping wooden slats. Spaces have been left between slats so that air can reach the skulls, thus allowing the spirits to come and go as they wish. To protect the skulls, the center placed them in clear, five-sided Plexiglas cases secured with soft silicone caulk. The cases can be removed by cutting the caulk with a razor blade, allowing the skulls to be cleaned or moved.

For the exhibition itself, the center chose to photograph the skulls, which were accompanied by text explaining the type of trauma to each skull.

King Sihanouk has proposed building a stupa at the old royal capital of Udong to house the ashes from the cremated skeletons. Once the Khmer Rouge tribunal is over, it may finally be possible to lay the victims to rest more than a quarter of a century after the genocide.

Photograph from the DC-Cam Tuol Sleng Forensics Exhibition: Cranium of a man, 25 to 45 years old. Gunshot wound of entrance in the left frontal convexity with the bullet passing into the brain from right to left and downward on a 45-degree angle (as indicated by the 'keyhole' effect) [Catalogue No TSL13, 2A50700]

[4] Phat, Kosal, (2004), 'Necessity of Preserving Physical Evidence' www.dccam.org/Archives/Physical/Importance.htm

[5] Original letter in the possession of the Documentation Center of Cambodia

[6] http://openhere.com/current/414456498.stm

[7] *The Cambodia Daily*, 19 April 2004

[8] Bail, Molly, and Lor, Chandara, 'Skull Map at Museum May be Removed', in *The Cambodia Daily*, 17 October 2001

[9] DC-Cam uses global satellite position mapping combined with fieldwork to document mass graves nationwide. To date, it has identified over 380 genocide sites containing more than 19,000 mass graves (these are defined as any pit containing four or more bodies, although some graves hold over 1,000) dating from the Khmer Rouge regime. In addition, the center has documented 189 prisons from Democratic Kampuchea and 80 genocide memorials

The Egyptian Museum in Turin

Graziano Romaldi

IN MOST PRIMITIVE civilisations, a lifeless human body was given particular attention with the purpose of preserving the remains and of worshipping the memory of the departed. Depending on the culture and religious beliefs, preservation was a means to lead the spirit to the hereafter through a rite of passage.

In the course of history, the preserved human body has taken on different meanings. It became a relic, a sign, evidence, an object of worship or a symbol of political and religious power. It has nevertheless always retained an aura of sanctity demanding respect and attention.

In the Christian West, the cult of the bodies of first-century martyrs represents a particular example of preservation. This worship stemmed from the mark the martyrs left in their life testifying to the firmness of their faith, and it represented an example to the community. In time, this custom was applied not only to the bodies of the martyrs, but also to other witnesses of the Christian faith and to illustrious religious people. In fact, relics of saints' bodies are commonly displayed in Christian churches. There were times when this custom degenerated into a mad quest for relics that turned into a market, losing all its original meaning.

In the Renaissance, the preservation of the human body was enriched with new meanings as a source of knowledge. It was scientific knowledge when the body was studied in order to understand its physical structure; it was humanistic knowledge when it was considered a witness and a medium of the time and the culture it represented.

In modern times, and with very different goals, secular culture misapplied religious tradition: bodies of the powerful have been preserved, displayed and used for political propaganda and as symbols of ideological trends.

When contemporary museums were established and consolidated, every element that bore knowledge and was part of the heritage of the collections was seen as useful to the understanding of ancient civilisations. This heritage often counts among its finds human bodies, funerary sets and tombs. Even in this context the human relic preserves its own sacredness, as we should not forget that the body had once life in it and it is a witness of our past.

A museum attempts to collect, preserve, study and display the breadth of its heritage or just a part of it. Displaying – showing to make known – is differently characterised according to the objective and the location. In addition, the criteria differ according to the type of object to be displayed and the way it blends into the general organisational plan. Over time, museum display criteria have varied greatly, mirroring the motivations and the needs of the prevailing culture in the different periods.

Displaying human remains in a museum to the public, that is, to heterogeneous and non-selected customers, demands good judgement, attention and sensitivity.

By its very nature, this type of remain or relic cannot be indiscriminately displayed. It can be correctly displayed as part of a general project where its presence brings significance and understanding to the whole, as bearer and witness of facts that cannot be grasped otherwise. The elements involved in displaying the human body, that is, preservation techniques, funerary sets and tombs, have always represented one of the main sources of knowledge for civilisations, religious beliefs and cultures. It is important to study the collocation and the contextualisation of the human relic with the other relics. The sight of the human relic then is an important but not exclusive part of the message that the exhibit intends to convey.

One of the risks to avoid when displaying human remains is turning them into a spectacle. If a display is aimed only at obtaining an emotional effect, it can destroy the sacredness and the sense of empathy that should be associated with the preserved remains. Moreover, it often distorts the historical and cultural context to which the relic bears witness. Focussing on the aesthetics of the relic for its own sake can uproot the relic from its original meaning and value as witness.

Displaying is one of the most effective ways of conveying knowledge, as it combines cultures and historical periods. Awareness of the signs of this past and their interactions helps to promote the sensitivity necessary for display planning, especially where human relics are concerned. It is not always easy to favour historical-documentary aspects rather than symbolic-artistic aspects. References to the general planning and knowledge of the signs of the historical context, however, are always useful. Some simple concepts can be helpful in the display of human remains. On the one hand, the human relic can be inserted into a broad museum plan, where it represents just an episode. On the other, several relics of the same type can constitute the main feature of a display, with each representing a unique and meaningful whole. Either way, the development of the visiting route is important.

Visiting routes overloaded with visual and sound impulses and stimulations are inappropriate. On the contrary, a plan that guides the mind of visitors to an attentive reading of the displayed material should be favoured. Physiological attention time should be taken into account, so the route should be interspersed with pauses and the rhythm of messages, colours and sounds should allow a clear understanding of the relics.

The relic needs its own space, almost a halo, defining its relationship with its surroundings and allowing a stimulating and deep interrelation with visitors to be established. When approaching the human relic, visitors should be visually guided, as much as possible, by evidence of the reality where the person lived. Alternatively a frame could be provided so that visitors are gradually led to the direct sight of the relic.

The average visitor perceives the meanings and the messages that the relic conveys. His or her reading is concise and nothing like the analytical reading of the expert. Analytical highlights should therefore have a subordinate role in the structure of the whole and should fit into it properly. Thus, different communication levels can be created, from didactic explicitness to thorough examination, in order to reach several types of visitors, differently educated and interested. Accessibility to a displayed object is indissolubly bound to the problem of communication and consequently to the orientation scheme that is provided.

What follows are experiences concerning human relic displays and settings in which the human relic is the main element – even if it is not always physically present.

We have, since 1986, been collaborating with the Egyptian Museum of Turin. We have been displaying temporary and regular exhibitions within the general readjustment project of the museum, elaborated by the supervisor of the museum, Anna Maria Donadoni Roveri. This collaboration allowed us to study and examine issues concerning the display of human remains.

Our collaboration with the museum includes:

1989	*From Museum to Museum*: temporary exhibition
1991	*VI National Symposium of Egyptology*: temporary exhibition in the Schiaparelli Wing
1992	rearrangement project: *Cantina dei Frati*
2000	rearrangement of the first two rooms of the museum: *Prehistory* and *Ancient Reign*

During these years we relied on the support, the motivation and the positive participation of Anna Maria Donadoni Roveri and the invaluable advice of distinguished Egyptologist Professor Sergio Donadoni.

Knowledge of a great civilisation like Egypt's is acquired for the most part through the study of funerary architecture – the protective shell that bears valuable witness to the context in which the buried person lived. The Egyptian Museum numbers among its collections complete tomb sets, such as the wonderful complex of the Tomb of Kha. Some of the museum's tomb sets have mummies, others do not; and little is known about the funerary context of some of the mummies.

In our planning work we also had to display tombs or tomb sets without coffins. In one case we had to reconstruct the context of a mummy so that its surroundings could be easily understood. Particular approach and planning criteria need to be met to allow relics to be clearly and correctly recognised while they are also protected and properly preserved. Our constant objective was to guide and lead visitors to visit and understand, spurring their curiosity and inducing them to tune in to the world, the culture and the history witnessed by the relic. We are not dealing here with the ethical problem of displaying such relics. However, we are aware that every relic carries a message of knowledge and evocative power. We believe that if relics are interpreted by experts they can be made understandable.

New display criteria have been applied at the Museum of Turin that favour reassembling items so that they appear as they did when they were found. When such compositions are contextualised, they become meaningful, they stir visitors' interest and give fuller meaning to the relics.

Display planning should use devices such as contextualising relics and compositions, studying their recognisability, reshaping or at least redefining the physical space in which visitors move, mapping out and defining the visiting route.

Visitors memorise images and knowledge that depend upon the olfactory, sound and tactile sensations they experience during the tour. Some visiting routes have been suggested (but could never be implemented) that involved being guided by lights and surrounded by a wide range of sensations, as if visitors were actually taking part in an event where the displayed items were the protagonists.

Displaying is not just showing. As far as relics are concerned, their display and the evocative power of their positioning should prompt learning and insight. They should turn curiosity into cultural interest so that, through them, visitors identify with the search for their own roots.

The following illustrations show some examples of our displays involving Egyptian funerary sets, tomb reconstructions and a tomb with a mummy.

We can summarise the principals we adhered to as follows:

- **offering** visitors knowledge of the relic as it was preserved
- **reconstructing** or rearranging spaces and compositions of relics as they were originally found to facilitate visitors' understanding and reading
- **evoking** compositions where relics are set in a context that is not real, because it is unknown, but evocative, as it is imagined.

Offering

The moment of 'offering' the exhibit is not just related to the structure of the display stand, but also of the 'path' chosen to guide visitors to see the relic.

A relic can simply be displayed to ensure its recognisability and visitors' prompt understanding (as, for example, in the amphorae of the Tomb of Kha); or the relic can be displayed with educational intent (as in the 'exploded' sarcophagus and mummy that show the relationship between their parts). Otherwise, the relics can be arranged so that visitors see them progressively, culminating in the most interesting relic. This is the case in the display that stands isolated in the centre of the first room of the museum. It was organised around some reference marks suggested by the architectural features of the room. The display stand, which acted as stage design for a pre-dynastic tomb and displayed various relics of the period, recalled the oval vault as a

route around which other curved display stands were arranged.

Reconstructing

In the general display planning we wished to call attention to a small oval pre-dynastic tomb whose body and unpretentious set are preserved in the museum.

'The corpse is crouched, covered with a length of cloth and matting. It is naturally mummified. It bears witness to one of the most ancient human body preservations without the direct intervention of man. The first mummifications began when corpses were laid in sarcophagi.' [1]

Avoiding any ostentation, the corpse was placed in the centre of the room creating a kind of womb emerging from the floor and containing the tomb. Visitors could not see the tomb until they were close to it and not before they had seen some of the displayed relics, so that they had already adapted their attention to the subject. The interior of the 'womb' was skilfully reconstructed by Professor Gianluigi Nicola and illuminated by a ring of cold optical-fibre lights. The display stand was carefully isolated from any heat source, and inside it we recreated hygrothermometric conditions identical to those of the site where the body was found. A hygrothermometer regulated the microclimate. The sight of the body, gradually approached in this way, did not arouse disgust, but rather tenderness and silent discretion.

For the tomb of Henib from Gau el Kebir, we chose to reconstruct a tomb where paintings and fragments of the sarcophagus were related to one other in a space identical to the original. There was no mummy and the fragments were the only remains, since the tomb had long since been pillaged. Restoration was carried out under the guidance of Professor Alessandro Roccati, now at the University of Rome, and with superb restoration and reconstruction by Professor Gianluigi Nicola from Aramengo d'Asti. They restored the paintings from the walls of the original cell and meticulously reconstructed the tomb, giving new life to a composition that time and the whims of history had spoilt.

The material was accidentally discovered in the museum storehouses. It was contextualised according to two pictures of the excavations that prompted and enabled the reconstruction. The original tomb was reached by a well that gave access to a cell sealed with a slab of stone. In the reconstruction it was represented by a stony block cut in the mountain and brought to the museum. Through a crack in the block, visitors could glimpse the interior of the funerary cell, the paintings on the wall and roof and the remains of the wooden sarcophagus.

The same procedure was followed for the reconstruction of part of the Tomb of Iteti from Giza. The museum holds four parts of this tomb: the door, two paintings with some goslings, and part of the statue of the deceased.

In these two last reconstructions there were no mummies. The items were related one another physically as they were found originally. Thus, they formed a unity full of significance and impact, allowing visitors an easier and more stimulating reading.

Evoking

For the Tomb of Ini from Gebelein we followed the 'evoking' criterion. The wooden sarcophagus and the funerary set were reconstructed as they were originally found. They were set, however, in an imagined context, which was designed to arouse feelings similar to those that might be evoked by sight of the original (unknown) context. The set of the tomb was organised according to the sole description available in the excavation journal, which did not provide precise information. The starred vault effect was obtained with optical-fibre illumination and the floor was recreated as natural soil, evoking a magical atmosphere surrounding the funerary set.

These notes summarise our planning experiences in the field and allow us to share our acquired knowledge. In today's multi-media-driven times, museums can tend towards holding 'events' and 'shows' rather than exhibitions. If they could rediscover their unique cultural function with regard to the display of human remains, it would certainly be beneficial to our disoriented society.

[1] Anna Maria Donadoni Roveri, (2000), Il Museo Egizio di Torino: nuova esposizione

The tomb of Ini

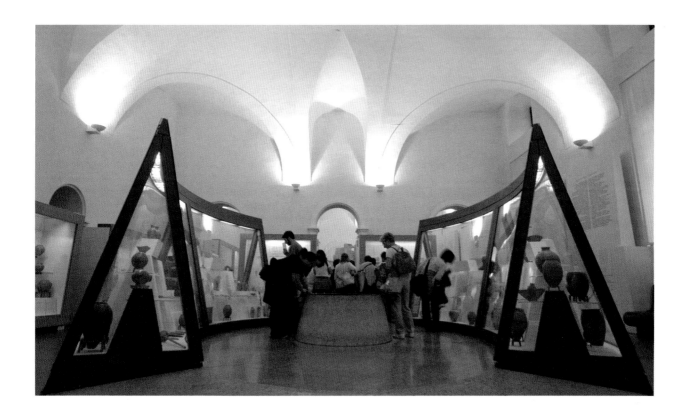

The central exhibition project

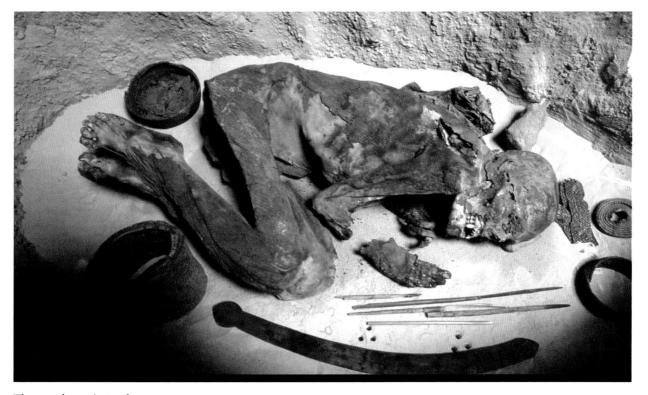

The pre-dynastic tomb

Finding Common Ground:
The English Heritage / Church of England Guidelines on the Treatment of Christian Human Remains Excavated in England

Joseph Elders

HUMAN REMAINS FROM the Christian period represent the majority (approximately 75%) of the several thousand inhumations disturbed every year in England. There is an unbroken link from the refoundation of the Church in England in 598 by St Augustine to the present institution of the Church of England and, according to the 2001 National Census, 74% of the population of this country still profess to be adherents of the same religion as the vast majority of the population of England over that long period. The treatment of the dead, therefore, should clearly take account of the views, traditions and practices of this very large faith group.

The Church of England would of course not presume to speak in the name of all Christians in England in this context, but rather as the established Church in this country and as the legal successor of the pre-Reformation Church in England. The Church of England has judicial and representative functions, and is responsible for a wealth of archaeologically important buildings and sites, including its many thousands of ancient churchyards and its cathedral precincts.

This is not merely a moral responsibility. The Church of England has its own legal system, the Faculty Jurisdiction, which operates within the so-called Ecclesiastical Exemption. It operates under two main pieces of legislation, the Care of Churches and Ecclesiastical Jurisdiction Measure (1991) and the Care of Cathedrals Measure (1990), supplemented by various other measures, rules and guidance notes.[1]

Church of St Andrew, Weaverthorpe, Yorkshire

The theological position of the Church of England regarding human remains is enshrined in its Canon Law, which holds that human remains entrusted into the care of the Church at burial should not be disturbed without proven need; and that if the need is proved, disturbed remains should consequently be reinterred in or on consecrated ground. This traditional and straightforward approach is in potential conflict with the views of archaeologists, museum curators and the scientific community, who point to the wealth of information that can be gained from the study of human remains, and the

legitimate public interest in this.

By contrast, where human remains are excavated outside the Church of England's jurisdiction, for example a disused friary burial ground, a complex raft of secular legislation applies, whereby Christian human remains (CHR) are not always reinterred, but are sometimes held indefinitely in museums or archaeological stores. We have therefore two radically different approaches in England to the disturbance of human remains, depending on whether the ecclesiastical or secular jurisdiction applies. This might be termed an accident of history, and one, that the recent Home Office consultation on reform of burial law seeks to address, though it may be some time before this process results in new legislation.

To define and attempt to resolve the potential conflicts and inconsistencies implicit in the present situation, and to ensure that archaeology is taken fully into account in such new initiatives, English Heritage and the Church of England agreed in 2001 to convene a Working Group to produce guidance on the treatment of human remains excavated from Christian burial grounds in England. The Working Group completed its work following the end of the formal consultation period on its initial report in July 2004, and the guidance document was published in late January 2005.[2] Here only the main recommendations are given, grouped under seven headings, followed by a brief discussion of the relevant themes for the purpose of this paper.[3]

Continuing burial

a. Digging any fresh graves in parts of an established burial ground thought to be an area of archaeological significance should be avoided unless all graves in the area are first excavated archaeologically.

b. Archaeological monitoring of gravedigging in churchyards and cemeteries is otherwise not something that can reasonably be required on a routine basis.

Development of burial grounds

a. If burial grounds, or areas within burial grounds, which may contain interments more than 100 years old have to be disturbed, whether for minor building work or larger scale development, to a depth that is likely to disturb burials, the relevant areas should be archaeologically evaluated. Any subsequent exhumations should be monitored, and if necessary carried out, by archaeologists.

b. The developer, whether a religious or a secular organisation, should be responsible for the cost, including study of excavated remains and their reburial or deposition in a suitable holding institution.

Research excavation

a. Research excavation of unthreatened burial grounds or areas of burial grounds is acceptable only if interments are more than 100 years old, and the proposed work is acceptable to the living close families of those who are buried, if known.

b. Research excavations should normally take place within established research frameworks. Specific research aims must also be identified and adequately justified.

c. The project budget should include sufficient provision to cover not only excavation costs but also the study of all recovered remains and their reburial or deposition in a suitable holding institution.

Excavation, study and publication

a. Archaeological excavation, study and publication of burials should conform to the standards and procedures set out in the body of this document.

b. When a skeleton lies only partly within an area under excavation it should not normally be 'chased' beyond it. However, if the burial is deemed osteologically or archaeologically important, the trench should be extended so that the skeleton may be lifted in its entirety, provided this will not result in disturbance of further burials. If it is not deemed necessary to lift the burial then the exposed remains should be reinterred in the trench.

c. Destructive analysis of human remains is acceptable provided that research aims are identified and adequately justified and if permission is given by the living close family of the individual involved, if known.

d. On excavations conducted for the purposes of evalu-

ation of a site, lifting of human remains should be kept to the minimum compatible with adequate evaluation.

Reburial and deposition

a. If living close family members are known and request it, excavated human remains should be reburied.

b. Excavated human remains shown after due assessment to have limited future research potential should be studied and then reburied.

c. Reburial should normally be by inhumation rather than by cremation.

d. When excavated human remains are more than 100 years old and have significant future research potential, deposition in a suitable holding institution should be arranged. Redundant churches or crypts provide an acceptable compromise between the desirability of deposition in a consecrated place and the desirability of continued research access. A working party, to succeed the Human Remains Working Group, should be set up to pursue this, looking in particular at funding and at establishing proper working practices.

Advisory committee

a. A standing committee should be set up jointly by English Heritage and the Church of England to serve as a national advisory body on human remains from Christian burial grounds in England. This committee will take forward the issues raised in this document and will complement any human remains committees that may be set up as a response to the findings of the Department of Culture, Media and Sport (DCMS) working group on human remains in museum collections.

Wider implications

a. The working group recognises that many of the issues raised here may have more general applicability to human burials excavated from English sites. It is hoped that this document may stimulate debate, which may lead to formulation of policy for dealing with human remains from a wider range of contexts.

b. The working group recognises that many of the issues raised here would benefit from further consideration in the broader context of dealing with human remains.

I should like to concentrate on four issues arising from these recommendations that seem relevant here. These are storage, destructive sampling, display of human remains, and burial artifacts. I will outline the relevant recommendations in the groups' report concerning these, and also try to explain the attitude of the Church of England in these respects.

The first issue is that of storage. There is general agreement that human remains are different from any other material held in museums. The holding of CHR within museum, university or archaeological units' stores is therefore one of the most emotive issues the group had to wrestle with. To quote from the guidance document:[4]

'The phrase "laid to rest", being common parlance for burial, implies that remains should not be disturbed. The finality of Christian burial should therefore be respected even if, given the demands of the modern world, it may not be absolutely maintained in all cases. The Church of England's attitude to burial is that human remains should be treated with respect and reverence: a society which cares for the dead demonstrates that it values life.'

The Church would therefore prefer all CHR to be 'at rest' on consecrated ground. To quote again from the guidance document:[5]

'In summary, it is central to Christian theology that, after death, the human body ceases to have any significance for the on-going resurrected spiritual life of the individual. However, following death, the physical remains should be treated with respect and reverence, even though ultimately it is the fate of the soul, rather than of the physical remains, which matters.'

In line with this attitude, there has generally been an acceptance that human remains may be made available for a limited period of time for study before reinterment. There is no property in a corpse in English law, but the

protection of the Church for those buried within its jurisdiction and still within it at the point of exhumation does not lapse. This is why the idea of consecrating stores is not considered appropriate; the issue is not merely that of consecrated ground, but of protection on behalf of the deceased, which requires a measure of control. If the Church or the Home Office demands the return of human remains to consecrated ground with or without the full weight of the law, how can we then mitigate the ensuing damage or destruction of potentially important material?

Effigy of a Lady, Church of St Andrew, Weaverthorpe, Yorkshire

The Group's recommendation regarding this is the setting up of Church Archives of Human Remains (CAHRs), whereby Christian human remains designated as being of high research potential could be held in churches. They could then be regarded to be 'at rest' on consecrated ground, while still available for research within defined parameters, these to be articulated and interpreted by a national advisory committee, of which more later. The problems of finance that have been raised could be resolved by the mixed use of churches rather than by designating a closed church purely as such an archive, which would have serious maintenance, security and staffing issues, though such a solution might be possible in some of our larger cities where there are very substantial collections. An example of how this might work is the redundant church of St Saviours in York, now the Archaeological Resource Centre (ARC) of the York Archaeological Trust. Human remains of all periods are kept here in discrete screened off areas, and access is strictly controlled.

The principle of multiple uses rather than a building dedicated purely as a bone store is a good one. Parts of several churches still used for worship evenly spread around England might be so used. This would provide security and obviate the need for staff on site; a designated person in a nearby institution could open the otherwise inaccessible collection for study, including temporary removal to research facilities. The guidance document further states:[6]

'The status of all collections should be subject to periodic review, allowing the case for reinterment or retention for further scientific study to be reconsidered. The review should be conducted by an external

[1] (1991), *Care of Churches and Ecclesiastical Jurisdiction Measure*, Her Majesty's Stationery Office (HMSO), London; (1990), *Care of Cathedrals Measure*, HMSO, London

[2] The guidance document can be obtained from the web at www.c-of-e.org.uk or www.english-heritage.org.uk, or a copy requested from English Heritage's Customer Service Department

[3] Church of England and English Heritage, (2005), *Guidance for Best Practice for Treatment of Human Remains Excavated from Christian Burial Grounds in England*, Church of England and English Heritage, London, pp4–5

[4] *Ibid* paragraphs 25 and 26, p9

[5] *Ibid* p9

[5] *Ibid* p9

[6] *Ibid* p49

advisory board and in conjunction with staff of the holding institution. Records of past research access and scientific outcome, and an assessment of future potential, should be made available to the advisory board.'

These ideas, we believe, provide a serious and viable solution to the conflicting demands for reinterment and the demands of the archaeological and scientific community, which are both demonstrably in the public interest.

The second question is that of destructive analysis. The guidelines conclude that destructive analysis is permissible, but must always be adequately justified, and that the minimum amount of material necessary should be destroyed. To risk a flippant example, you may not need all your remaining teeth in the afterlife, but it might be considered disrespectful and inappropriate to annihilate the entire remaining dentition. This would also, of course, destroy a potential resource for future investigation, so with common sense and dialogue, a solution can usually be found.

The third question is that of display. Again the guidance document recommends that display of CHR is permissible, but only within a serious educational context, and with necessary consultation. As far as the attitude of the Church is concerned, it is possible even in this country to view human remains in churches in the few remaining ossuaries. Visiting Catholic churches in Europe will of course expose one to a multitude of such ossuaries as well as mummified corpses on display in churches, including such recent ones as Saint Bernadette of Lourdes or the Capuchin catacombs in Palermo, where over 800 bodies are on display.

Display, then, is generally acceptable within the Christian tradition, but the important issue is again that of respect. The examples just cited are protected, and at rest within consecrated ground. While display for a clearly defined educational purpose might be acceptable, the Church and indeed the public might consider it disrespectful to display Christian human remains permanently, unless of course one has the permission of that person. Again, consecrating museum display cases is not the answer. Eventually, when the exhibition is over, the remains should ideally return to a place where they can be considered 'at rest', preferably a CAHR. This would not preclude, of course, the possibility of further display in the future.

The fourth issue is the matter of burial artifacts. To quote from the guidance document again:[7]

'there is no theological position on the long-term fate of coffin fittings and other grave furnishings. In Christian theology, interred personal items have no import for the afterlife of the deceased.'

Therefore they may be held and displayed, as one can see in many cathedral museums and treasuries. Reburying significant items would mean their deterioration or destruction, unless they were carefully preserved *in situ* which has been done on some occasions. The guidelines tentatively suggest that a distinction might be made in certain cases between items such as coffin furnishings or pieces of clothing and accessories that might be kept, and those things which might be designated 'personal' items such as a wedding ring, particularly in more recent burials where identity can be ascertained. Again, it is a question of respect for the deceased and the wishes of living relatives. Such exceptions to the rule that grave goods may generally be kept and displayed (if the landowner, often the Church, allows this) are likely to be rare. Of course, if the human remains are held in a CAHR, any associated grave goods could also be held with them, when they are not required for display. So that problem again has an acceptable solution.

To sum up, I believe that the general adoption of the advice in the guidelines would go a long way towards resolving the contradictions and conflicts inherent in the present system. For the future, the recommended dual approach of the establishment of CAHRs and a national advisory committee on Christian human remains in England, complementing any human remains committee set up as a response to the Working Group set up by the DCMS, offers a positive way forward. This would mark a major step towards an ethically robust and effective approach to the treatment of Christian human remains in England.

[7] *Ibid* p15

Somebody's Husband, Somebody's Son: Crash Sites and the War Dead

Vince Holyoak

DESPITE BELONGING TO the recent past, crashed military aircraft have historic, archaeological and academic value. However, their excavation is problematic, since in many cases their loss resulted in the deaths of their crews. In the United Kingdom the Ministry of Defence (MoD), concerned about the number of excavations that had unexpectedly uncovered human remains, and the outrage of the press, veterans' groups and the families of the deceased, introduced a system of licensing. Nonetheless, the basic principle underpinning licensing – that no excavation will be permitted where the presence of human remains is suspected, even if it is at the request of relatives – has in itself created a moral dilemma. This paper discusses the background to the current situation and reviews the differing approaches taken by the United Kingdom and United States to the recovery and repatriation of the war dead.

Since the 1960s there has been a growing interest in excavating or recovering the remains of crashed military aircraft, primarily those dating from World War II. In the early years, such activities were purely the preserve of aviation enthusiasts, viewed by many as at best souvenir-hunters and, at worst, grave-robbers. In more recent times, however, aircraft remains have increasingly become recognised as a legitimate, if not entirely mainstream, element of archaeological resource.[1] Nonetheless, the motives of those excavating crash sites are still viewed with suspicion. Whilst aviation enthusiasts argue that by recovering the shattered remains of

the aircraft they are perpetuating the memory of the deeds of the many thousands of airmen who took part in the air war, the commercial market in both legally and illegally recovered crash-site artifacts continues to grow and is a cause for concern. Much of this unease is caused by the fact that such sites are by their very nature also indelibly associated with human loss.

For many people, particularly veterans and the families of the deceased, the emotions associated with crash sites are still too raw, and many believe that the sites should be left alone. Enthusiasts counter that buried aircraft remains deteriorate at such a rate that to leave them in place is to consign them to oblivion.[2] This, they argue, is not a fitting memorial. Even if one accepts the academic value of their excavation therefore, their disturbance raises moral questions. This difficult situation is exacerbated by two further considerations. First, the sheer volume of casualties and the nature of their loss meant that wartime salvage operations were seldom completely successful, and many crash sites involving fatalities still contain human remains, whether or not the crews were officially recovered at the time. Second, under United Kingdom law crash sites cannot be excavated without a licence, and where human remains are known to be present, the sites are deemed to be war graves. In such cases it is Government policy not to issue licences, a principle that applies even if relatives have formally requested an excavation, or the remains are actively being disturbed. Given the circumstances it

seems right to look in more depth at the background to the controversy.

By the end of the war well over 11,000 aircraft had been lost flying from or around the United Kingdom, and in excess of 100,000 airmen had been killed. The Commonwealth and Royal Air Forces lost over 60,000 aircrew flying from or over the United Kingdom during World War II, the Luftwaffe 2,000 and the United States Army Air Forces 50,000. In churchyards around the United Kingdom small plots of aircrew graves began to appear, some of them close to the airfields from which the crew had flown, others containing crews whose bodies had been brought home by relatives. For Commonwealth aircrew whose bodies could not be repatriated, the RAF established a series of regional cemeteries. Similarly, a major United States cemetery was constructed at Madingley near Cambridge, whilst German casualties were gathered together at Cannock in Staffordshire. For a large proportion of aircrews, however, nothing more was heard or seen of them after take-off. At the war's end therefore the fates of some 40,000 RAF and Commonwealth aircrew had still not been established, and they were officially listed as missing. Over the next five years the RAF's Missing Research and Enquiry Service investigated many crash sites across northwest Europe, interviewing witnesses and combing local records and cemeteries. By 1950 the RAF had located almost half of the missing aircrew and in October 1953 Her Majesty the Queen inaugurated the memorial to the missing at Runnymede, on which the names of 20,466 airmen of the British Commonwealth and Empire with no known graves were commemorated.

In the view of the British Government and the RAF, the unveiling of the Runnymede Memorial effectively discharged their responsibilities. In particular, no further efforts were made to locate the missing. With memories of the war still fresh in many people's minds, and with surviving veterans and relatives attempting to rebuild their lives, this position was accepted. However, the release of the film *The Battle of Britain* in 1969 became a catalyst for growing nostalgia, and with it came a realisation amongst aviation enthusiasts that relics of the air war – the remains of the aircraft wrecks that had once littered the countryside – were there for the taking. Throughout the 1970s, loose affiliations of enthusiasts competed in a scramble for the best artifacts. Virtually every accessible Battle of Britain site was picked over, many being investigated several times. Attention then turned to sites from later in the war, and in more recent years modern survey and recovery techniques have been used as well as more widely available official records to locate and excavate sites that had confounded earlier attempts at identification.

It was under such circumstances that in May 2003 aviation archaeologists applied to the MoD for permission to excavate Pilot Officer William Gordon's Spitfire, known to have crashed at Hadlow Down, East Sussex, during the height of the Battle of Britain. An attempt by enthusiasts to locate the wreckage in 1974 had ended unsuccessfully, and permission was granted because Gordon's body had been recovered at the time and taken home to his native Mortlach in Banffshire, where he was buried in the presence of his parents and two sisters. However, in a disturbing twist, not only did the 2003 excavation reveal pieces of the aircraft, but Gordon's unused parachute, his tattered tunic and, contained within it, substantial human remains. This was a shock to all concerned, not least his surviving relatives. The explanation however was simply that wartime recovery gangs worked under intense pressure in the face of unrelenting aircraft losses, and high-speed crashes, often accompanied by fire or explosions, made the identification and recovery of bodies difficult. The recovery teams, often civilian contractors, frequently lacked both the equipment and the time to effect a thorough search, but legally it was necessary to recover only 7lb (about 3.2kg) of human remains, including an organ without which it would be impossible to sustain life, in order to effect a burial. It was rumoured therefore that many coffins were weighted, so as to appear to relatives fuller than they actually were. Though it is not widely reported, small pieces of bone can still be found at plane crash sites, even when the aircrew has graves elsewhere. In truth, although disturbing, the case of Pilot Officer Gordon was just one in a much longer list of similar discoveries.

Given the Royal Air Force's post-war stance in respect of the missing, and the ever-growing interest amongst enthusiasts in excavating crash sites, in the early days of aviation archaeology it was inevitable that

substantial human remains would be found. Since official records were still classified, enthusiasts often relied on local knowledge, with little idea as to what type of aircraft a site contained, let alone its identity. In 1972, following months of painstaking research by enthusiasts to locate the crash site of his Hurricane in Kent, Pilot Officer George Drake became the first missing airman to be recovered by aviation archaeologists. It seems that no official efforts had been made to find Drake since he went missing in 1940, it having been assumed that he was lost at sea. The discovery of Leutnant Werner Knittel's remains followed in 1973, then those of Gefrieter Richard Riedel and Flying Officer Franciszek Gruszka (1974), Oberfeldwebel Karl Herzog, Obergefrieter Herbert Schilling and Sergeant Edward Egan (1976) and Oberleutnant Ekkehard Schelcher (1979). Each discovery was greeted by the press with outrage. By 1979 a further nine aircrew had been found, but one case in particular – the excavation of a crashed Hurricane on the Isle of Sheppey which revealed the remains of Flight Lieutenant Hugh Beresford, also missing since 1940 – caused a particular furore. The excavation was filmed by a BBC television crew, and showed Beresford's remains being handed to the police in a dustbin bag.[3] Within weeks the MoD had issued revised guidance to recovery groups, but a further three aircrew were discovered in 1979, and two in 1980. The only answer, it seemed, was legislation. As a result, in 1986 the Protection of Military Remains Act made it an offence to disturb any crash site in the United Kingdom without a licence from the MoD. Underlining the necessity for legislation, Leutnant Helmut Strobl was found just days before the 1986 Act came into force, from a site that had already been excavated twice before. Earlier finds had included Strobl's parachute harness buckle and Iron Cross, but reportedly no human remains. However, during the third excavation Strobl's bones and identity disk were recovered, buried in a plastic carrier bag.

The effects of the Protection of Military Remains Act

Since the introduction of the Act it has been MoD policy not to issue licences where the presence of either live ordnance or human remains were suspected, irrespective of the wishes of relatives. This is because the MoD believes – probably with justification – that in order to get access to the remains of the aircraft, individuals have on occasion pressured relatives into calling upon the MoD to allow excavations. Such stringent rules notwithstanding, since 1986 11 more missing aircrew have been recovered. Three were excavated accidentally, when licences were issued for the wrong aircraft. The most disturbing cases are two found by an enthusiast who was angered by the MoD's refusal to grant licences. His first dig was in Chilham, Kent, at a crash site long suspected to be that of Sergeant Gilders, who was listed as missing in action in 1941. It was reportedly common knowledge locally that the aircraft contained a body, for which reason the landowner had repeatedly vetoed excavation. However, when ownership changed, the enthusiast, with the consent of both the new owner and the Gilders family, asked the MoD to investigate. The MoD declined, saying there was no proof that the crash site was Sergeant Gilders', nor any certainty of recovering remains. Yet when the enthusiast applied to excavate the site himself, he was refused on the grounds that the site might contain human remains. Exasperated, he conducted an excavation. Having found both Gilders' remains and proof of identity, he was then tried under the Protection of Military Remains Act, but received an absolute discharge. In the second case the same man excavated a crash site near Lydd, Kent, from which it was known that the pilot had not been recovered in 1940. A small excavation in 1973 was thought to have found human remains. The landowner and the pilot's family gave their consent, and the enthusiast excavated without even applying for a licence. Curiously, it seemed that the aircraft had already been fully excavated. The enthusiast was again charged under the Protection of Military Remains Act. However, it was discovered that an RAF team had re-excavated the site shortly after the

[1] See Holyoak, Vincent, (2000), 'Airfields as battlefields, aircraft as an archaeological resource: British military aviation in the first half of the 20th century', in Freeman, P W M, and Pollard, A, (eds), *Fields of Conflict: Progress and Prospect in Battlefield Archaeology*, British Archaeological Reports International Series 958, Oxford, pp253–64; BAR and Holyoak, Vincent, (2002), 'Out of the blue: assessing military aircraft crash sites in England', 1912–45, in *Antiquity* 76, (2002), pp657–63

[2] Saunders, Andy, (2004), 'Corroded in Action' in *British Archaeology* 75, pp14–15

[3] Ramsey, Winston, G, (ed), (1982), *The Battle of Britain, then and now*, Battle of Britain Prints International, London

original 1973 recovery, and had found human remains. With the identity of the wreck unproven, these had been buried as 'unknown'. When this came to light, the MoD dropped charges. Since this same individual had already excavated a third site without permission, the MoD may have felt compelled to take action, but their apparent intransigence concerning the missing requires further explanation and should also be considered.

In his book *Missing in Action: Resting in Peace?*[4] Dilip Sarkar identified seven Battle of Britain crash sites thought to contain missing crew. One, beneath a disused warehouse in Gravesend, Kent, had already been the subject of an illegal recovery attempt. Sarkar reported that only once, in 1990, had the MoD acted on the wishes of a pilot's family and carried out a recovery: this appeared to be due solely to the intervention of the Prince of Wales.

Why then, even when directly requested to do so by relatives, has the MoD declined to recover the remains of missing aircrew? In its defence, it points out that the Protection of Military Remains Act does not provide for relatives' wishes, and cites historical precedence, saying that the 'battlefield grave' is an honourable British tradition. In fact this tradition goes only as far back as World War I, at the cessation of which the Empire's dead were left where they were, for reasons of cost and equality. It was argued in both parliament and White-hall that repatriating only identified remains would discriminate against the families of the 900,000 whose final resting places had never been identified and were as a result buried in graves marked only 'Known unto God', or listed as missing.[5] Although the Imperial War Graves Commission was established by Royal Charter in 1917 with duties to mark and maintain the graves of the members of the imperial forces, to build memorials to those who have no known grave and to keep records and registers, it had no obligation to actively search for the missing.[6] The commission – renamed the Commonwealth War Graves Commission in 1960 – has a database listing 1.7 million men and women of the Commonwealth forces who died during the two world wars, and the 23,000 cemeteries, memorials and other locations worldwide where they are commemorated. However, such was the scale of losses that the pressure group Campaign for War Graves Commemoration

estimate that some 15,000 servicemen and women are missing entirely from the CWGC's records. It is suggested that part of the problem is the United Kingdom's obsession with secrecy since, 90 years after the end of World War I and 60 years after World War II, information relating to burials is still not publicly available.

Missing in Action – United States policy towards the war dead

The British Government's attitude to the war dead, both then and now, contrasts sharply with that of the French who, in 1920, swayed by public opinion, allowed relatives to reclaim their war dead at State expense. Within two years, in a remarkable exercise in logistics, some 300,000 fallen had been exhumed and returned to their home towns. Similarly, after World War I the United States committed itself to identifying and repatriating its war dead, a policy which continues to this day. Whereas the RAF finished searching for remains in 1950, each of the United States' services still has a permanent staff dedicated to locating, identifying and repatriating servicemen and women killed during 20th-century conflicts. Teams operate across all continents and the results of their work are made publicly available. One can therefore, for instance, see on the internet the results of work by the United States Army's Central Identification Laboratory, Hawaii, where images depicting remains recovered from the crash site of a United States Air Force gunship lost during the Vietnam war are shown. In fairness to the MoD however, one might compare the openness of the United States military on historical losses to that of more recent conflicts. In April 2004, BBC News reported that Pentagon lawyers were examining the release of photographs showing the coffins of dead United States soldiers repatriated from Iraq, since rules dating back to 1991 ban the media from covering the return of the remains of soldiers killed abroad. As the BBC report noted, critics argued that the rule was designed to cover up the human cost of war, whilst Defence officials insisted that it was in the interests of bereaved families. Whatever the truth, it is instructive to see how in practice the United States' approach to its dead from earlier conflicts contrasts with that of the United Kingdom.

In March 1945, B17 Flying Fortress Tondalayo of the

858th Bombardment Squadron, VIIIth United States Army Air Force, was shot down while returning to base at Cheddington, Suffolk. Official records state that Tondalayo was hit by a German night intruder, but surviving crew members reported that they had in fact been brought down accidentally by flak from British batteries engaging the night fighter. The pilot, Lieutenant Colonel Earle J Aber, and co-pilot, 2nd Lieutenant Maurice J Harper, struggled to keep Tondalayo airborne, hoping to make it to an emergency airfield at Woodbridge. However, almost immediately Aber realised that there was little chance of doing so, and gave the signal to bail out. Nine of the crew had managed to do so when Tondalayo cartwheeled into the sea off the River Stour, Essex, taking Aber and Harper with it. A subsequent search by United States Navy divers recovered nothing of Harper. Of Aber only an arm and hand, identified by a Scout ring he was accustomed to wearing, were found, and these were buried at the United States cemetery at Madingley.

In 1990, despite its policy on the non-disturbance of crash sites containing missing airmen, the MoD inexplicably approved an excavation at which, it was reported, flying clothing was recovered and human remains were subsequently exposed on a sand bank at low tide. Concerned, the Midlands Aircraft Recovery Group, amateur but highly experienced aviation archaeologists, asked the MoD to effect a recovery or allow them to do so. The Ministry refused both. The United States Mortuary Affairs team, prompted by lobbying, made an assessment visit in 1998. Two years later, with the help of the East Essex Aviation Museum and a local marine contractor, they made a full recovery, finding bones and Aber and Harper's wallets. Those remains not positively identified by DNA testing were buried with full military honours in a joint grave at Arlington national cemetery. Aber's bones were deposited in his existing grave at Madingley and Harper's returned home to Birmingham, Alabama. It was reported in the *Portage County Gazette* that Lieutenant Colonel Aber's sister Margery said before the funeral 'That will be the final closure. But one of the hard things for me, is talking about bones. What is most important is his spirit. He had a wonderful spirit.'

Conclusion

The remains of Earle Aber and Maurice Harper would still be lying exposed on a sandbank were it not for the direct intervention of the United States military. Given the location of the crash site in the United Kingdom, it seems doubly ironic that current MoD policy means that, had they been British, no official efforts would have made to recover them, nor would private individuals have been allowed to do so. But the United States is not unusual in its more enlightened approach to the war dead. Having signed the 1949 Geneva Convention on Humanitarian War Legislation, the Netherlands committed itself to recovering, identifying and, where requested by relatives, repatriating aircrew remains of all nationalities. Since the 1950s it has undertaken a large number of official aircraft excavations, many leading to the identification and burial of missing aircrews. The wishes of the families of missing British and Commonwealth aircrews have had greater recognition in Netherlands than in Britain. The Protection of Military Remains Act does not of course extend overseas. With the exception of a few countries where reciprocal arrangements exist so official permission will not be granted without the agreement of the MoD, there is no obstacle to non-United Kingdom nationals excavating any British or Commonwealth crash site abroad, irrespective of the presence of human remains. The MoD has a hard task in administering the licensing system, and has in many respects made the best of difficult circumstances. But we have come to a strange situation whereby there is an official moratorium upon the recovery of missing RAF and Commonwealth aircrew actually within the United Kingdom, but not elsewhere and, paradoxically, this moratorium does not extend to United States aircrew missing in the United Kingdom.

In 1973 an excavation of the crash site of Sergeant Stanislaw Duszynski, killed in 1940 whilst serving with the Free Polish Air Force, revealed not only his parachute (indicating that he never left the aircraft), but also

[4] Sarkar, Dilip, (1998), *Missing in Action: Resting in Peace?* Ramrod Publications, Worcester

[5] Eksteins, Modris, (2000), *Rites of Spring: the Great War and the Birth of the Modern Age*, Papermac, London

[6] Coombs, Rose, (1990), *Before Endeavours Fade. A Guide to the Battlefields of the First World War*, Battle of Britain Prints International, London

pieces of uniform, a shoe, and personal notes. However, no human remains were reported, and no further action, official or otherwise, has ever been taken. Perhaps, 65 years after the death of men such as Sergeant Duszynski, a better way of remembering or even honouring their individual sacrifice would be to review case by case the possibility of retrieving remains, rather than simply just saying 'No'.

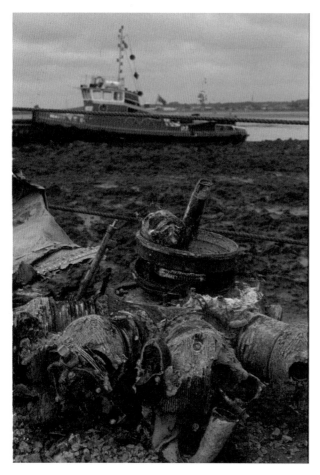

During 2000 a United States Mortuary Affairs team carried out a difficult excavation on a tidal sandbank in the Stour estuary in order to recover the remains of Lieutenant Colonel Earle J Aber and his co-pilot 2nd Lieutenant Maurice J Harper (Mark Evans)

CHAPTER 13

Public Reaction to the Displaying of Human Remains at the Museum of London

Hedley Swain

THE MUSEUM OF LONDON is the largest urban history museum in the world. It was opened in 1976 as the amalgam of two previous museums. Publicly funded from national and local government, it seeks to tell the story of the area now covered by Greater London from prehistory to the present day.[1]

The Museum of London currently holds about 17,000 human skeletons. Apart from a few skeletons and parts of skeletons in the core collections – mainly skulls, normally derived from antiquarian collections – the vast majority are held as part of archaeological excavation archives in the London Archaeological Archive and Research Centre.[2] These skeletons have been recovered as parts of controlled excavations on sites due for redevelopment in Greater London over the last 30 years. All are covered by British Government Home Office licenses, which state either that they must be reburied after study has taken place or, in the more recent examples, that if remains are of high scientific value they can be retained 'archivally' for research use.

All the skeletons are associated with archaeological records that give information about the context and circumstances of their burial. Most come from large assemblages (the largest group of about 10,000 from the medieval hospital of St Mary Spital, Bishopsgate)[3] that make them statistically viable for scientific research.

Most skeletons disturbed by development in London and elsewhere do not end up being studied by archaeologists or stored in museums. They are cleared by

contracting firms and reburied immediately. Only assemblages of proven research potential warrant the expensive and time-consuming exercise of excavation. The skeletons held at the Museum of London are not strictly owned by anyone, as English law does not allow for humans or parts of humans to be owned. Therefore the remains are in the care of the Museum of London either to be studied and then reburied, or to be stored archivally because of their scientific value.

There is no formal guidance or legislation that identifies what constitutes 'sufficient scientific value'. Similarly there is no existing guidance as to how long it is permissible to keep remains before they are reburied, or that covers such issues as whether or not they can be displayed, sampled, photographed or used for teaching. All these matters are left to the discretion of the holding museum.

There is no doubt about the research value of the skeletons held by the Museum, which is currently undertaking a project funded by the Wellcome Trust to produce an online database of 4,000 of them to promote research (see White in this volume). Recent projects have identified the presence of congenital syphilis in medieval skeletons – the disease was previously thought to have been introduced to Europe by Columbus's expedition to Central America (see Thomas in this volume). Another identified major differences between the health of medieval monks and their hospital charges, and another is trying to identify evidence of a known medieval

famine in an assemblage of skeletons from victims of the Black Death. Information recorded for the Wellcome database is also being supplied to doctors at Great Ormond Street Hospital who are studying genetic spinal disorders. At a more basic level the skeletons have given information such as the changing average height of Londoners through time.[4]

Traditionally the skeletons have been treated in the same way as other 'bulk' archaeological finds. That is, kept in plastic bags within cardboard boxes on shelves amongst other archaeological finds in one of the Museum's off-site stores.

The Museum has had skeletons on display in its permanent galleries since it opened in 1976, and still has several on show. It has also occasionally displayed skeletons as part of temporary exhibitions.

In 1998, the then new director Simon Thurley was so fascinated by the work of the Museum's team of archaeological osteologists that he developed the idea for the exhibition *London Bodies*.[5] The exhibition aimed to show how the physical appearance of Londoners has changed through time. It featured a very modernist design by Wordsearch including a number of complete skeletons on mortuary trolleys below perspex domes. The 'clinical' look of the exhibition was influenced by the then just-published book by artist Damien Hurst, *I Want to Spend the Rest of My Life Everywhere, With Everyone, One to One, Always, Forever, Now*,[6] and the recently opened 'Pharmacy' bar in Notting Hill, London. The exhibition also included a number of skeleton parts including that of a medieval stillborn foetus still partly within the pelvis of its mother, who had died in childbirth.

In undertaking the exhibition, the Museum was conscious that some might be disturbed or upset by its content, or simply not wish to see it. For this reason it was carefully shielded from the rest of the museum with clear panels explaining its content. Unaccompanied children and school parties were not allowed to enter. The Museum prepared a statement on the context and use of remains. The aim of this was to force the Museum itself to think through its reasoning behind the exhibition and give a clear and unified message in response to any enquiries.

The exhibition was certainly a success with visitors.

Figures suggest about 15,600 people came specifically to see it. Since detailed records started in 1992, *London Bodies* registered the highest proportion of visitors entering an exhibition and the highest average daily visitor figures of any of the Museum's temporary exhibitions (the figures have since been surpassed by those of other exhibitions).

The visitor comments from the exhibition were kept and analysed. Twenty-eight were left in the visitor comments box and 134 made as part of market research surveys. Of these, 110 were positive and 62 negative (figures do not exactly correlate as some individuals gave more than one view). Of the negative comments only one visitor was unhappy about the ethics of displaying human remains. This compares with 17 who felt that captions and displays were too high; one who was hoping the exhibition would be 'more shocking'; and one who wanted to see more skeletons. Hopefully these figures justify the Museum's belief that the public are happy to see skeletons displayed under the correct circumstances. Ironically, during the run of *London Bodies*, the Museum had to deal with far more complaints about a small exhibition on Oliver Cromwell that had neglected to comment on his actions in Ireland.[7]

When presenting conference papers about the exhibition I have come in for some criticism for the nature of the display, and for the slightly less than serious approach used to attract press coverage. The press launch – put on for journalists to encourage them to review the exhibition and so generate publicity to encourage visitors – was 'lighthearted' and 'gimmicky'. After a themed breakfast of 'long-bone' toast and 'blood' (tomato) juice, we explained that the electricity had failed in our store and gave each journalist a torch. We then led them into the darkened subterranean store to see examples of skeletons explained by our osteologists. The idea was to create a slightly 'creepy' atmosphere and sense of anticipation. Whether it worked or not I am not sure, but there were no complaints or comments at the time. Very few actual skeletons were involved and they were handled only by our osteologists.[8]

One year after *London Bodies*, Museum of London archaeologists unearthed a late Roman stone sarcophagus containing a lead coffin at Spitalfields.[9] It was clearly a very rich burial and possibly had good levels

of survival within the lead coffin. It was brought back to the Museum unopened, and put on display. Media interest was high, which led in turn to a high level of public interest. The coffin was opened one evening after the Museum had closed and the skeleton was immediately put on public display, where it remained for a month. This discovery led to an extra 10,000 visitors coming to the Museum. Some queued for an hour and a half to see the skeleton and other finds. Again there was no negative response from anyone.[10]

The *London Bodies* and Spitalfields experience shows clearly that not only is the vast majority of the public comfortable seeing skeletons in museums, but also on occasions such remains can be a special draw. The Museum has continued to use skeletons in its permanent galleries, including that of a child with rickets in the *World City* gallery that covers the period 1789–1914, and two complete skeletons and several skulls in the *London Before London* gallery that covers the Greater London area in prehistory.[11] Again there has been no negative response.

The Museum has continued to carry out visitor surveys about the use of human remains. These have taken place as part of research for the development of a new *Medieval London* gallery and in association with public events presenting the study of skeletons from excavations. These surveys, normally including about 100 respondents, always produce a figure of over 85% (normally over 95%) in support of the Museum's holding, studying and displaying human remains. Admittedly these surveys have always drawn their respondents from very particular groups: those already choosing to visit the Museum or those with an interest in history and archaeology.

I am not suggesting that this experience should be taken as carte blanche to use human remains indiscriminately. Several factors need to be borne in mind. First, all our skeletons were obtained through 'non-controversial' means; all are unidentified. All are over 150 years old. No communities lay claim to them, and no descendents are likely to claim ancestors from amongst them; as such they might be considered 'uncontested'.

Second, times are changing. London is becoming rapidly more multi-cultural. Key target audiences for the Museum are groups who are likely to be for example

Muslims, many groups of which find close contact with human remains offensive.

Most modern Londoners have what I have called a 'pick'n'mix' belief-set whereby even if they adhere to one strong religious belief they will have borrowed beliefs and ideas from others, and very few Londoners will have a single set of easily identified beliefs. This makes the characterising of opinions more interesting and more complicated.[12]

The very fact that this volume has been published would suggest that the 'intelligentsia' is questioning the use of remains. Through opinion forming, this will filter through to mainstream thought. So, the Museum of London is taking its responsibilities seriously with regard the care and display of remains.

The Museum has formed a Human Remains Working Group that oversees policy. This has provided evidence to, and commented on, the recent government and other reports. The group has also reviewed the long-term care of the skeletons we hold and on research grounds divided them into three categories:

Category one

Human bones that have no potential for scientific research and could be reburied immediately. The Museum has approximately 1,000 skeletons in this category. This group will normally include disarticulated skeletons and parts of skeletons from un-stratified contexts.

[1] Shepperd, F, (1991), *The Treasury of London's Past*, Museum of London, London; Ross, C, and Swain, H, (2001), *Museum of London: 25 Years*, Museum of London, London

[2] Swain, H, (2002A), 'The London Archaeological Archive and Research Centre', in *Current Archaeology*, 179, pp480–82

[3] Thomas, T, (2004), *Life and Death in London's East End: 2000 Years at Spitalfields*, Museum of London, London, and this volume

[4] Werner, A, (1998), *London Bodies*, Museum of London, London

[5] *Ibid*; Museum of London, (1999), *Annual Report for 98–99*, Museum of London, London

[6] Hurst, D, (1998), *I Want to Spend the Rest of My Life Everywhere, With Everyone, One to One, Always, Forever, Now*, Monacelli Press, New York

[7] Museum of London, (1999), *op cit*

[8] *Op cit* pp22–23

[9] Roberts, M, and Swain, H, (eds), (1999 and 2001), *The Spitalfields Roman*, Museum of London, London

[10] *Ibid* and Swain, H, (2000), 'Public Archaeology and the Role of Museums', in *IFA Yearbook*, pp36–7

[11] Swain, H, (2003), 'London Before London', in *Minerva*, 14, 1, pp9–12

[12] Swain, H, (2002B), 'The ethics of displaying human remains from British archaeological sites', in *Public Archaeology*, 2, 2, pp95–100

In November 2004 the Museum reburied the first group of these skeletons: about 350 from the 1986 excavations at Bermondsey Abbey in Southwark.

Category two

Human bones of limited research potential for which long-term storage off-site would appear to be the best solution. There are approximately 300 skeletons in this category. These are normally very small groups of stratified and articulated skeletons. The sample sizes make them too small for valid research at present but it is recognised that future excavation on neighbouring sites might produce more material to make them viable for research.

Category three

Large samples of skeletons that have a high research potential and for which on-site storage is preferable. There are approximately 16,700 boxes (approximately 15,300 remains) in this category.

One of London's local authority cemeteries has agreed to rebury skeletons in mass graves as necessary. In the meantime, all skeletons are now kept in a dedicated store away from other material. The Museum has also compiled a publicly available inventory of all human remains holdings.

The Museum hopes eventually to find a more suitable store for the category two and three skeletons: possibly a redundant church. A recent report by the Church of England and English Heritage[13] has identified the need for such stores, and preliminary discussions are under way to try to find such a site for London.

Although all the above would suggest that the vast majority of the remains will remain in our care, the important principle is to continually review the situation, and remember that all remains are just that – in our care – not part of the permanent collections.

The Museum has also prepared guidelines for the future display of remains that are reproduced here.

Museum of London Guidance for the display of human remains

'Human skeletons are an important part of the Museum of London's archaeological collections and provide important evidence about the past lives of Londoners. If dealt with in a responsible and sensitive way they have the ability to act as a powerful method of interpretation for the Museum.

There is a long tradition of using skeletons in British museums, the vast majority of the British public are familiar with skeletons, are not offended by them, and expect to see them in museums.

The Museum of London will continue to use skeletons in its displays, but will think carefully about when and how this is done, follow careful guidance, best practice where it is available, and be alive to the views of its users.'

Skeletons will be used only if they are part of the Museum's collections and have good provenance.

A named individual will be displayed only if we are happy that it is with the consent of any known descendants.

If a skeleton from an identified community is displayed, it will be done only with the consent of any bona fide living members of that community.

Skeletons will be handled only by, or under the supervision of, appropriate Museum of London staff.

Where a skeleton has been recovered complete, it will be kept complete for display.

A skeleton will be displayed only where the project team is happy that it makes a material contribution to a particular interpretation, and that that contribution could not be made in another way.

Wherever possible skeletons will be displayed in the position and layout in which they were found.

Wherever possible skeletons will be displayed in the coffin or burial surroundings in which they were found.

Skeletons and burials will be displayed in high-quality plain cases.

As a general principle skeletons will not be on 'open display' but located in such a way as to provide them with some 'privacy'. This might be in a specially partitioned or alcoved part of a gallery.

The Museum will invite visitors and users of the Museum to comment on the general and particular display of skeletons, and take note of comments received.

The Museum will not loan skeletons for display to other institutions.

The Museum will review this guidance in the light of changing views in society.

The Human Remains Working Group will make any decisions that are needed over the interpretation of these guidelines.

For more information, please see the Museum of London website: www.museumoflondon.org.uk

[13] Church of England and English Heritage, (2005), *Guidance for Best Practice for Treatment of Human Remains Excavated from Christian Burial Grounds in England*, Church of England and English Heritage, London

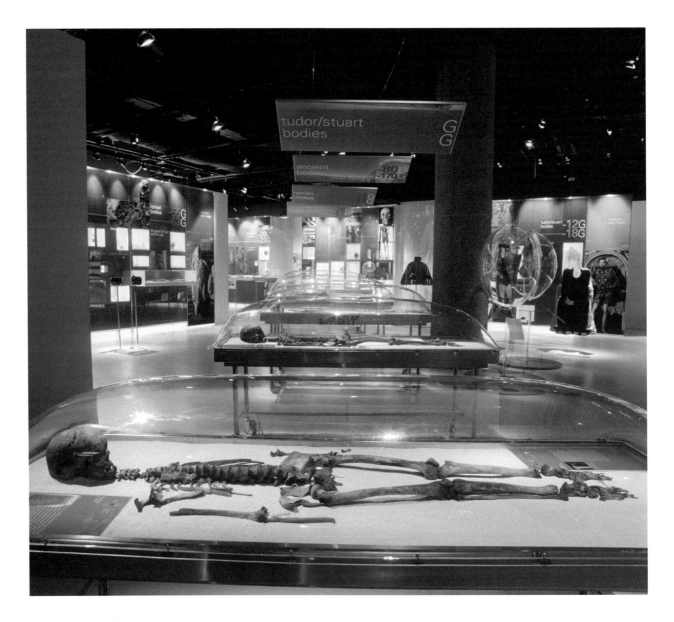

The *London Bodies* exhibition

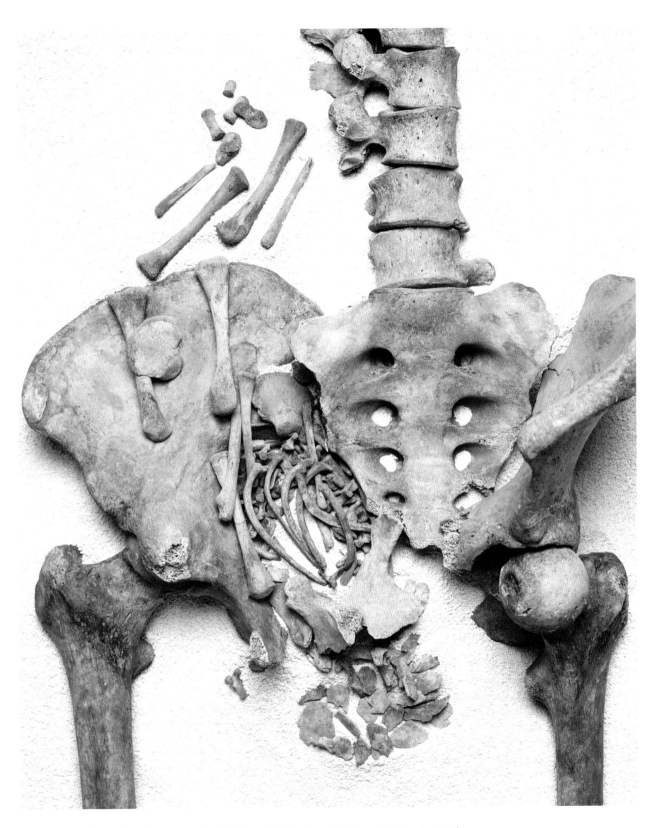

The pelvis of a medieval woman who died in childbirth, as displayed in *London Bodies*

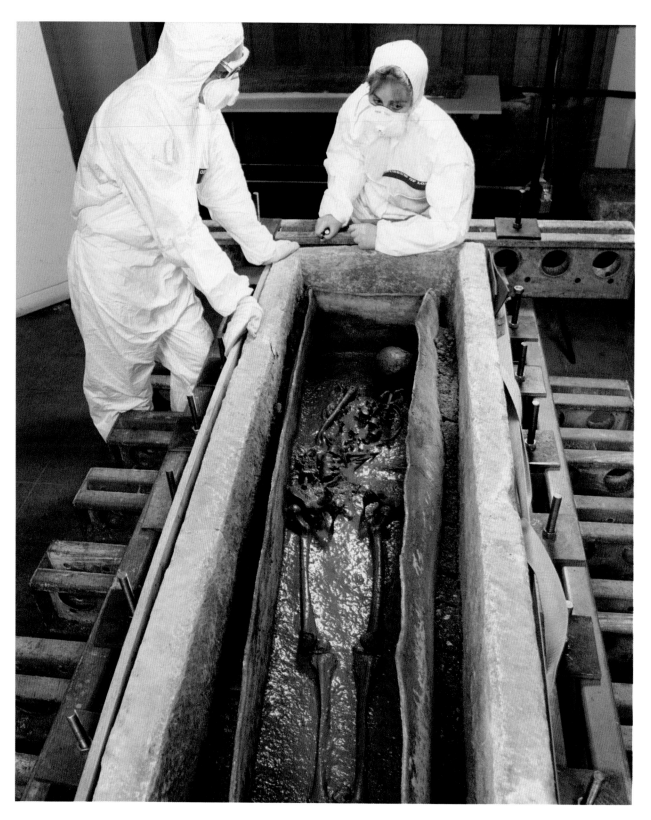

The Spitalfields Roman shortly after her coffin was first opened

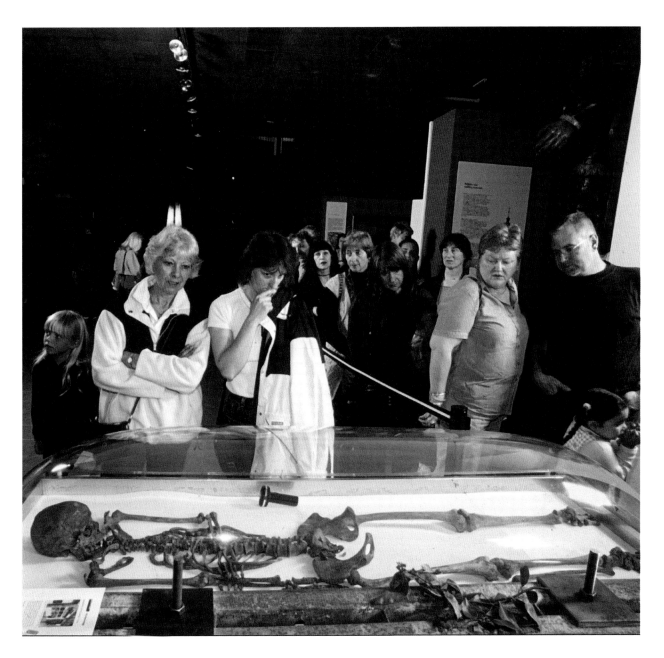

The Spitalfields Roman on public display

The Museum of London's Wellcome Osteological Research Database

Bill White

THE MUSEUM OF LONDON, through the London Archaeological Archive Research Centre (LAARC), curates more than 17,000 human skeletons. In 2002, The Department for Culture, Media and Sport (DCMS) Working Party under Professor Palmer identified 132 United Kingdom institutions holding among them 61,000 human remains.[1] Even if this proves to be an underestimate, it is clear that the Museum of London (MoL) is a major player. Its vast archive has accumulated during urban archaeology in the Greater London area during the past 30 years. These human remains are not the result of prospecting, but have been acquired during rescue (salvage) archaeology in advance of building development or redevelopment.

Acquired eclectically, the skeletal material covers all periods of London history, from prehistoric to post-medieval and, hence, constitutes an important resource for research. Much research in Britain is based upon a limited series of collections housed in universities or museums. Such collections tend to be derived from one or two archaeological sites each and therefore are much smaller than the MoL's holdings. Of the larger collections in Britain some are charnel in nature (for example those in Hythe, Kent or Rothwell, Northamptonshire), others comprise mainly specimens exhibiting pathology (such as the Hunterian Museum at the Royal College of Surgeons of London), or are chiefly anthropological in character, including skeletal material from around the world but not necessarily entire skeletons (for example

the Natural History Museum, South Kensington or the Duckworth Laboratory, University of Cambridge).

The LAARC, by contrast, tends to contain stratified samples of complete skeletons. Indeed, these currently comprise the largest scientifically excavated and documented human bone assemblage known from any city in the world. This dated material provides a unique opportunity to follow trends through time in a major urban centre. The assemblage is also multi-focal in that it may be used for teaching purposes yet it remains available to Museum personnel or external academic bodies for hypothesis-driven research projects.

In common with other holdings of skeletal and other materials in museums, universities and archaeological units, the human remains from many London archaeological sites were largely unknown, unpublished, and little studied; and reposed unused in a dedicated store. Brian Connell of the Museum of London Specialist Services, now the lead osteoarchaelogist in the St Mary Spital osteological recording project, had the idea of producing an electronic database encompassing all the skeletons. This would be used to disseminate detailed information about the holdings. In 2002 an application was made to the Wellcome Trust for a grant to enter skeletal data to construct such a database, in order to unlock the research potential of about 5,000 human skeletons from the larger archaeological sites in London. The database was developed in-house, using recording forms re-designed by Brian Connell and converted into

electronic format by Peter Rauxloh, the Museum's IT manager.[2] The database uses an Oracle relational database and had been devised and tested during the direct recording of skeletons from the St Mary Spital project. Accordingly a major aim of the Wellcome Osteological Research Database (WORD) project, set up under an award from the trust in 2003, is to analyse and record the skeletons directly onto the electronic database. Meanwhile, archaeological site summaries and interpretative reports will be integrated into the database with the aim of making the cumulative data available via the internet.

The completed database should have the capacity to resolve a number of questions at population level pertaining to the biocultural adaptation of the people of London as the city underwent complex social, environmental, commercial and political changes. These changes included urbanisation, commercialisation (with expanding trade links via the Port of London and into the hinterland of the metropolis) and industrialisation.

Characterisation of the state of health of the populace can be addressed for all historical periods via analysis of dental disease, dietary status, degenerative disease, neoplastic pathology, infection, trauma and so on. Remote researchers will be able to access the databank in order to abstract information on demography, skeletal measurements and prevalence of pathological conditions. Furthermore, it will be available to assist them in the formulation of research design. Access to the database will also allow the identification of a specific archaeological site or sites. The documentation of osteological indicators of disease will permit scholars to identify key bone specimens to use in their own project designs.

The database allows rapid data capture by computerised direct entry. Two entire skeletons can be recorded exhaustively by one operative per working day. The electronic fields for observations match the pages of the paper precursor format. The first field allows a catalogue of all the bones present in the excavated skeleton to be compiled, noting the condition of preservation and completeness. Subsequent fields allow for the recording of metric and non-metric information to minimum standards. All palaeopathology recording makes use of

free text on the database and is based on the accurate description of the location, type of bone alteration and distribution throughout the skeleton, as recommended in guidelines published by the British Association for Biological Anthropology and Osteoarchaeology.[3] The completion of the electronic database will involve the detailed examination and recording of about two million human bones across the two major projects.

Sites included in the project

The WORD project involves the recording of 4,840 skeletons from 55 different archaeological sites in London. The skeletons obtained were from all historical periods. These are summarised in Table 1.

Table 1 Numbers of human skeletons included in the WORD project

Date	Number of individuals
Romano-British	975
Anglo-Saxon	80
Medieval (excluding St Mary Spital)	2,240
Post-medieval/Early Modern	1,545
Total	4,840

[1] DCMS, (2004), *Care of Historic Human Remains: a consultation on the report of the working group on human remains*, Department for Culture, Media and Sport, London

[2] Connell, B, and Rauxloh, P, (2003), *A Rapid Method for Recording Human Skeletal Data*, MoLAS (unpublished), London

[3] Roberts, C, and Connell, B, (2004), 'Guidance on recoding pathology' in Brickley, M, and McKinley, J I, (eds), (2004), *Guidelines to the Standards for the Recording of Human Remains*, IFA Paper No7, British Association for Biological Anthropology and Osteoarchaeology/Institute of Field Archaeologists, Reading, pp34–39

The Royal Mint site

Excavations in 1986–88 on the site of the Royal Mint recorded substantial parts of two separate periods of medieval burial. The earlier was a large 'catastrophe cemetery' associated with the Black Death (1348–50). It covered approximately 2ha (4.9 acres) in which 750 burials were clustered in two groups, termed the Eastern and Western catastrophe cemeteries, some 50m apart. The later burial ground represented the monastic cemeteries associated with the Cistercian Abbey of St Mary Graces (1350–1540), from which 420 burials were recorded. This site proved of great interest to academic researchers as it included the sample of victims of the Black Death. For this reason it was decided that the Royal Mint site should be the first to be recorded fully on the database. Details of 1,034 individual skeletons have been entered, including those of 616 skeletons from the catastrophe cemetery of 1348–50. Work continues on the remaining 3,800 skeletons from all periods that were obtained from the other 54 archaeological sites.

Research and reburial issues

The excavated human remains now curated in the Rotunda Store at the Museum of London were rescued in advance of development and cannot be reburied at their original sites, as these have been built upon. They are anonymous and, although they may be capable of telling us much, they cannot reveal their own names. Tracing direct descendants or close family members hence is impossible. They are retained by the LAARC under burial licences issued by HM Home Office, under the powers of Section 25 of the Burial Act 1857, for the purposes of scientific examination. These licences specify that the remains be treated with care, respect and decency, though the wording of the licence can vary. A growing number of burial licences direct that remains be retained for continuing research if considered of sufficient scientific importance, or reburied if not. In most cases, however, it is understood that the remains will be reinterred on completion of the scientific investigation. One of the problems that arises, therefore, lies in judging when the potential for scientific research can be deemed to have been exhausted.

The past 50 years have seen the development of sophisticated scientific techniques that can be used in human bone studies, and have informed and enhanced the analytical results thereby. These include radiocarbon dating, the Polymerase chain reaction (PCR) in DNA analysis and the various forms of stable isotope analysis. These refinements have not merely been applied on new excavations but frequently have been employed to re-visit human skeletal material collected long before. During the next few years, analytical methods of increasing subtlety and power will be developed. The issue regarding which type of samples should be retained in order to both develop and benefit from these more elegant and efficient techniques therefore needs careful consideration. However, the types of material retained in the Museum's store offer certain ready possibilities.

The WORD Project specifies the inclusion of the human skeletal remains from London archaeological sites with a minimum sample size of 50. This choice was made in order to establish the groundwork for population-based studies. However, about 300 skeletons in storage are derived from 100 sites that produced much smaller samples: often merely a single individual and rarely reaching double figures. It may prove that some of these are derived from areas where there is reason to expect that future excavations in the vicinity will generate a large cemetery sample. Unless such minor groupings can be subsumed into a cumulative sample they will remain of limited scientific interest. These remains are candidates for storage off-site until required.

As mentioned, it may not always be simple to determine when the research potential of a group of skeletons has been fulfilled, but it is easier for one category of human remains in particular, that of 'disarticulated bones'. Disarticulated bone is bone that has become separated from buried skeletons by activities on the cemetery site subsequent to the original act of burial. When a burial ground is in use for a prolonged period, the digging of fresh graves may disturb the occupants of earlier graves. In the past, the gravediggers or sextons were unconcerned about such disturbances and did not take the trouble to restore these stray bones to their original graves. Comparable actions occurred in disused graveyards that had been built over, where the effects of the subsequent building operations were to

disturb the original interments. These disarticulated bones can no longer be attributed to a particular person who was buried there. Apart from certain parts of the pelvis or skull, they cannot be identified even as to age or sex. Furthermore, a date for the death of the individual person cannot be obtained readily. Although these bones may show pathology that is worth recording, they cannot be regarded as having intrinsic scientific value.[4] Their retention cannot be justified upon any grounds. Archaeological sites in London have produced variable quantities of such bone and there are precedents for the reburial of disarticulated bone well in advance of that of the skeletons from the primary burials at the same site. The reburial of disarticulated human bone continues, chiefly at the City of London Cemetery. The relative importance of samples of human remains from the point of view of scientific research is kept under constant review and reburial considered on a case-by-case basis.

Meanwhile, the Museum's assemblage of human skeletons has already attracted a large number of researchers from many academic establishments from around the world. Thus, we have been able to furnish research material for scholars from Toronto and McMaster Universities in Canada, Penn State University and the Smithsonian Institution in the United States and from the universities of Queensland and Tokyo. In the United Kingdom, we have assisted in post-graduate and post-doctoral research on human remains, collaborating with staff and students from the universities of Birmingham, Bournemouth, Bradford, Durham, Kingston, London South Bank, Oxford, Roehampton, Sheffield, Southampton, the University College London, University of Manchester Institute of Science and Technology, and York University. We have also supported research on human skeletal remains by representatives of other institutions such as St Bartholomew's Hospital and the Royal London Medical School, the British Museum, the Natural History Museum, English Heritage, the Institute of Archaeology and the Wellcome Institute for the History of Medicine.

Among the long-term projects that our collaborators have embarked upon are the following:

- cortical bone loss – changes in the severity of oste-

oporosis in London over 1,600 years
- evidence for experience of the Great Famine of 1315–17 in those who died from the Black Death in 1348–50
- comparison of spinal changes in the skeletons of individuals of different monastic orders buried in London in the Middle Ages
- influence of diet and environment on child growth and development in London (various periods)
- health status of adults and juveniles in early modern London as compared to other contemporary cities throughout the world.

Other projects have sought information on London skeletons at sub-microscopic level, largely involving analysis for ancient DNA (aDNA) in bones:

- aDNA analysis for evidence of bubonic plague *Yersinia pestis* in Black Death victims
- aDNA analysis in the distinction between brucellosis (*Brucella abortus*) and tuberculosis (*Mycobacterium tuberculosis* and *M bovis*) in medieval skeletons
- aDNA analysis for attempted confirmation of venereal syphilis (*Treponema pallidum*) in medieval and post-medieval skeletons
- estimation of the age of weaning via stable isotope analysis
- evidence for immigration into London via stable isotope analysis.

Conclusions

Many of the 36 academic researchers involved in the previous projects have signed up for further research on the key human skeletal resource curated at the MoL. Most of them originally learned of the assemblage by word of mouth but when the details of the archaeological skeletons are made available online around the end of 2006, a vastly increased pressure on research material is expected. The Centre for Human Archaeology will be gearing up to respond to and manage these increased requests by would-be collaborators on research programmes.

[4] Mays, S, Brickley, M, and Dodwell, N, (2002), *Human Bones from Archaeological Sites: guidelines for producing assessment documents and archaeological reports (Centre for Archaeology Guidelines)*, English Heritage, Swindon

Excavations at St Mary Spital

The Museum of London Osteology lab

Scientific Research on Archaeological Human Remains in the United Kingdom: Current Trends and Future Possibilities

Jelena Bekvalac, Lynne Cowal & Richard Mikulski

Recent controversial events such as the Alder Hey inquiry[1] have resulted in debates questioning the moral implications of studying human remains. Although focused mainly on soft tissue retention, these debates also concern human skeletal remains held by museums and other institutions within the United Kingdom. The importance of scientific research, however, should not be diminished or underestimated as a result. Many institutions and organisations within the United Kingdom are currently involved in scientific analysis of archaeological human remains. Due to the quality and quantity of archaeological assemblages available for study, there is keen interest from international scientists eager to take advantage of research opportunities. The diversity of scientific research pertaining to human remains is extremely broad and complex, covering many fields of expertise. This chapter will focus on aspects of medical, forensic, archaeological and evolutionary research and will aim to give a broad overview of current research in the United Kingdom, while discussing potential benefits from the scientific research of human remains assemblages.

Medical benefits

Scientific analysis of archaeological human remains can contribute to current medical research projects. The human skeleton comprises a major biological repository for information pertaining to the pattern and spread of disease, evolution of pathogens and a new understanding of modern illnesses. Research on archaeological human remains has driven scientists to question former medical assumptions. It has now been shown that some diseases that had been considered to be associated with modern living, for example osteoporosis and rheumatoid arthritis, can be found in archaeological populations.[2] This has resulted in a revision of ideas within different medical sectors. Another continuing debate concerns the origin of syphilis, highlighting the complex epidemiology of treponemal diseases. The presence of venereal syphilis in the British Isles and Europe was regarded as the result of its having been brought from the New World by Columbus. The credibility of this theory now has been called into question by archaeological skeletal evidence from pre-conquest populations, including examples from medieval England.[3]

The evolutionary history of bacterial infections is a branch of medical science that also benefits from con-

1 Burton, J L, and Wells, M, (2001), 'The Alder Hey affair: implications for pathology practice', in *Journal of Clinical Pathology* 2001, 54, pp820–23

2 Hacking, P, Allen, T, and Rogers, J, (1994), 'Rheumatoid Arthritis in a Medieval Skeleton', in *International Journal of Osteoarchaeology* 4, pp251–55; Mays, S, (1999), 'Osteoporosis in Earlier Human Populations', in *Journal of Clinical Densitometry* 2, pp71–78

3 Mays, S, Crane-Kramer, G, and Bayliss, A, (2003), 'Two Probable cases of Treponemal Disease of Medieval Date from England', in *American Journal of Physical Anthropology*, 120, pp133–43; Baker, B J, and Armelagos, G J, (1988), 'The Origin and Antiquity of Syphilis', in *Current Anthropology*, 29, pp703–37

tinued research on archaeological human remains. Despite several decades of research regarding the evolution of different bacteria, there is still much to be learned about how they mutate over time. A modern example of this is MRSA, which mutated from the previously controllable strains of *Staphylococcus aureus*. It has been contended that the evolution of other infective micro-organisms may be traced through the archaeological record.[4] Attention has recently focused on the current dramatic rise in cases of tuberculosis and syphilis, particularly in urban centres in the West. While these two diseases potentially can be controlled by modern medicine, they will still have the capability of breaking out in future pandemics. By studying the epidemiology of such diseases in archaeological skeletons, scientists expect to gain a better understanding of the pathogens involved, which will help to determine the best course of action for dealing with future outbreaks.

Forensic benefits

The primary aim of forensic anthropological investigations is to determine the identity of an individual through assessment of sex, age, dentition and pathological configuration. Developments in the field of forensic anthropology have been driven largely by archaeological skeletal analysis, in which many British institutions are currently engaged. Analytical procedures that continue to be improved upon specifically concern the ageing and sexing of skeletal human remains.[5] These techniques continue to be refined with reference to archaeological collections, such as the population of known age and sex from Christ Church Spitalfields, London, which provide the opportunity for techniques to be tested and thereby the accuracy assessed. Furthermore, analysis of remains is not dedicated solely to the identification of adults but also of sub-adults. Whilst the ability to attribute sex to an adult is more clear-cut, sexing sub-adults remains a contentious subject and research in this area is ongoing. Continuing global conflicts, acts of terrorism, human rights atrocities and other mass disasters stress the need for such studies to provide greater reliability of identification and to preserve the integrity of evidence.

The study of taphonomy (the conditions and processes acting upon remains following death/deposition)

is crucial to understanding how the burial environment affects the body after death ('diagenesis'). Through the study of archaeological assemblages, insight into the survival and decomposition of bone can be gained. This can be beneficial to modern forensic cases, providing information relating to movement of the body, scavenging, weathering, diagenetic modification and the general burial environment.[6] Cox and Bell[7] provided an example of the benefits of this type of study when they looked at the skeletal survival within archaeological assemblages. The data gathered was later used as a comparison in modern forensic cases to prevent misinterpretation of missing skeletal elements.

The skeleton provides a record of the traumatic events an individual has experienced during life. It is possible to distinguish between trauma that has occurred before death (ante-mortem), that which has occurred around the time of death (peri-mortem) and changes or breakages occurring after death (post-mortem). In a forensic context, the ability to make such distinctions is especially important when considering the possibility of torture and human rights abuses. Further research is being carried out to investigate and identify the effects of different weapons or objects used on the body and to compile an injury database for skeletal material.[8]

Archaeology

It is largely through archaeological excavation that modern populations have an insight into the lives of people who lived in the past. From an archaeological perspective, the scientific research on human remains has blossomed in the United Kingdom in the last 20 years. Mays[9] reviewed the literature on human osteological work in Britain, finding it to be a burgeoning field wherein the vast bulk of studies used indigenous British skeletal remains, rather than material of British colonial acquisition. The study and analysis of human remains of archaeological origin incorporates elements discussed above, while also providing further insight into past diet, migration patterns, medical care and demography.

Over the last ten years there has been a growing trend in research into stable isotope analysis, which has allowed researchers to gain insight into the diet of past populations.[10] Information relating to diet can be

gleaned from bone sample analysis and the multi-study investigation of human teeth.[11] Subsequent dental studies have also helped archaeologists investigate specific historical events, such as the Great Famine of 1315–17. Developmental defects (enamel hypoplasia) found in the dental enamel of adults buried in Black Death plague pits have provided new insight into the impact of famine on an urban population. Individuals buried in the plague trenches at the Royal Mint site, London (1348–9), who were in their 30s at the time of their death, would have lived through the Great Famine as children. Since the enamel of teeth forms during childhood, it was possible to use their dental development to investigate the impact of the famine on their overall health. The timing of growth disturbances could then be compared to the detailed chronology of the Great Famine and the data is further complemented by historical documents referring to the movement and trade of comestibles such as wheat and corn.[12]

Archaeological assemblages of human remains have provided data on the evolution of medical treatment, surgical intervention and the setting of broken limbs, among the more obvious examples. Such cases illustrate a high degree of social care amongst communities in the past. From the skeleton, it is possible to identify intervention that may have been taken to assist the healing process, for example in the wounds from interpersonal violence. It is possible to see cases where fractures have been realigned and set and to trace the development of surgical treatment such as amputation and trepanation.[13] These discoveries can be complemented by reference material held in institutions, for example the Royal College of Surgeons, where it is also possible to examine the instruments used for surgical procedures themselves. Furthermore, evidence found on skeletons that have had craniotomies and other postmortem treatments show a growing desire on the part of medical practitioners to learn about the disease process and how the human body works. These factors, from an archaeological perspective, illustrate the type of care and medical intervention shown to people over the ages and how such care has changed with medical advances.

The demographic characteristics of past populations are obtained by studying collective groups rather than single individuals. This allows us to better under-

stand the impact of different environments on populations and to compile profiles for sites from different time periods. When combined with modern advances in stable isotope analysis, we can investigate patterns of population migration and of geographical profiling of distant populations, allowing long-term trends and patterns to be observed.[14] Statistically such results are more dependable in larger samples. The archiving of large samples of human remains has allowed greater insight into the nature of these populations.

Human evolution

Although the majority of the remains used in evolutionary research are not of British origin and are traced back many millennia, comparative research and analysis are imperative in the understanding our evolution and origins. The parameters of evolutionary studies cannot simply be placed in the remit of research in the United Kingdom: research is on a global scale. The results obtained are the result of collaboration amongst scientists worldwide, using fossilised material from numerous sites and skills and expertise from numerous institutions. The history

4 Manchester, K, (1984), 'Tuberculosis and Leprosy in Antiquity: an Interpretation', in *Medical History*, 28, pp162–73

5 Buckberry, J L, and Chamberlain, A T, (2002), 'Age Estimation from the Auricular Surface of the Ilium: a Revised Method', in *American Journal of Physical Anthropology*, 119, pp231–39

6 Haglund, W D, and Sorg, M H, (1996), *Forensic Taphonomy: The Postmortem Fate of Human Remains*, CRC Press, Boca Raton, Florida; Haglund, W D, and Sorg, M H, (2001), *Advances in Forensic Taphonomy: Method, Theory and Archaeological Perspective*, CRC Press, Boca Raton, Florida

7 Cox, M J, and Bell, L M, (1999), 'Recovery of Human Skeletal Elements From a Recent United Kingdom Murder Enquiry: Preservational Signatures', in *Journal of Forensic Sciences*, 44, pp945–50

8 Black, S, http://www.dundee.ac.uk/biocentre/PDF/uafa_sblack.pdf, latest update: 16/11/2004

9 Mays, S, (1997a), 'A Perspective on Human Osteoarchaeology in Britain', in *International Journal of Osteoarchaeology*, 7, pp600–604

10 Mays, S, (1997b), 'Carbon Stable Isotope Ratios in Medieval and Later Human Skeletons from Northern England', *Journal of Forensic Science*, 24, pp 561–67

11 Brothwell, D R, (1959), 'Teeth in Earlier Human Populations', in *Proc Nutrition Society*, 18, pp59–65; Hillson, S, (1996), in *Dental Anthropology*, Cambridge University Press, Cambridge; Whittaker, D K, and Molleson, T, (1996), 'Caries Prevalence in the Dentition of a Late Eighteenth Century Population', in *Archives Oral Biology*, 41, pp44–61

12 Antoine, D M, Hillson, S W, Keene, D, Dean, M C, and Milne, G, (2005), 'Using growth structures in teeth from victims of the Black Death to investigate the effects of the Great Famine (AD 1315–1317)', in *American Journal of Physical Anthropology*, 40, p65; Antoine, D M, and Hillson, S W, (2005), Famine, Black Death and health in fourteenth-century London, *Archaeology International* [8] 2004/5, Institute of Archaeology, UCL, in press, London

13 Fiorato, V, Boylson, A, and Knusel, C, (2000), *Blood Red Roses: The Archaeology of a Mass Grave from the Battle of Towton AD 1461*, Oxbow Books, Oxford

14 Mays, S, (1997b), *op cit*

of our origins is ongoing. This has been illustrated in the recent discovery of *Homo floresiensis* from the Late Pleistocene of Flores, found in a large limestone cave at Liang Bua, Indonesia. By comparing the cranial and postcranial elements of previously discovered hominids it has been possible to assign these remains to a new species. The results have been invaluable in allowing physical anthropologists to learn more about the genus Homo: 'Importantly, *H floresiensis* shows that the genus Homo is morphologically more varied and flexible in its adaptive responses than previously thought.'[15] Furthermore, the analysis of such a discovery has changed '... our understanding of late human evolutionary geography, biology and culture.'[16]

In summary

Scientific research of archaeological human remains in the United Kingdom consists of a multiplicity of scientific fields involving an overlap in medical, forensic and archaeological data. The wide variety of studies relating to these fields can only continue to enrich and broaden our scientific research horizons.

This research has grown in momentum since the 1980s and continues to develop new avenues of investigation, through both the evolution of technology and the interaction and collaboration of researchers working in previously unrelated and unconnected fields. This is exemplified by the work of Antoine et al[17] funded by the Wellcome Trust.

Recently however, this research has been tempered by events questioning the moral implications of retaining human remains for scientific research. The issues of repatriation and reburial have also come to the fore, bringing into question the future of scientific research in the United Kingdom. Despite this, it is clear that scientific research of archaeological human remains has facilitated the development of new investigative techniques and methods, furthering our knowledge in many areas pertinent to both our past and our present.

If human skeletal remains are properly curated and looked after with due care and respect they are a valuable research source. The blanket reburial of valuable human remains assemblages would for example have prohibited the development and technical progress of

several areas of medical, forensic and archaeological investigations. This is particularly highlighted through the enhancement of ancient DNA (aDNA) studies and stable isotope analysis. The ability to revisit collections has been integral to the refinement of such techniques. It is unquestionable that archaeological human remains assemblages are an immensely rich repository of potential information and understanding.

Bill White, osteologist at The Museum of London

[15] Brown, P, Sutikna, T, Morwood, M J, Soejono, R P, Jatmiko, Wayhu Satomo, E, and Rokus Awe Due, (2004), 'A New Small-bodied Hominin from the Late Pleistocene of Flores, Indonesia', in *Nature*, 431, pp1055–61

[16] Mirazon Lahr, M, and Foley, R, (2004), 'Human Evolution Writ Small', in *Nature*, 431, pp1043–44

[17] Antoine, D M, (2005a, 2005b), *op cit*

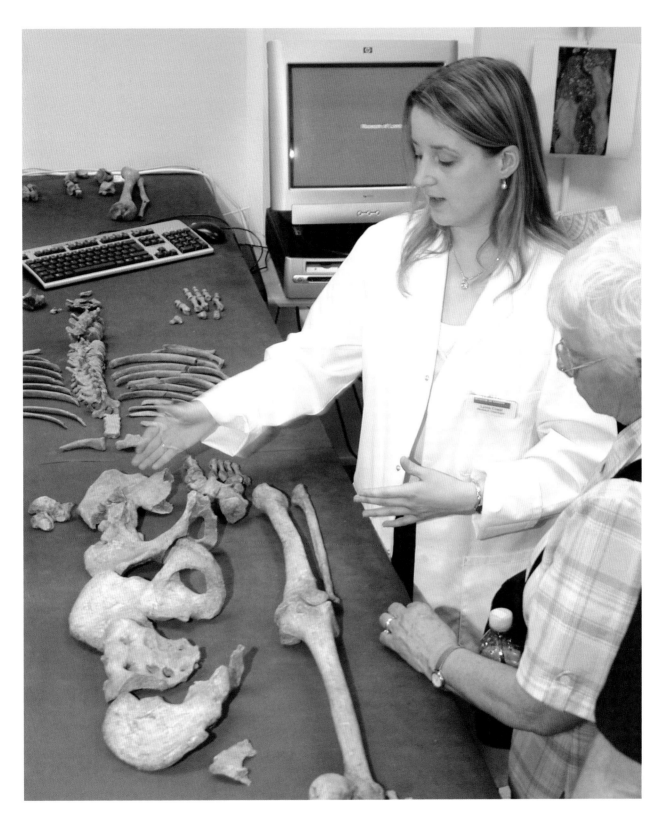

Metric analysis of human skeletal remains can provide insight into general population health and the ethnic background of the individual

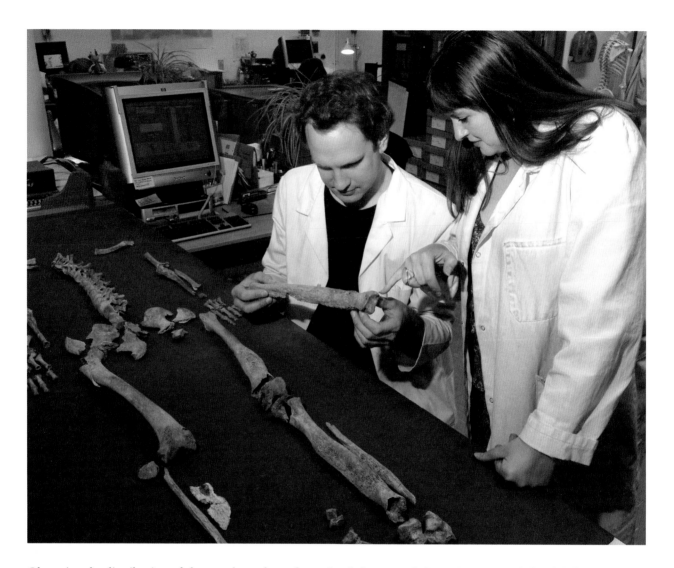

Observing the distribution of changes throughout the entire skeleton can help to give a more defined differential diagnosis of pathological conditions, but human remains can yield important information even when incomplete and/or fragmentary

The Cemetery at the Priory and Hospital of St Mary Spital

Chris Thomas

THE PRIORY AND HOSPITAL of St Mary Spital was the largest medieval hospital in London and one of the largest in Britain. It is defined by the State as a nationally important site and as such is accorded the status of a Scheduled Ancient Monument. The Museum of London Archaeology Service (MoLAS) and its predecessor bodies have been excavating on the site in advance of various redevelopment projects since the 1980s. Their work is described in MoLAS Monograph 1[1], which was published in 1997.

The relocation of Spitalfields Market in the early 1990s as part of a wider policy of moving London markets out of the centre of town prompted a major regeneration of the area. The historic 19th-century buildings have been retained and form a thriving local market today, whilst the remainder of the site has been redeveloped as residential, office and retail units. To make the new development sustainable, all traffic was put underground and the ground-level space set aside for pedestrians. The 4–5m depth of archaeological deposits covering the area, spanning from the 19th century right back to the Roman period, had to be removed and a massive programme of archaeological excavations, funded by the Spitalfields Development Group, was undertaken.

During this programme, which took place on and off from 1991 to 2004, large parts of St Mary Spital were excavated, including parts of the outer precinct, the gardens, parts of the church, the canons' infirmary complex, large numbers of houses and workshops and almost the entire medieval cemetery.

The Priory and Hospital of St Mary-without-Bishopsgate, more commonly known as St Mary Spital, was founded in the late 12th century by a group of wealthy Londoners, prominent amongst whom were Walter and Roisia Brunius. The hospital was founded to look after the sick, the poor, women in childbirth, and the children of women who died in childbirth up to the age of eight. It is thought to have catered for 12 inmates initially, before a major refoundation in 1235 increased its capacity to 60. New infirmaries were built in the late 13th and early 14th centuries, increasing its capacity still further, perhaps to the 180 beds that John Stow, writing at the end of the 16th century, claims it to have had.

The skeletal assemblage and our research strategy

The main medieval cemetery lay to the southeast of the church and covered an area of about 5,500m². A total of 10,516 burials were excavated from this cemetery making it possibly the largest archaeologically excavated cemetery in the world. The completeness of the skeletons varied due to later truncation usually by other burials, and a team of four osteologists is engaged in a three-year

[1] Thomas, C, Sloane, B, and Philpotts, C, (1997), *Excavations at the Priory and Hospital of St Mary Spital*, Museum of London Archaeology Service, London

programme to record almost 7,000 skeletons onto a relational database designed for the purpose. Analysis will take place once the recording is complete and publication of the results is due in 2008.

A series of research aims were initiated before excavation and have been developed and adjusted throughout the excavation and post-excavation processes. The Museum of London sees the long-term curation of a large part of this extraordinary assemblage as essential for further scientific study. Already the scientific community, as it becomes aware of the work being undertaken and the material available for study, is extremely keen to carry out collaborative ventures. Joint work programmes include a project with colleagues from Reading University on isotopic studies to try to locate where people were born and bred, and, with colleagues from the University of New Mexico, on the DNA of tuberculosis, a disease that affected many of those buried at the cemetery.

The questions that are being asked of this material are enormous in number and highly varied but it is worth considering some of the more general research questions and aims of the project. The skeletal material is not being looked at in isolation: the value of this material is that it has been excavated archaeologically with great care and thoroughness. The stratigraphic records have been used to allocate the skeletons to different periods of time, allowing the chronological developments to be examined in detail. Their location can tell us much about the use and management of a cemetery, and the way the bodies were buried and the artefacts that were buried with them tell us much about medieval burial practice – an important insight into the medieval mind and attitudes towards life and death.

Osteologically, various issues are being examined, all of which can be charted chronologically allowing analysis of the patterns of development throughout the 350-year history of the hospital. All are aimed at gaining a greater understanding of those who attended, worked in or donated to a medieval hospital and the wider London and English medieval population as a whole. The changing nature of the demographics is a central theme of the project: for instance how did the life-expectancy of the medieval population change over time? Was that life-expectancy the same for men as for women? Who were the people buried in the cemetery and why were they buried there? Do the demographics of a hospital population contrast with those of other medieval populations?

There are then a series of question relating to the recorded palaeopathologies. What was the general health of the population? What evidence is there for lifestyle- or work-related disease? What is the evidence of infectious disease? Does the prevalence of these diseases change over time and do they affect different sections of the community differently? What is the evidence of trauma amongst the population? And what evidence is there of medical or surgical intervention? These are just a tiny sample of questions that can be asked of this assemblage but make clear the enormous potential of this body of evidence whose size will crucially allow us to overcome the usual statistical problems associated with small groups of material.

The results

This long-term project is only halfway through analysis and thus any statements given here are provisional, but certain hypotheses can be put forward and some of the results to date set out. All of the human remains were excavated under the conditions of burial licences issues by the Home Office. These conditions, plus conditions imposed by the local authority's environmental health department, ensured that all the remains were treated with dignity and respect during excavation and subsequently during storage and analysis. The excavation was screened from the public so that no one could inadvertently see the removal of the skeletons, and all visitors were warned that there were skeletons on the site.

Once the analysis is complete we intend to retain a large sample of the skeletons (in particular those that are complete enough to provide information on sex and age) and rebury the remainder in consecrated ground. Both English Heritage and the Museum of London believe that the future research potential of these remains is enormous, particularly since analysis techniques such as DNA and istopic studies are only in their infancy and may be retrospectively applied.

Cemetery use and burial practice

The 10,516 burials excavated to date represent only a proportion of the original medieval cemetery population. Some small areas are not yet excavated, some destruction has been caused by later activity on the site, and some by later burials disturbing earlier ones. The most severe damage was incurred during work on the 1920s extension of Spitalfields Market when the cemetery was destroyed without record (although about 1,000 skulls were measured by a contemporary osteologist). This was a serious loss of potential information as well as a flagrant disregard for the care and reverence owed to the dead.

An estimate of the likely total number of interments in the main cemetery outside the church is approximately 18,000. Of these, about half – or a little over 9,000 – were probably buried in single graves whilst the remainder were buried in mass-burial pits. These mass-burial graves break down into three broad categories: vertical stacks from two to 11 bodies buried one on top of the other; single layered buried pits with up to seven (but usually two) bodies in each; and multi-layered pits of eight to 45 bodies in a single pit. These large pits were focused, in the main, along the southern and eastern extremities of the cemetery, at the furthest distance from the church. There seem to have been two broad phases to them: the initial phase containing ten to 20 individuals and a secondary phase cut though the first comprising much larger graves aligned due west-east, often containing upwards of 30 individuals.

Radiocarbon dating has been carried out on a few skeletons from these pits and suggests that the people died somewhere between say 1280 and 1320. In some of the second phase pits, whole limbs were found which could not have belonged to individuals in those pits. One possible explanation is that they originated in the first phase pits. Given that the limbs were still articulated, it would seem reasonable to infer that the second phase burial pits were dug no more than a handful of years after the first, possibly much less. This suggests that, certainly in the southern part of the site, the mass-burial pits may contain people who died in a single event over a relatively short time period. Certainly within the pits themselves, there was often little or no soil between the skeletons suggesting that the

burials took place in a single event, not over weeks. In almost all cases the burials were laid in the traditional Christian manner – on their backs with their heads to the west. Occasional prone – face down – burials were most probably accidental instances of the corpse rolling over when dropped into the pit, leaving the gravedigger reluctant to climb through the mass of corpses to right it. There were, however, a number of instances of burials aligned south–north at the feet of the other skeletons – probably due to lack of space in the pit.

So who were the people interred here? How many of them were inmates or officials at the hospital and how many were from outside the establishment? Certainly officials at the hospital are represented. Doubtless the lay sisters – the equivalent of hospital nurses – were buried in the main cemetery although no analysis has yet been carried out to identify whether there were specific areas designated for them. We have evidence of other members of the hospital community being buried in the cemetery: there are seven instances of priest burials, for example, each of which included the symbolic pewter chalice and paten. There may have been more but unfortunately the areas where priests seem to have been buried had been heavily disturbed. Benefactors were also buried in the cemetery.

Seven tombs have been discovered in the cemetery. These were commonly sited in prominent positions, no doubt to advertise the occupant's importance. Two substantial tombs with below-ground structures were sited in the south-western corner in front of the charnel house. One had been badly disturbed whilst the other contained the remains of a woman with a late 14th-century papal bulla, a papal indulgence thought to have been granted for worthy or charitable deeds which was believed to allow the recipient a certain amount of time off from purgatory. This may be the tomb housing the remains of Johanna Eynsham, wife of William Eynsham who endowed the charnel house with a chantry. We know she was buried in this position and the date of the bulla accords well with the date of her death. Her husband willed that he be buried next to her if he died sufficiently close to London that his body could be brought back. Whether he was is uncertain, but the other tomb may have contained his body.

Four other people were buried with papal bullae,

three in a similar location – in front of the charnel house – suggesting that that was a focus for burial for those who could afford it. Two other individuals were interred in lead coffins.

Given that we can identify certain small sections of the community, can we identify the remainder? Are the large mass-burial pits, for instance, filled with individuals who died in London, and was St Mary Spital therefore was acting as an overflow cemetery? Did it take on that responsibility in general, and do some of the single burials also represent people from the general London community? Evidence from the late medieval period suggests that 6% of those whose wills survive wished to be buried at St Paul's and St Mary Spital.[2]

We seem to have three major examples of burial type:

- individual graves representing single deaths. These might be a mix of hospital inmates, officials and benefactors, significant numbers also being from other London parishes, who were buried there either by choice or because burial space in their own parish was limited;
- small mass-burial pits, perhaps containing the bodies of two or more people who died on the same day, and were buried according to the hospital's usual practice in those circumstances;
- and large mass-burial pits, which may be an instance of St Mary Spital acting as an overflow cemetery during one or more catastrophic events. At present it is not certain that they form a single phase but the evidence increasingly points that way. The cause of death is unknown but certain osteological and dental traits and documentary evidence suggest that these were perhaps victims of famine.

About 56% of bodies (from the untruncated areas of the site) were buried in single graves, 21.5% in pits with seven or fewer individuals, and 22.5% in the large mass-burial pits.

Demography

Demographic evidence from the first 3,000 or so skeletons analysed clearly indicates an overall population who, in the main, survived childhood and adolescence. Half the population died between the ages of 26 and 45. It will be fascinating to see how these demographics change from period to period. The pilot study also noted clear statistical differences between those buried in mass-burial pits (a higher proportion of under-18s) and those buried in single graves (a lower proportion of 18–25-year-olds).

Pathology

The variety and form of pathology recorded in the cemetery sample reinforces the importance of this site from a national and international perspective. The influence of the urban environment upon age at death may be identified in terms of the range, severity and prevalence of the diseases recorded, for example the frequent evidence of tuberculosis supports historical and bioarchaeological evidence for poor hygiene and cramped living conditions in London. Many skeletons display indications of osteomyelitis, a long-standing, often fatal, level of infection in the body; in others, cribra orbitalia suggests sustained dietary deficiencies; and in others there is evidence of scurvy and rickets.

Palaeopathology also has a role to play in the understanding of past identities, since it provides physical evidence of events that may have influenced individuals' lives. So far, one 15-year-old has been identified with a cleft palate. Another, who was buried in the late 13th century, had congenital syphilis, proving once and for all that Columbus and his men did not introduce the disease into this country. There are, in fact, a fair number of treponemal diseases appearing throughout the population. Three cases of congenital hip dislocation have been diagnosed in adult males, Paget's disease and evidence of birth trauma have also been identified. These skeletal abnormalities would have changed the appearance of the person, and may have affected their role and status within society.

Medicine

It is generally believed that there was little active surgery or medical intervention carried out in medieval hospitals – medicine, however inadequate, was for the rich not

the poor. However, there is documentary evidence that both doctors and surgeons may have worked at the hospital and that medicinal and surgical procedures were carried out (although not necessarily at the hospital). Medicinal remedies seem to have been made in a group of large ceramic industrial vessels found in pits outside a building related to the canons' infirmary. Containing residues of metals such as arsenic, mercury, copper and lead, these could be distillation vessels, used in what may have been a pharmacologist's workshop.

A number of individuals have been trepanned, a procedure designed to reduce swelling in the brain, and others have had limbs amputated. It will be interesting to establish whether or not these surgical interventions were performed at the hospital. Certainly some individuals were buried with ankle and knee braces and there is plentiful evidence of healed fractures, suggesting the use of splints.

Conclusion

In conclusion, archaeologically and osteologically, the excavations of St Mary Spital and in particular of its cemetery, provide us with an unparalleled window into the lifestyles, beliefs, environment and deaths of medieval Londoners. The site offers the potential to understand cemetery use and layout, burial practice, demography and disease over much of the medieval period, as well as insight into the workings of a medieval hospital.

New technologies, new evidence, new theories, new working practices will all help augment our understanding of the past and its people. This project will never be able to answer all the potential questions or reveal the whole story behind these skeletons, but through careful excavation and well-organised complex analysis we will at least have set the benchmark and recorded the data upon which future studies will be based.

[2] Harding, V, (1992), 'Burial Choice and Location in Later Medieval London', in Bassett, S, (ed), (1992), *Death in Towns: Urban Responses to the Dying and the Dead, 100–1600*, University of Leicester, Leicester, pp119–35

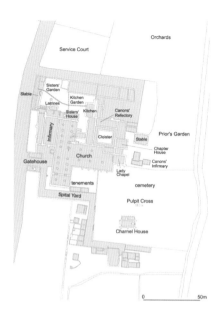

A plan of the hospital precincts in about 1500

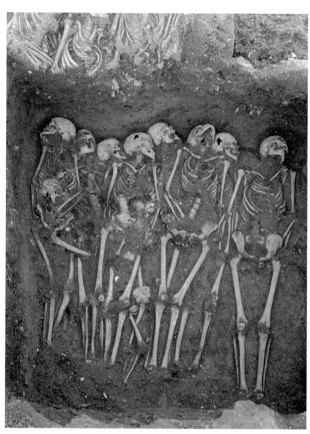

A mass-burial pit dating to around 1300 containing large numbers of victims of an as yet unknown catastrophe

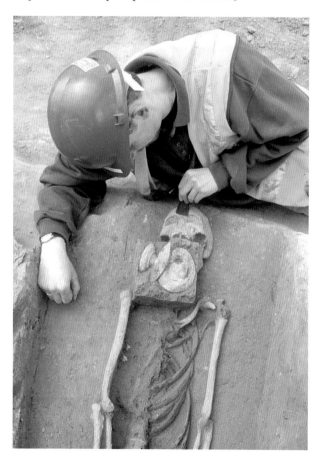

An Augustinian priest from the priory buried with his symbolic pewter chalice and paten set

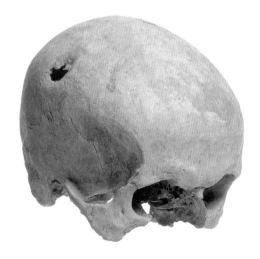

A skull with a trepanning hole. Trepanning was and still is used to release pressure on the brain, and was a common treatment for epilepsy

Bodies: Taking Account of Viewers' Perspectives

Katherine Goodnow

Wᴴᴬᵀ ɪѕ ɪᴛ that attracts us to viewing human remains? Why do we sometimes feel revulsion and dismay while at others we feel safely distant from the object viewed? How can we unravel these various responses? And what are their implications for museums and museum displays?

This chapter starts from the position that for museums to achieve their purpose, they need to understand the mixed emotions that viewers can bring to displays of bodies and body parts. The opening section considers why bodies are sometimes repulsive to view. The chapter then moves on to explanations of why they are at the same time fascinating. Finally it asks how museums can build on the fascination but contain the horror through the use of border creation, atmosphere and the viewers' understanding of genre. These aspects of viewing (and some of their implications) are illustrated by examples from museum displays and from film. Throughout, I have drawn also from semiotic and anthropological analyses of our feelings about what is 'other'.

Bodies, corpses, and the impure or abject

I begin by borrowing a concept from Julia Kristeva, starting with her description of the repulsion we feel on seeing a corpse in a morgue setting:

'In that compelling, raw, insolent thing in the morgue's full sunlight, in that thing that no longer

matches and therefore no longer signifies anything, I behold the breaking down of a world that has erased its borders The corpse, seen without God and outside of science, is the utmost of abjection. It is death infecting life. Abject.'[1]

More broadly, Kristeva argues, the concept of the abject and our ambivalent reaction to viewing bodies stems from the way society creates borders between what is seen as clean versus dirty, living versus dead, human versus animal.

Kristeva draws here on the anthropologist Mary Douglas and her theories of purity and danger.[2] Douglas argues, as Kristeva does, that what we call 'filth' is that which threatens system or order. Kristeva adds to Douglas the proposal that images of wastes – body wastes particularly – stand for the 'work of abjection'. They stand for the effort to exclude or eject from ourselves that which threatens the borders, or for the reassurance that this effort has been successful and we may accordingly survive. The physical response we make to what we loathe is part of this 'work of abjection':

'the spasms and vomiting that protect me. The repugnance, the retching that thrusts me to the side and turns me away from defilement, sewage and muck … the gagging … spasm in the stomach, the belly … sight-clouding dizziness, *nausea* … "I" want none of

that element ... "I" do not want to listen, "I" do not assimilate it, "I" expel it.'[3]

She continues with direct reference again to corpses:

'A wound with blood and pus, or the sickly, acrid smell of sweat, of decay ... without makeup or masks, refuse and corpses show me what I permanently thrust aside to live.'[4]

These divisions between the clean and the dirty, both Douglas and Kristeva note, are not fixed. What is seen as 'filth', Douglas points out, is not necessarily the same from one society to another. The division, Kristeva adds, may also change over time. Changes in concepts of clean and dirty, and in methods of defence can be found, for example, within religious practices.

Old Testament injunctions against 'abomination', she comments, contain a concern with the threat of defilement from without and a major reliance on one particular way of coping. This coping is by a series of rules and prohibitions that concentrate on 'separating, ... constituting strict identities without intermixture'.[5] Food shall be unleavened (no mixture of grain with yeast). What touches meat shall not be in contact with what touches milk (the Kosher kitchen):

'thou shalt not let thy cattle gender with a diverse kind; thou shalt not sow thy field with mingled seed; neither shall a garment mingled of linen and woollen come upon thee.'[6]

In a still further separation of the pure from the impure:

'whatsoevery man ... that have a blemish, he shall not approach: a blind man, or a lame, or he that hath a flat nose, or anything superfluous, or a man that is brokenfooted or brokenhanded ... he shall not come nigh to the bread of his God.'[7]

For Kristeva, these ways of dealing with the abject were ways by which Judaism, struggling 'to constitute itself', distanced itself from and fought 'against paganism and its material cults'.[8] In an extension of the same argument that radical changes (in religion and in social orders)

come about through a re-drawing of boundaries, she proceeds to describe Christianity as making two major changes to previous ways of coping and thinking. One was 'through abolishment of dietary taboos, partaking of food with pagans, verbal and gestural contact with lepers'.[9] The other was through an 'interiorization of impurity'.[10]

Where, in Judaism, defilement came from without – from what was taken in, and so needed to be avoided – now defilement came from within: from the presence of sin, with some of that 'original sin' becoming an inherent rather than an acquired part of human nature. 'Sin' in Kristeva's phrase, is 'subjectified abjection'.[11]

Kristeva then notes the variety of new ways of coping with the abject once it was placed within the individual: confessing sin, abjuring sin, seeking absolution from a representative of God, obtaining the remission of sins, and the conversion of sin into grace. In effect, changes occur in the form of what is seen as impure or abject and in the forms of coping, ejecting, or distancing. The underlying concern with threats to borders and boundaries and with containment, however, remain constant.

Bodies and their fascination

If repulsion were the only emotion involved, decisions about museum displays would be simpler. In fact, feelings of that kind are also linked with other emotions: in particular, with fascination. Gunther von Hagen's *Body Worlds* exhibition provides one example. Why do people pay to see exhibits that include bodies or decaying animals, to be fascinated as well as terrified? Why do people, to take a parallel question, pay to watch horror films?

There is a range of psychoanalytic explanations for our fascination with what also frightens us. One lies in the way some images and themes represent, in classical Freudian theory, the world of early pleasure and forbidden desire. In Oedipal terms, the child desires the mother, the father forbids access to her body (orally, visually, or genitally), the child represses desire, but desire is not extinguished. The ' return of the repressed' may occur in disguised form: in dreams, myths, legends, slips of the tongue. But the desire remains – both for the early gratification and for the one-ness and non-separated state that once existed. So also does the sense of

loss that the separation entails. The presence of the continued desire and loss (desire especially) fuels a great deal of artistic endeavour as we attempt to evade the censors of repression using a variety of symbols. The presence of continued desire also fuels intense interest – on the part of the listener, reader, or viewer – in the disguised presentation of the forbidden.

Some further answers, related to the first, lie (a) in the proposal that our early desire to look, either for gratification or for reassurance, is a particular desire that is forbidden, and (b) in the argument that the pleasure of looking is based on some process of identification. Film texts, literary texts or some artworks, for instance, may provide the articulation and expression of desires, fears, and conflicts that are otherwise difficult to express (the 'words' are lacking or forbidden expression). In this respect, the text gives 'voice' to what otherwise has been difficult to say or to name.

To these accounts of fascination, Kristeva adds a particular emphasis on two aspects. One (to be found also in Freud in discussions of the unconscious) is an emphasis on the energising quality of contact with a less ordered world. The other – an important part of Kristeva's argument and one that transcends 'filth' – is the pleasure of encounter with material that may contain the rhythms, the 'pulsions', the music or the poetry that an emphasis on the syntax and semantics of a linguistic order has set aside.

Answers to the second question (why do people pay to see horror films or exhibitions that deal with the abject?) have to do with the way encounters with the abject or the forbidden are regulated. This is again a topic – in terms of the forbidden – that has been addressed by classic Freudian theory. To cope with the forbidden and frightening feelings of rage towards the mother when she limits one's pleasures, the image of the mother may be split (good mother/bad mother) and the feelings of anger directed towards, or displaced onto, the bad half only. To cope with the conflict of wishing to look, but being forbidden to look, the viewer may be allowed to look at only part of the original object. The image becomes fragmented and its parts treated in 'fetish' fashion.

Can such arguments be useful ways of considering the appeal of seeing human bodies on display? Clearly there is a sense of being allowed to see what is normally kept on the 'other' side: that which is normally hidden or forbidden.

Consider some specific examples. I start with one to which the response of many viewers was strongly negative. Marilyn Martin, in this volume, offers an insight into the uproar created by the use of body casts of black Khoisan by a white artist in an exhibition at the National Gallery of South Africa titled *Miscast*. Here the uproar was related in part to power relations, and the presumption that casts of others' bodies may be used as part of a white person's artwork – even if the artwork is condemning white representations and appropriations. The uproar was also related to the way in which the casts and body parts were presented. They were in pieces, in almost fetishist style. The goal of the exhibition was to force people to look at suppressed history, one that included a particular relation to the bodies of the subjugated majority. For the majority of viewers, however, looking was simply a reminder and a repeat of the fetishist use of their ancestors' bodies.

For further examples, we may turn to other artworks and exhibitions that have played with the crossing of borders. Artists have repeatedly used the abject as a way of pointing to society's moralising about, and removal of, that which is seen as dirty or unwanted. Hannah Wilkes, in her *Starification Object Series* project (1974), marked her naked body with vaginally-formed sculptures made of chewing gum, and photographed herself in positions that made fun of magazine models. Cindy Sherman created series of photographs of the repressed side of human bodies (decay, disease, 'the normally hidden parts'), using casts. In Jan Avgikos' interpretation,

1 Kristeva, J, (1982), *Powers of Horror: An Essay on Abjection*, translated by Leon S Roudiez, Columbia University Press, New York, p4

2 Douglas, M, (1966), *Purity and Danger: An Analysis of Concepts of Pollution and Taboo*, Routledge and Kegan Paul, London

3 Kristeva, (1982) *op cit* pp2–3, emphasis in the original

4 *Ibid* p2

5 *Ibid* p93

6 Leviticus, cited by Kristeva, (1982), p103

7 *Ibid* p102

8 Kristeva, (1982) *op cit* p94

9 *Ibid* p113

10 *Ibid* p122

11 *Ibid* p128

Sherman thereby forced viewers to acknowledge their dual relation to bodies:

'Automatic scopophilic consumption, whether narcissistic or voyeuristic, is interrupted. By rendering the body problematic, and exposing what is conventionally hidden, Sherman infuses the desirous look with a sense of dread and dis-ease.'[12]

Kiki Smith has also worked with our ambiguous relations to the female body and created sculptures showing organs, the womb, the bleeding.[13] Robert Gober has made sculptures of transsexuals and the feminisation of the male body and the body harmed.[14] Works of scatological art present us with that which we perceive as the dirty within us – shit, dirt, excretion. Sam Goodman and Boris Lurie's NO! Sculpture Show from 1964 is an early example. In effect, many exhibitions engage 'the abject' to create particular kinds of responses on the part of viewers, and viewers do come to look.

Containing the abject

What do proposals of the kind outlined offer us for the study of museums' roles and of their displays of human remains?

To bring out several possibilities, I continue with some concepts from Kristeva and draw links to work in film theory, in particular to analyses of filmic representations of bodies.

Kristeva argues that we create spaces and rituals within which we can come into contact with 'the other' or 'the abject'. Religious rituals, noted above, provide one space within which boundaries are drawn between good and evil, clean and dirty. This space allows us to come into contact with 'sin', with the abject within, but at the same time to eject it from us. The Church and religious ceremonies often provide safe contact with the dirty or the abject, allowing it to be expelled and leaving the participant cleansed afterwards.

Barbara Creed, drawing on Kristeva and Douglas, sees horror films as another site in which we may encounter the abject and human remains at a safe distance:

'The horror film abounds in images of abjection, foremost of which is the corpse, whole and mutilated, followed by an army of bodily wastes such as blood, vomit, saliva, sweat, tears, and putrefying flesh.'[15]

For Creed, viewing the horror film signifies:

'a desire not only for perverse pleasure (confronting sickening, horrific images, being filled with terror/ desire for the undifferentiated) but also a desire, having taken pleasure in perversity, to throw up, throw out, eject the abject (from the safety of the spectator's seat).'[16]

In fact, spectators of horror films – and of museum exhibits of human remains – do not all react in the same way. For some, the emotion becomes 'too strong'. It floods one's being, overcomes one's usual rationality, breaks down one's usual control. The effects, one fears, will be overwhelming, lasting beyond the limits of the time of watching rather than being contained or limited in extent and in time. The viewer has a sense that the film and its images have been 'too much'. The ideal experience, then, consists in having some sense of unsettling thrill, but in having this contained or stopped before it becomes 'too much'.

This combination is the essence of what Kristeva has termed 'rituals of defilement'. The individual is allowed to come close to what is abject, and is permitted the thrill of doing so, but is at the same time protected from being overwhelmed. The thrill is contained.

The two implications in relation to museum displays are these. First: there are differences between human remains. The cleansed skeleton is often less abject than the 'more human' mummy retaining hair and skin, or the diseased body parts displayed in formaldehyde.

Second: we can ask how museum displays of human remains contain the horror we may otherwise experience. On this score, we may turn to films as a starting point. How do horror films produce this 'containing' effect once emotions have been set ajangle by the initial encounter with what is feared/desired/held to be impure?

Part of the containment lies in the way that the spectator is seldom presented with the whole horror. What

is offered is a fragment, or a section, a piece of the body or the action.

What is offered may also be something that only stands in for 'the real thing'. Just as Christians eat wafers presented as the body of Christ, but know that they are wafers, viewers watch violence but know that it is really acting. Viewers know also that they can leave.

Part of the containment in film is based also upon the strategies and opportunities that the film offers for stepping back, for 'distancing'. The action may be set in a foreign place. The camera may offer long-shots or blackouts so that the viewer is not forced to rely on his or her own use of the strategy of not looking. The moments of horror may also be broken up by moments of humour (Shakespeare's comic second acts are a classic example), or by quiet interludes.

Part of the containment must also lie in the viewers' sense that the story will include arrangements for the horror to be 'contained', in the form of some predictable aspects of sequence and style. Without trust on the part of the viewer that some limits will be observed (and some desensitisation from past viewing), neither the religious ritual nor the film ritual can be successful.

Do these same containments apply in museums? The methods are again of several kinds.

Partial presentation, fragments and casts

Many museum displays do not show the whole body – in fact not even the whole skeleton. Often what is presented is only the skull, a hand, or a small body part. This is the case particularly in the presentation of diseased body parts. A whole body showing leprous lesions is not only unlikely to be shown because of the size of the container it would need, but also because of the reminders of its relation to ourselves: of our own vulnerability, the weakness of one's own flesh.

Border protection and glass cases

The body is also almost without exception separated from the viewer by some sort of border – usually a border of glass and often a railing. This separation has its parallel in the need to control borders in general. Whenever something is excluded from life, but not extinguished,

the need arises to patrol the border in some way and to reinforce it. Prisons are surrounded by high walls and patrolled by guards. The doors to forbidden attics are locked and barred. The threat of 'leaks' may still remain. In film, for example, radiation leaks (as in *Silkwood*) or the spread of disease or contamination are the source of horror. The borders and boundaries normally put up and maintained by science and scientists have proved insufficient.

Wherever something is set apart from life and remains impure or dangerous, there must be ways of dealing with breakouts or breakdowns. Decontamination areas, special clothing, body-checks, alarm systems: all of these come into play.

The Museum of London's (1998–99) *London Bodies* exhibition provides a museum example. The exhibition showed how disease had affected the skeletons of people who had lived in the geographical area that is now London. The 'bodies' did not have flesh – they were only skeletal remains. The manner of their display can be seen as an attempt not only to create the usual border – the glass case – but also to further decontaminate the space that the bodies inhabited.

The 'bodies' were laid out on tables reminiscent of the morgue. The space surrounding them was cleansed, white and supposedly sterile. Entering into the exhibition was somewhat similar to entering into a surgical space, with a heavy door to interposed between our lives and the medical world. A warning was issued to the faint-hearted and children were not allowed to enter the space unless accompanied by an adult.

Hedley Swain, Head of Early London History and Collections, argues in this volume that he would not now advocate a similar display without greater debate on ethics and the audience.

I use this example also to bring out an unexpected side to containment. In one sense, the exhibition may

[12] Jan Avgikos, (1993), 'Cindy Sherman: Burning Down the House', in *Artforum*, 38, January, p78

[13] For example, *Trough*, (1990)

[14] For example, *Untitled*, (1990), of a body divided in two: half man, half woman

[15] Barbara Creed, (1985), 'Horror and the monstrous feminine: An imaginary abjection *Screen*, 27(1), 44–70, p45

[16] *Ibid* p48

be seen as having gone too far in its play on the sterile medical, morgue or scientific space. By moving too far away from traditional display methods, from the dampened light and museum genres we recognise, concerns were raised among viewers about the manipulation of bodies and, behind that, about the scientist-narrators. Were they drawn to the skeletons by a purely rational fascination? Was this fancy presentation masking more morbid interests?

This fear of scientists working with motives other than the general good of humankind, and thus treating bodies in ways we would not accept, can be seen also in film. In the 1978 film *Coma*, for example, scientists begin to steal bodies from hospitals – sometimes before they are dead – for profit through the resale of organs. The bodies are kept indefinitely in a cleansed hangar in a state of limbo between life and death: a state of permanent display that suggests concern only with the interests of science, and gives no indication of respect for the dead. The kind of display used in the *London Bodies* exhibition appears to carry the same overtones.

Control by knowledge of the genre

Just as participants in any purification ceremony must know how the ceremony proceeds and must have some trust in the capacity of those conducting the ceremony to see them safely through the horrible parts, so also must the spectator of museum displays and of the horror film. The pleasure of terror lies not only, as Creed suggests, in physical fright and revulsion 'from the safety of the spectator's seat'. It also lies in the safety of knowing the rules of the genre. As in any Gothic novel or in any melodrama, the reader takes pleasure – and reassurance– from knowing that the hero(ine) will not be killed. The viewer has the further advantage of knowing that particular kinds of settings, particular camera perspectives, particular music, allow some prediction of what is to come and keep the viewer from being overwhelmed.

Museums can and do benefit from similar knowledge. First, some distance is created from previous experience. Many of us as children have seen skeletons – either 'real', casts or perhaps only drawings – as part of our primary education in biology. The skeleton here is part of a genre we know: a medical genre.

In museums also we may be presented with skeletons that fall easily within the genre or story of the development of humankind from apes, or medical history. We may be presented with medical stories. The Inca ability to deform skulls and carry out brain surgery, for example, incorporates some of the safety of a medical genre in our viewing of ancient skulls.

Second, museum viewers can draw on rituals and spaces or genres that are known from outside of the museum space. The Egyptian Museum in Cairo, for example, presents its mummies in a space we recognise from religious activity. The mummies are not displayed in the general museum space. Visitors must queue and enter a separate room created especially for the display. Silence is expected. Guides are not allowed. The room is darkened, and the mummies laid out carefully within their separate glass coffins. Visitors follow a path around the mummies as if paying last respects to a revered leader.

This preparation leading up to the visit is an example also followed by the Turin museum as described in this volume. It is the reverential, the carefully crafted almost religious space that allows the spectator to come into contact with the body but regulate its meaning. Here the museum curators are also signalling their respect for the body and we as viewers are in collusion with them – this time not as curious, morbid voyeurs but as beings in awe of something that is greater than ourselves (life itself).

Containment through wrapping versus unwrapped bodies – skin, hair and nudity

Most of the mummies in the British Museum are presented wrapped. The wrappings themselves create a safe border between the living and the dead similar to the glass cases. Some of the mummies are also accompanied by images from a CAT scan. The scans are a reassurance that science is no longer invasive; that scientists, and therefore we, respect the dead; that we maintain in acceptable ways the border between the dead and ourselves.

Three of the mummies in the British Museum, however, are not wrapped – or have not been rewrapped as is the case with many of the mummies in the Cairo

museum. Particularly disturbing for the first-time visitor is the mummy known by many British visitors as 'Ginger' (giving him a name in itself is a way of creating distance from the rawness of the image, it is a way of 'domesticating' the body). Part of the horror comes from the fact that the remains still have skin and some hair.

Skin, to take up a further part of Kristeva's argument, is a border between what is inside and outside the body. For it to be torn or punctured presents us with the collapse of this border:

> 'It is as if the skin, a fragile container, no longer guaranteed the integrity of one's "own and clean self" but, scraped or transparent, invisible or taut, gave way.'[17]

The state of skin is also a marker for what is 'inside'. Clear, clean skin reflects the pure and innocent, while unclean skin reflects internal disorder and filth. Unclean skin as a metaphor for evil is common in film (for example, the lesions that grow on the surface of pop-star Sting in *Dune*). 'Ginger's' skin, alas, is punctured and drawn. His skin and hair, and the fossilised remains of his genitalia, take us out of the genres in which wrapped mummies are safely contained. He is more than a skeleton. He was, we are forced to admit, a human being curled up in a foetal position as if trying to avoid death. He was and still looks vulnerable – afraid of both death and the afterlife. The afterlife we have given him as spectators is one in which he might continue to fear the control of others. His position seems to say that rest is not yet achieved.

What does such a lack of containment do to us as spectators? To be able to view human remains, I have argued, some form of containment and thereby distance must be created, a form that prevents us from becoming overwhelmed by the feelings generated by looking. When other forms of containment are denied us – the medical context, the religious setting etc – we must create distance through seeing these bodies as different from us – as truly 'others'.

We can turn people into 'others' through time or through geography. We can then display the raw bodies of other people, but not of our own. Our own must be treated carefully, displayed or disposed of in ritual manner.

But when 'others' are manipulated and displayed in a 'raw' state, humiliation arises, as demonstrated in the photographs emerging from the Abu Ghraib prison. Here is a clear example of how bodies should not be treated. Even a prison is meant to be reasonably 'safe', rationally controlled and regulated by conventions. Adding to the horror and the sense of lack of decency and civilisation provoked by these photographs was the fact that in some it was a woman who crossed the border from good to evil, from regulator to contaminator.

Some final questions

We have been assuming that there is a purpose to museums' displaying bodies and that the core issue is one of how to do so 'effectively' in both an educational and a moral sense.

I end, however, with the suggestion that part of the way forward consists of looking at those purposes, and at the rationales we offer, and at the extent to which the ways we proceed meet all of them. We may, for example, add interest to bodies – and justify displays – by presenting them as 'other' than us. That very move may diminish our sensitivity to others. Creating distance or recasting Egyptians as 'others' whose bodies may be treated with less reverence than 'our own' is not a lesson that fosters inter-cultural respect. Effective containment techniques may also contribute to our desensitisation to human remains. Is that desensitisation a step forward in the process of enlightenment? When is it necessary, and what do we add to human understanding, when we as museum workers present 'the real thing'?

Those are large questions. Let me end by anchoring them in a specific example that highlights for me the unsettling discrepancy that can exist between a museum's display and its implicit message. The example is the mummy in the National Museum of Ecuador in Quito. She has hair and her head lies slightly angled as if to look back at the viewer. Her moment of death, alone in a cave, elicits a strong emotional response. She is wrapped in clothing and her glass coffin is lowered into a recess in the room with dampened lighting.

[17] Kristeva, (1982) *op cit* p53

Objects from her period are nearby but not in the same case. She is treated then in a careful balance between subject and object.

The mummy is ostensibly displayed for some limited educational purposes. Tour guides carefully explain to students and visitors how the materials she is wearing have managed to survive so many hundreds of years. The text accompanying the exhibit emphasises the differences in durability of the different textiles.

Why it is necessary to exhibit her at all, however, if the issue is one solely of teaching students and visitors about the durability of local cloth? Museums, we are reminded, are conveying more than their explicit message, are balancing and building on more than viewers' simple interest in 'information'. The steps forward, I suggest, lie in understanding what we, as well as others, seek, intend and feel.

Author Biographies

1 | Why and When do Human Remains Matter? Museum Dilemmas

KATHERINE GOODNOW
Professor, University of Bergen, Norway

Katherine Goodnow is a professor with the Department of Information Science and Media Studies at the University of Bergen, Norway. Her research focuses on the areas of representation and diversity. Goodnow wrote *Challenge and Transformation: Museums in Cape Town and Sydney* – the first book in the UNESCO series on Museums and Diversity.

Katherine Goodnow's work on diversity and media representation also includes participation in a major Nordic research project on refugees, financed and initiated by the Nordic Ministry Council. Her publications from this project include (1999), *Norway: Refugee Policies, Media Representations*, Nord, Copenhagen. Goodnow is also a filmmaker and has directed a number of documentary series dealing with issues of representation and diversity for the Norwegian Broadcasting Corporation.

2 | Parading the Dead, Policing the Living

JACK LOHMAN
Director, Museum of London, United Kingdom and Professor, Bergen National Academy of the Arts

Of Polish origin, Jack Lohman is the director of the Museum of London and Professor of Museum Design at the Bergen National Academy of Arts. He was formerly Chief Executive of Iziko Museums of Cape Town, a new organisation bringing 15 national museums together for the first time. He studied architecture and fine arts at the Freien Universitat in Berlin and the University of East Anglia. He is President of the City of London Archaeological Society and a member of the UN's International Network for Cultural Diversity.

3 | The Politics of Human Remains: the Case of Sarah Bartmann

JATTI BREDEKAMP
Chief Executive Officer, Iziko Museums of Cape Town, South Africa

Professor Henry Charles (Jatti) Bredekamp was Director of the Institute for Historical Research at the University of the Western Cape before becoming CEO of the of Iziko Museums of Cape Town in November 2002.

Jatti Bredekamp holds an MA in Liberal Studies (Wesleyan University) and an MA in History (Univer-

sity of the Western Cape). He has served on the governance and management structures of many private and public institutions, including the Van Riebeeck Society of South Africa, Genadendal Mission Museum, Suid-Afrikaanse Sendinggestig Museum and the South African Heritage Resources Agency. In the mid-1990s, he was Vice-Chairperson of the Western Cape Business Opportunities Forum (WECBOF). As CEO, Bredekamp also serves on the Groot Constantia Trust and the Castle Control Board.

His most recent contributions to publications include (2004), 'The South African National Oral History (SANOH) and Indigenous Music Programmes in a Decade of Democracy, 1994–2004', in *Comma: Journal of Council on International Archives*; (2003), 'Gathering the dead bones of Adam Kok I: The history of the Le Fleur family in South Africa', in P Faber & A van der Merwe (eds), *A History of South African Families*, Kwela Books, Cape Town; and (2002), 'l'Influence des Autres Africains sur l'Histoire de l'Afrique du Sud', in *Ubuntu: Arts et Cultures d'Afrique du Sud*, Musée National des Arts d'Afrique et d'Océanie, Paris.

4 | *The Miscast Exhibition at the South African National Gallery*

MARILYN MARTIN
Director of Art Collections, Iziko Museums, South Africa

In May 2001, after 11 years as Director of the South African National Gallery in Cape Town, Marilyn Martin was appointed Director of Art Collections for Iziko Museums of Cape Town. Prior to her career in the museum sector, she was Senior Lecturer in the Department of Architecture, University of the Witwatersrand, Johannesburg.

Marilyn Martin was a member of the National Arts Council from its inception until 2005, a trustee of the Arts and Culture Trust, and her biographical listings include *Who's Who of Southern Africa* and *The International Who's Who of Women*. She has curated exhibitions of South African art in Mali, Denmark, France, the United States and Brazil. Martin participates in national and international conferences and selection panels, and has written numerous articles on art, culture and

architecture. Recent publications include essays in the following catalogues and books: (2003), *Coexistence: Contemporary Cultural Production in South Africa*, Rose Art Museum, Brandeis University, Waltham, Massachusetts; (2003), *Art/Aids South Africa* (co-author with Kyle Kauffman), the exhibition catalogue, Iziko Museums; (2004), *AIDS and South Africa: The Social Expression of a Pandemic*, Palgrave-Macmillan, London; (2004), *A Decade of Democracy South African Art* 1994–2004 *from the Permanent Collection of Iziko: South African National Gallery*, Double Storey Books, Cape Town; (2004), *New Identities Zeitgenössische Kunst aus Südafrika*, Museum Bochum and Hatje Cantz, Germany; (2005), *Globalisierung/Hierarchisierung Kulturelle Dominanzen in Kunst und Kunstgeschichte*; Jonas Verlag, Germany.

In 2002, Martin was admitted to the Légion d'Honneur of the Republic of France at the rank of Officer.

5 | *Policy and Research Issues Affecting Human Remains in Australian Museum Collections*

MICHAEL PICKERING
Repatriation Program Director, National Museum of Australia

Before becoming Repatriation Program Director at the National Museum of Australia, Michael Pickering worked as Head Curator with the Indigenous Cultures Program of Museum Victoria; Native Title Research Officer with Aboriginal Affairs, Victoria; Regional Officer with the Northern Territory Aboriginal Areas Protection Authority; as an anthropologist with the Northern Land Council; and as a consultant archaeologist and anthropologist. His research interests and publications include studies on material culture, cannibalism, hunter-gatherer archaeology and anthropology, heritage management, and repatriation.

6 | Policy and Practice in the Treatment of Archaeological Human Remains in North American Museum and Public Agency Collections

FRANCIS P MCMANAMON

Chief Archaeologist, National Park Service, United States

Francis McManamon is the Chief Archaeologist of the United States National Park Service. He also serves as the Departmental Consulting Archaeologist for the Department of the Interior, and Manager of the Archaeology Program in the NPS headquarters office in Washington, DC. His article in this book is a work of private scholarship and is not an official statement of the National Park Service or the Department of the Interior.

McManamon is involved in the development of policy, regulations, and guidance for National Park system and United States government archaeology, public outreach and general information exchange about archaeology, and archaeological resource management. McManamon's technical assistance and guidance about archaeology includes a series of technical publications on archaeological topics; the development and maintenance of the National Archaeological Database; a variety of interagency cooperative activities; and national archaeological policy, regulation, and guideline documents. Much of the information on these topics can be accessed at www.cr.nps.gov/archeology/index.html.

7 | The Scientific Value of Human Remains in Studying the Global History of Health

RICHARD H STECKEL

Economics, Anthropology and History Departments, Ohio State University, United States

Richard H Steckel is SBS Distinguished Professor of Economics, Anthropology and History at Ohio State University. He is known as a pioneer in anthropometric (or biological) history, an interdisciplinary field that blends subject matter from economics, history, human biology and medical anthropology. His latest book (co-edited with Jerome Rose), *The Backbone of History: Health and Nutrition in the Western Hemisphere*, examines pre-Columbian health in very long-term perspective.

CLARK SPENCER LARSEN

Anthropology Department, Ohio State University, United States

Clark Spencer Larsen is Distinguished Professor of Social and Behavioral Sciences and Chair of Anthropology at Ohio State University. He is the author or editor of 25 books and monographs, including *Bioarchaeology: Interpreting Behavior from the Human Skeleton* (Cambridge University Press) and *Skeletons in Our Closet* (Princeton University Press). He is the past president of the American Association of Physical Anthropologists and current editor of the *American Journal of Physical Anthropology*. With Richard Steckel, Phillip Walker, and Paul Sciulli, he co-directs the Global History of Health Project.

PAUL W SCIULLI

Anthropology Department, Ohio State University, United States

Paul W Sciulli is Professor of Anthropology at Ohio State University and has served as a member of the editorial board of *American Journal of Physical Anthropology*. His research interests focus on dental health.

PHILLIP L WALKER

Anthropology Department, UC Santa Barbara, United States

Phillip L Walker is a Professor in the Department of Anthropology, University of California, Santa Barbara, and is also past president of the American Association of Physical Anthropologists. His research interests span a broad range of topics including the history of human health, skeletal biology, and paleopathology.

8 | Chullpas: Aymara Indians and their Relationship to Ancestors on Display

VERÓNICA CÓRDOVA S
Assistant Professor, Bolivia

Filmmaker and researcher on issues of national identity and national cinema, ethnicity, representation, new technologies and democracy, Verónica Córdova studied journalism and anthropology in her home country, Bolivia, and film and television at EICTV Film School in Cuba. Masters and Doctoral studies were completed at the University of Bergen in Norway. Córdova is an Assistant Professor at the Department of Information Science and Media Studies at the University of Bergen and works as screenwriter and producer for the film production company Imagen Propia in Bolivia.

9 | Buddhist Cremation Traditions for the Dead and the Need to Preserve Forensic Evidence in Cambodia

WYNNE COUGILL
Documentation Centre, Cambodia

Wynne Cougill began working as a volunteer editor and writer for the Documentation Center of Cambodia (DC-Cam) in early 2000. She is the lead author of (2004), *Stilled Lives: Photographs from the Cambodian Genocide*, DC-Cam, Phnom Penh, and has been working at the Center in Phnom Penh since January 2004. DC-Cam is an independent Cambodia research institute dedicated to documenting the history of the Khmer Rouge.

10 | The Egyptian Museum in Turin

GRAZIANO ROMALDI
Architect

Graziano Romaldi took his degree at the Turin Politecnico in 1970 and studied architecture in Turin, specialising in planning for museums and temporary exhibitions. His temporary exhibition projects have included *Drawings of Tuscany* at Palazzo Chiablese (1979); *Karl Arnold,* an itinerant exhibition (1979); *Strips of Africa,* the drawings of Hugo Pratt (1985); *Felice Casorati* at Accademia Albertina (1986); and the exhibition pavilion at the 'Salone del Libro' for the city of Turin (1988).

Between 1989 and 2003, Graziano Romaldi was involved in the planning of projects at the Egyptian Museum of Turin. These included the *From Museum to Museum* exhibition (1989); an exhibit for the National Egyptology Congress (1991); a restoration project for *Cantina dei Frati* (1992); the design of the 'Prehistory' and 'Ancient Reign' rooms (2000); and the *Pharaoh's artists* exhibition (2003).

11 | Finding Common Ground: The English Heritage / Church of England Guidelines on the Treatment of Christian Human Remains Excavated in England

JOSEPH ELDERS
Archaeologist to the Church of England, United Kingdom

Joseph Elders has worked extensively on medieval archaeology in Britain and in the Middle East, where he excavated a 6th-century Nestorian monastery in the Perisan Gulf; and in Germany, where he excavated a Carmelite friary at Esslingen am Neckar. Elders has been Archaeology Officer at the Cathedral and Church Buildings Division of the Church of England since 1999, and co-convenor (with Simon Mays) of the Church of England / English Heritage Human Remains Working Group, which produced its guidance in 2005. He is Chair of the Advisory Panel on the Archaeology of Christian Burials and a member of the Department of Culture, Media and Sport Human Remains Advisory Service. He has contributed to various publications on his work in Arabia and on church archaeology.

12 | Somebody's Husband, Somebody's Son: Crash Sites and the War Dead

VINCE HOLYOAK
Senior Rural & Environmental Policy Officer, English Heritage, United Kingdom

Vince Holyoak was previously an archaeologist with English Heritage's Monuments Protection Programme, where he took the lead on the development of English Heritage policy towards the conservation and management of military aircraft crash sites. He is currently a member of English Heritage's Military & Naval Strategy Group, military archaeology being a long-standing interest. In 1995, Vince published a well-received history of the wartime airfield at Bottesford in the English Midlands, the result of six years' work with veterans' groups. In 1997 he reviewed the protection afforded to a remarkably complete suite of Civil War sites around Newark, Nottinghamshire, and subsequently also produced proposals for the management of the surviving defences around Dover and Portsmouth. He has since contributed to various publications on a range of military themes. The treatment of human remains in the context of crash sites combines two broad interests: along with his work with veterans' groups his PhD at the University of Nottingham was on burial customs in Neolithic and Bronze Age Cornwall.

13 | Public Reaction to the Displaying of Human Remains at the Museum of London

HEDLEY SWAIN
Head of Early London History and Collections, Museum of London, United Kingdom

Hedley Swain has worked for many years for the Museum of London, first as an archaeologist and more recently as a curator. He was involved in the curation of the *London Bodies* Exhibition in 1998, and a year later in the display of the 'Spitalfields Woman'. He is responsible for the London Archaeological Archive and Research Centre that includes the human remains in the Museum's care.

Hedley Swain is an honorary lecturer for the Institute of Archaeology, University College London; and teaches for Royal Holloway and Birkbeck College, University of London. He is Chair of the British Society of Museum Archaeologists, the Archaeological Archives Forum and the London Archaeological Forum. In 2005 he chaired the drafting group that produced the United Kingdom government's guidance for the care of human remains in museums.

14 | The Museum of London's Wellcome Osteological Research Database

BILL WHITE
Curator of Osteology, Department of Early London History and Collections, Museum of London, United Kingdom

Over 20 years Bill White has analysed the skeletal remains of thousands of Londoners from many periods between the Bronze Age and the early 19th century. He joined the Museum of London formally in 1997, becoming inaugural Curator of Human Osteology in 2003. Bill has produced many human bone reports and published widely in archaeological and historical journals.

15 | Scientific Research on Archaeological Human Remains in the United Kingdom: Current Trends and Future Possibilities

JELENA J BEKVALAC
Research Osteologist, Centre for Human Bioarchaeology, Museum of London, United Kingdom

Originally from an archaeological background and with an interest in skeletal human remains from excavating at Appledown, Sussex, Jelena Bekvalac went on to study for an MSc at Sheffield and Bradford University in Osteology, Palaeopathology and Funerary Archaeology. After graduating, she worked in Jordan for two seasons for the British Museum; on various projects in the Czech Republic; for the Institute of Archaeology, City Museum; and most recently in the National Museum, Prague. Bekvalac is also involved in the processing and assessing

of hundreds of the skeletons on site at Spitalfields.

LYNNE S COWAL MA
*Research Osteologist, Centre for Human Bioarchaeology,
Museum of London, United Kingdom*

Lynne Cowal has an MA in Ancient History and Archaeology from the University of St Andrews in Scotland and an MSc in Forensic Anthropology from the University of Bradford. She presented her MSc thesis, *Dimensional variation in the ulna: A method for sex assessment* at the 2003 British Association for Human Identification (BAHID) conference in Sheffield.

RICHARD N R MIKULSKI
*Research Osteologist, Centre for Human Bioarchaeology,
Museum of London, United Kingdom*

Richard Mikulski studied initially for a degree in Archaeology at University College London, where he developed his interest in human remains in between gaining experience of archaeological excavation in northwest Peru, Barbados, and Bignor in East Sussex. He completed his MSc in Forensic Anthropology at the University of Bradford. In April 2003, he presented a Masters dissertation paper at the 2003 British Association for Human Identification conference in Aberdeen. After graduating, Mikulski worked briefly in commercial archaeology before returning to Peru to carry out human remains analysis in 2003. In the same year, he began his association with British Museum-sponsored excavations at Sidon, Lebanon, taking up the position of burial archaeologist. He is currently recording human remains as part of the Wellcome Osteological Research Database.

16| *The Cemetery at the Priory and Hospital of St Mary Spital*

CHRIS THOMAS
*Project Manager, Museum of London Archaeology Service,
United Kingdom*

Project Manager since 1998, Chris Thomas was Senior Archaeologist at MoLAS from 1986–98 and directed the Spitalfields project between 1991 and 2003. His major publications include (1997), *Priory and Hospital of St Mary Spital*, MoLAS Monograph 1, London; (2002), *London Charterhouse*, MoLAS Monograph 10, London; (2002), *Archaeology of Medieval London*, Sutton Publishing, Stroud; (2003), *London's Archaeological Secrets*, Yale University Press, New Haven, and MoLAS, London; (2005), *Royal Palace of Westminster*, MoLAS Monograph 220